UNDEREXPOSED!

Editor: Connor Leonard
Designers: Eli Mock, Deb Wood, and Jack Woodhams
Production Manager: Larry Pekarek

Library of Congress Control Number: 2020931056

ISBN: 978-1-4197-4469-3
eISBN: 978-1-68335-918-0

Posters: Page 10 © Tom Coupland (BoyThirty), Page 16 © Kreg Franco, Page 20 © Joe Sanchez, Page 24 © Dave O'Flanagan, Page 31 © Freya Betts, Page 35 © Neil Davies, Page 41 © Bella Grace, Page 44 © Ben Turner, Page 49 © Alexandra España, Page 53 © Jaren Hemphill, Page 56 © Guillem Bosch, Page 63 © Kevin Tiernan, Page 69 © Albert Collado, Page 72 © Simon Caruso, Page 79 © Julien Rico Jr., Page 87 © Anthony Galatis, Page 91 © Brandon Michael Elrod, Page 94 © Danny Schlitz, Page 98 © Rafał Rola, Page 105 © Genzo (Zoltan Kovacs), Page 108 © Scott Saslow, Page 115 © Chris Garofalo, Page 119 © Laura Streit, Page 122 © SG Posters, Page 126 © Mat Roff, Page 130 © Noah Bailey, Page 134 © Nico Bascuñán, Page 138 © Ksenia Lanina, Page 142 © Alexander Cherepanov, Pages 146, 148, 149 © Brit Sigh, Page 152 © Edgar Ascensão, Page 159 © Aleksey Rico, Page 162 © Liza Shumskaya, Page 168 © Miki Edge, Page 172 © Yvan Quinet, Page 176 © Patrick Connan, Page 182 © Si Heard, Page 189 © Of Stick and Bone, Page 193 © Sister Hyde Design (Drusilla Adeline), Page 197 © Josh Campbell, Page 200 © Dakota Randall, Page 204 © QzKills (Quinnzel Kills), Page 211 © Sam Coyle, Page 215 © Derek Eads, Page 218 © Laura Racero, Page 224 © Nicky Barkla, Page 231 © Rachael Sinclair, Page 237 © Nick Taylor, Page 240 © Mark Levy, Page 247 © Matt Talbot

Foreword © Fred Dekker 2020

Cover © 2020 Abrams

Printed and bound in China
10 9 8 7 6 5 4 3 2 1

Abrams books are available at special discounts when purchased in quantity for premiums and promotions as well as fundraising or educational use. Special editions can also be created to specification. For details, contact specialsales@abramsbooks.com or the address below.

Abrams® is a registered trademark of Harry N. Abrams, Inc.

ABRAMS
The Art of Books

195 Broadway
New York, NY 10007
abramsbooks.com

POSTERSPY PRESENTS

UNDER EXPOSED!

THE 50 GREATEST MOVIES NEVER MADE

JOSHUA HULL

FOREWORD BY FRED DEKKER

ABRAMS, NEW YORK

CONTENTS

FORE WORD

MY FIRST MOVIE HAS AN EASTER EGG IN IT. IN THE COMIC-CON AGE OF MARVEL AND *Star Wars* and a million nerd podcasts, producers and filmmakers love to plant hidden references ("Easter eggs") to related movies, franchises, or characters. It's a way to let the fans feel like they're *in on something*, like backdoor software or a secret club handshake.

But with all humility, I did it before it was fashionable.

The year was 1986. I was in production on my directorial debut, a horror-comedy called *Night of the Creeps*. The scene was a campus restroom where a character finds himself trapped by the titular "creeps"—experimental space slugs from another world. As our intrepid, handicapped sidekick leaps off the toilet to escape an extraterrestrial demise, we briefly glimpse graffiti on the restroom wall: *"GO, MONSTER SQUAD!"*

Clearly, this would have meant nothing to *Creeps'* first audiences, but it was a sly wink that I'd already set up what would become my *next* film. And like the early James Bond movies, which announced the next installment's title in the end credits, it was with no small amount of hubris that I was touting my second feature before my first was even finished. I didn't appreciate it at the time, but the miraculous part was this: *The Monster Squad* was actually made and released the following year.

Now comes the sad part. While my first two films found a cult audience in subsequent decades, neither of them made any money at the time and my directing career was on life support as quickly as it had started. But *before* that happened—before *The Monster Squad* was even finished—the company financing it was fairly enthusiastic about it and asked me what I wanted to do next.

As it turns out, this same company controlled the rights to my favorite childhood cartoon adventure show! So, we made a deal for me to adapt the animated series into a live-action feature for the big screen, which is why, if you look very carefully in *The Monster Squad*, you'll see a poster for *Jonny Quest*. (Spoiler: It's on the wall in Eugene's bedroom.)

But alas, the box office failure of *Squad* was the death knell for my *Jonny Quest* movie, in addition to the beginning of my understanding that for every movie that gets made, there are hundreds, thousands, millions that *don't*.

That's what this book is about.

As I was licking my wounds over the box office failure of *Squad*, my friend Shane Black (who'd co-written it with me) asked me to help him rewrite a script of his own—his first, in fact—which he'd sold to Universal. It was an action-horror thriller called *Shadow Company*, with Walter Hill producing and John Carpenter directing. Things were looking up. We were given an office/trailer on the Universal backlot and, like Dr. Frankenstein, set about trying to apply the electrodes to bring *Shadow Company* to life.

"Too violent," said the studio after we turned in the rewrite. The story involved a platoon of U.S. Special Forces found dead in Cambodia, killed during the Vietnam war. No sooner are their bodies shipped back to the U.S. for military burial than they rise from their graves as the walking (and heavily armed) dead, only to lay waste to small town America. A grisly metaphor for the karmic damage of war.

Too violent? Maybe. But also too political. "Moviegoers don't want their noses shoved in the tragedy of Vietnam," we were told. "They go to the movies to *forget* things like that!" And so, we learned that while people may like chocolate in their peanut butter, combining action, horror, *and* metaphoric social commentary was a tough sell. *Time for a new project*, I sighed.

I wanted to write a *Dirty Harry* movie. There had only been two really good ones (the first two, IMHO), so I wrote a screenplay in which a criminal from Callahan's past is released from prison—or escapes, I can't remember—sand sets out to make Harry's life a living hell. I called it *Ricochet*, and when it was done, I gave it to my friend Joel Silver, for whom I'd written the first episode of HBO's *Tales from the Crypt*.

"It's the high school play of *Cape Fear*!" he enthused, damning with faint praise. "Let's give it to Clint!" I had gone out of my way to change the lead characters' name, just in case "Clint" didn't consider it worthy of his most iconic role. This, as it turned out, was the case. "Too grim," was Eastwood's response.

Joel was undaunted and, to my surprise, asked if I wanted to direct it. In short order, Warner Bros. had bought the script and I was meeting with Kurt Russell about playing San Francisco Police Detective Nick Styles.

I'm not certain what happened exactly, although I suspect I didn't win Kurt over (I think this should probably be my on my tombstone: *HUS-BAND-FATHER-DIDN'T WIN KURT OVER*). In any case, as happens with most movies, a new writer was hired, then a new director, and *Ricochet* starring Denzel Washington as Nick Styles eventually came to a theater near you in 1991.

When I saw it, I noted seven things that still remained from my original script.

The same thing happened around the same time with a script I'd written called *Teen Agent*. Seeing the comic genius of Anthony Michael Hall in John Hughes's early films inspired me to concoct a "high-concept" action comedy about a nerdy high schooler mistaken for an international spy who's tasked with saving the world while also not flunking his biology midterm.

I met with Mr. Hall. We made small talk and watched MTV, and eventually came to an agreement that Bruce Springsteen's "I'm On Fire" video was pretty rad. But Michael (as he was known) was apparently done playing nerds . . . so *Teen Agent* was a no go for him, even though he would've gotten the girl *and* driven a red Lotus Esprit. Without Hall, I lost interest in the project. Cue new writer; in this case, my UCLA schoolmate and *Sex and the City* creator Darren Star. Amazingly, *If Looks Could Kill* starring Richard Grieco was released the same year as *Ricochet,* but to me, the fact that Grieco was a smoldering teen heartthrob somewhat negated my whole premise.

And so, two major Warner Bros. releases that I had created were unleashed on the movie-going public the same year, but neither was remotely the movie I'd conceived. And they were followed by *decades* of movies I almost made, but for one reason or another, never saw the light of a projector bulb.

So, what's the moral of the story? What's the lesson in all this? The way I see it, there are three:

Lesson #1: *More often than not, your movie never gets made.*

Lesson #2: *If it does get made, it may bear little resemblance to your original vision.*

Lesson #3: *"I'm on Fire" is still pretty rad.*

FRED DEKKER
Los Angeles, March 2020

INTRODUCTION

THEY SAY, "WRITE WHAT YOU KNOW"–AND WHAT I KNOW IS HOW HARD IT IS TO GET MOVIES MADE.

As a no-budget filmmaker based in Indiana, I haven't found the filmmaking process to be a particularly smooth ride. I've been lucky enough to make three feature films, but I've talked about making a whole lot more. So many potential projects have crumbled due to funding, casting issues, and/or a term you'll read many times in the pages of this book: creative differences.

Let me repeat: it's *hard* to get movies made.

The process of filmmaking doesn't show prejudice; it doesn't care what your budget level is. There are always countless mountains to climb, whether you have $200 million or $200. Whether you live in Indiana, Kansas, or Los Feliz, California, filmmaking is a beast that dares you to step inside its mouth.

That's a dare I love taking, no matter how many times I lose. And listen: filmmakers lose a lot. Some of these losses we hear about and others we don't. Some we hear *too* much about, and it immediately casts a cloud over the production and the final movie. Regardless of the film or the budget, each project creates its own entire world, brought to life by countless people: writers, directors, concept and special effects artists, editors, producers, production designers, and more.

But what about the losses we don't hear enough about?

What about the movies that never happen, that languish and die in the underexposed belly of the Hollywood machine? What about *those* lost worlds, the projects announced or discussed by filmmakers and studios; the ones we all see online and share or retweet our excitement about and never hear from again? What about the people and the stories behind those films?

Well, friends, we're going to talk about them.

Hollywood is a well-oiled machine that makes and releases hundreds of films a year. But for every film that gets made, there are hundreds of others that stall, get shut down, or remain in development hell. We're going to

explore the development history of fifty such unmade movies. We're going to track their beginnings and their unfortunate ends.

Then we're going to bring them to life.

Fifty of the best poster artists and designers from around the world have given these movies a life they otherwise never would have had. For example, we all know about Peter Jackson's *The Lord of the Rings*, but did you know the Beatles once tried to convince Stanley Kubrick to make a *Lord of the Rings* movie starring them? Now you do. And artist Liza Shumskaya has brought that unmade film to life via her original poster art.

Stanley Kubrick's *Lord of the Rings* is just one of fifty such "almost films" we'll discuss and illustrate. We'll follow the path not taken by some of our favorite films, as well as films that would have been our favorites if they could have just gotten that little ever-so-essential green light (I'm looking at you, *At the Mountains of Madness*).

We have a lot more in these pages, too, but why spoil it in the introduction? Turn your phone on silent, grab your favorite movie theater snacks, and join us for a trip to the Alternate Movies.

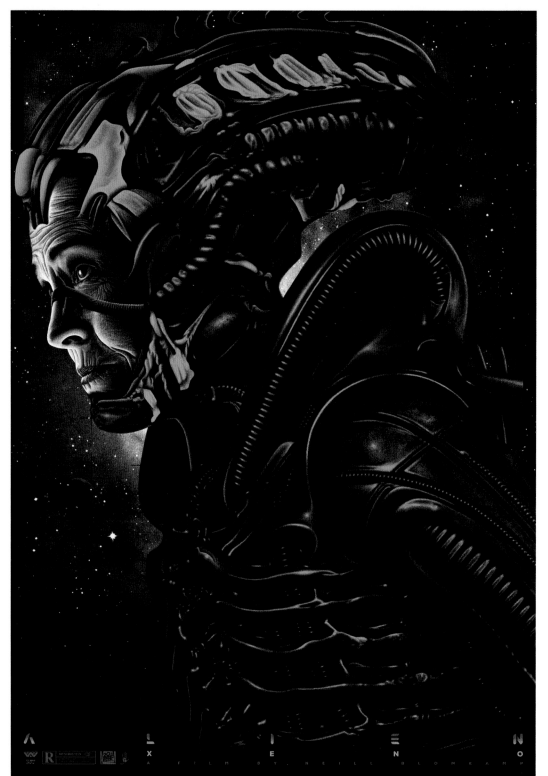

ALIEN

A FILM BY NEILL BLOMKAMP

NEILL BLOMKAMP'S
ALIEN 5

THE PLAYERS

Director
Neill Blomkamp

Screenwriter
Neill Blomkamp

Producers
James Cameron
and Ridley Scott

Starring
Sigourney Weaver,
Michael Biehn

FADE IN

After lying dormant for five years, the *Alien* franchise found its way back to the big screen in 2012 with Ridley Scott's *Prometheus*. The film was Scott's return to the world (and horrors) he brought to life in 1979. Instead of the source of a distress transmission, the crew of the Prometheus were searching for the origin of mankind. Both crews, however, discovered that you should just enjoy space and never attempt to find or rescue anything up there. Ever.

Released in June 2012, *Prometheus* ended its theatrical run with a box-office take of $403 million worldwide. While closing some chapters in the film, *Prometheus* left some wide-open questions unanswered, which laid the groundwork for another sequel. But how do you engineer a sequel to a prequel that was meant to bridge the gap between *Prometheus* and *Alien*?

You do, and you don't.

FLASHBACK

Development on the "Promethequel" started before the 2012 release and continued for the next few years. Small bits of information trickled out about where Scott was taking the series, but nobody expected the curveball that was thrown on February 18, 2015: *District 9* director Neill Blomkamp posted a piece of Alien art on Instagram with a one-line caption: "Um . . . So I think it's officially my next film."

After starting out in the industry as a special-effects artist and 3-D animator, Blomkamp exploded onto the larger filmmaking scene in 2010 with the *Landfall* series of live-action short films, based off the Xbox game *Halo*[1]. The success of that series led to Blomkamp landing his first feature-film directing gig: the blockbuster adaptation of *Halo*. At the time, Peter Jackson

1 Guillermo del Toro was first attached to direct, but left the production early on to focus on *Hellboy II: The Golden Army*.

was attached to produce the film in a unique partnership between Microsoft, Universal, and 20th Century Fox.

(*Halo*, the game and would-be film, follows Earth's battle with an alien force known as the Covenant, which is faintly ironic, given how Blomkamp's career trajectory soon crossed paths with the *Alien* franchise.)

After months of work and some displeasure with the direction Blomkamp was taking the film, and in no small part due to the pressures of a massive budget that was to be split among three companies, development on *Halo* came to a crashing halt. Blomkamp has since been vocally critical of his treatment at the hands of 20th Century Fox (more specifically, of former studio head Tom Rothman), and has sworn off ever working for the company again.

Blomkamp and Jackson shifted their focus to a much smaller film they could collaborate on: a feature-length adaptation of one of Blomkamp's earlier short films, *Alive in Joburg*. The feature version, *District 9*, is a docustyle science-fiction film that follows government agent Wikus van de Merwe (Sharlto Copley) as he leads the relocation efforts of an alien species known as Prawns to their new "home" in a slum called District 9. Here, Wikus is exposed to their alien technology and begins to turn into one of the Prawns he's in charge of moving. *District 9* had a budget of $30 million and went on to make $210 million worldwide. It also received a number of prestigious accolades, including four Academy Award® nominations (for Best Picture, Best Screenplay, Best Editing, and Best Visual Effects). Not bad for a first-time filmmaker who had just been put through the wringer by three major companies. *District 9* officially put Blomkamp on the map.[2]

He returned four years later with the Matt Damon/Jodie Foster sci-fi thriller *Elysium*. Set in the year 2154, the unlucky Max (Damon) has no choice but to join the conflict that could bring equality to the people of Earth, by facing off against the extremely wealthy, sequestered segment of the populace who live on the space station *Elysium*. The film built on the social commentary–style themes of *District 9*: immigration and overpopulation. Released in August 2013, *Elysium* grossed a worldwide total of $286 million.

For his third film, Blomkamp gave his usual science fiction flare a gangster makeover with *Chappie*. Once again set in the future, a mechanized police

2 A sequel, *District 10*, has been discussed for years, but as of 2019, no further developments have happened.

force controls all crime in Johannesburg. A robocop named Chappie is stolen by criminals Ninja, Yo-Landi, and Yankie (played by Ninja and Yo-Landi Visser of the South African hip-hop group Die Antwoord and Jose Pablo Cantillo) and given new programming. He becomes the first robot to have a conscience, as well as the ability to grow and learn. *Chappie* was just months away from release when Blomkamp entered 2015 with his *Alien* news waiting to burst out of his chest.

What he didn't know was the incubation process on the Prometheus sequel was almost up.

ACTION!

Blomkamp's *Alien 5* (known briefly as *Alien: Xeno*) would have been a legacy sequel released long before *Halloween* (2018) or *Terminator: Dark Fate* (2019). *Xeno* was going to be a direct sequel to James Cameron's *Aliens*, completely ignoring David Fincher's *Alien 3* and Jean-Pierre Jeunet's *Alien Resurrection*[3]. Blomkamp planned to bring Cameron along for the ride as a producer, and he wouldn't be the only one strapping in for the trip.

Sigourney Weaver had just appeared in *Chappie*, where Weaver and Blomkamp initially started discussions about a new *Alien* film. Originally, Blomkamp pitched a Ripley-less new film, but after drawing Weaver's interest, he developed an entirely new take that would once again see Weaver suiting up as Ripley. Michael Biehn, who played Hicks, was also slated to return for the film. Blomkamp continued to tease the film over Instagram with concept art and other images. Some of the most intriguing of these horrifying images depicted a fully grown Xenomorph scaling a ventilation shaft, mutated humans, and possibly the most exciting: Ripley in a Xenomorph suit.[4]

CUT!

Development continued on *Alien 5* through summer 2015, and it all seemed to be going very well.[5] In November 2015, Scott announced the

3 It would also ignore the *Alien vs. Predator* films, but everyone basically ignores those anyway.

4 Featured in artist Tom Coupland's artwork for this book.

5 Literally. A Blomkamp Instagram post from July 16, 2015, stated, "#alien going very well."

long-developed Prometheus sequel would be called *Alien: Covenant*, with principal photography scheduled for April 2016. At this point it became clear that 20th Century Fox was planning to move forward with only one of these two *Alien* sequels in development.

Would it be the trusty filmmaker Scott, who brought *Alien* to life in 1979 and who was paving new ways for the universe to move forward and away from the familiar? Or the newcomer, who wanted to take the franchise back to 1986 and breathe new, horrific life into the series?

Well...

Chappie opened with a thud in March 2015 and proved to be Blomkamp's first film that failed to impress critics and capture audiences. There's no telling if the reception of *Chappie* played a part in *Alien 5* failing to come together or if it was more of a case of Scott tightening his grip around the franchise, but in November 2015, around the time Scott revealed his *Covenant* plans, it was announced that Blomkamp would instead be adapting Tom Sweterlitsch's murder mystery/science fiction novel *The Gone World*. *Alien: Covenant* opened in May 2017 and ended up grossing a disappointing worldwide total of $240 million.

In July 2018, Blomkamp reopened his legacy sequel dreams and signed on to direct *RoboCop Returns*, a direct sequel to Paul Verhoeven's 1987 original. And yes, the plan was for Peter Weller to return. On August 15, 2019, however, Blomkamp tweeted that he was "Off RoboCop" due to scheduling conflicts. As of June 2019, *The Gone World* project was still in development, and Blomkamp and Sweterlitsch have collaborated on a number of projects for Blomkamp's popular Oats Studio slate.

As for Blomkamp's *Alien 5* future?

It's still floating in the atmosphere above LV-426. Walt Disney Pictures finalized the purchase of 20th Century Fox in 2019, officially moving the *Alien* franchise over to the House of Mouse. Plans for the series have been quiet ever since the lackluster reception to *Covenant*, even as rumors swirl that plans for a second sequel to *Prometheus* have been canceled. At CinemaCon 2019, however, Disney confirmed that they were actively continuing the *Alien* franchise after their purchase of Fox. Could this be Scott's sequel to *Covenant*? Could it be something entirely new? Or, considering that James Cameron's *Avatar* series (and Pandora—The World of Avatar theme

park area) now has a home at Disney, could Cameron also somehow revive Blomkamp's *Alien 5*?

Only time, and space, will tell.

Alien celebrated its fortieth anniversary in 2019. Between popular toy lines (from Funko and NECA), Reebok's collaborative release of official Alien Stompers in 2016, Jonesy the Cat getting his own book in 2018, limited-edition prints commanding healthy secondary-market prices, and even a high school drama club stage adaptation of *Alien*[6], fan demand for the franchise appears to be at an all-time high.

6 North Bergen High School in New Jersey performed *Alien* on March 22, 2019. It was so popular, they performed an encore on April 26 with the financial support of Ridley Scott. Sigourney Weaver surprised the cast after the show. The full performance is available online.

OVEREXPOSED!
ALIEN 5

Blomkamp's *Alien 5* isn't the only potential franchise entry to get face-hugged by development hell. We're going to briefly discuss the other infamous unmade *Alien* film.

WILLIAM GIBSON'S *ALIEN 3*: In 1987, William Gibson wrote a sequel to Cameron's *Aliens* simply titled *Alien 3*. The *Neuromancer* author brought his very own trademark science fiction style to the franchise.[1] Much like the previous entry, *Alien 3* was heavy on the action. The film would have seen Ripley, Hicks, Bishop, and Newt captured by a mysterious group called the U.P.P. (Union of Progressive People). The foursome is taken to a space station called the *Anchorpoint*. It's here where our characters discover that Union and Weyland-Yutani are in an arms race with genetically modified Xenomorphs. And since it's an *Alien* movie, the *Anchorpoint* soon becomes overrun with the modified aliens.

Gibson's screenplay missed the mark for the studio, and rewrites were requested. After a few attempts to bring it down in scale (and thus in budget), Gibson walked away from the film altogether. The script was finally brought to life in 2018 as a graphic novel from Dark Horse Comics. In 2019, the script was adapted by Audible Studios into an audio drama starring Michael Biehn and Lance Henriksen. As for the actual *Alien 3* we all got?

Everyone knows how that turned out. (Not well.)

1 See pages 157–161 for more on Gibson's *Neuromancer*, featuring art by Aleksey Rico.

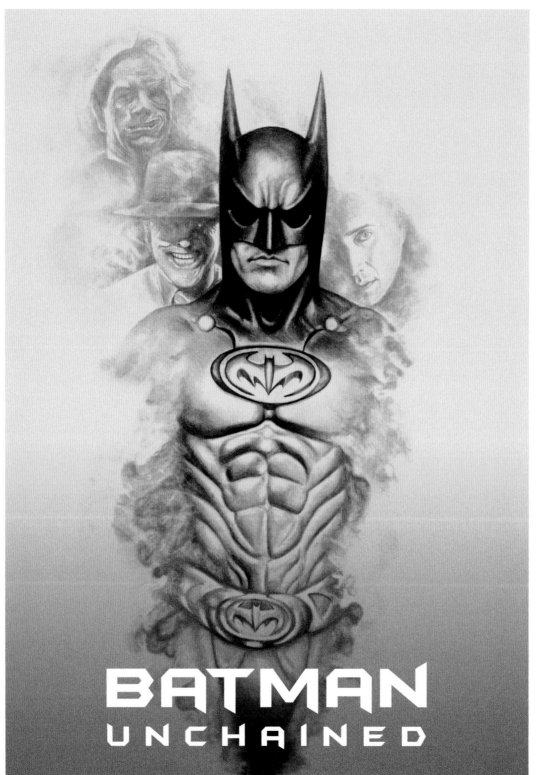

BATMAN
UNCHAINED

JOEL SCHUMACHER'S
BATMAN UNCHAINED

THE PLAYERS

Director
Joel Schumacher

Screenwriter
Mark Protosevich

Starring
George Clooney,
Chris O'Donnell,
Alicia Silverstone,
Nicolas Cage,
Courtney Love,
Jack Nicholson,
Danny DeVito,
Michelle Pfeiffer,
Tommy Lee Jones,
Jim Carrey

FADE IN

By 1997, long gone were the days of parents' complaints over overt sexual innuendos between the patent leather–clad Cat and the monstrous Penguin.[1] Warner Bros. had stepped away from Tim Burton's dark, gothic Bat-universe and handed the keys to the Batcave to Joel Schumacher. They wanted to give their franchise a colorful makeover.

What Schumacher did was entirely something else . . .

FLASHBACK

"Colorful" isn't exactly the kind of word you would use to describe Schumacher's filmography up to that point. *St. Elmo's Fire* (1985), *The Lost Boys* (1987), *Flatliners* (1990), *Falling Down* (1993), and *The Client* (1994) were all relatively dark, thrilling films.

Regardless of how it looked on paper, Schumacher went on to direct the follow-up to Burton's *Batman Returns* and gave the Bat franchise the bright makeover that Warner Bros. so desired. Released in 1995, *Batman Forever* introduced Val Kilmer as the new Batman/Bruce Wayne. Michael Keaton, a fan favorite to this day, left the role after disagreeing with the direction the franchise was heading—a sentiment that was soon echoed by Burton and, not long after, fans worldwide.

Ethan Hawke was offered the role after Keaton left, but quickly turned down the cowl. Warner Bros. and Schumacher had their eyes on a number of other possible Batmen, including Daniel Day-Lewis, William Baldwin, and Johnny Depp. Kilmer eventually signed on the dotted line without reading the script or knowing who the director would be.

Harvey Dent, who had been portrayed in Burton's *Batman* by Billy Dee Williams, was recast with Tommy Lee Jones. Robin Williams was briefly in

1 *Batman Returns* was met with complaints from parent groups due to the monstrous appearance of Danny DeVito's the Penguin, as well. Such groups protested marketing materials and promotional tie-ins, including Happy Meals and specialty cups at McDonald's.

talks for the Riddler, but the role ultimately went to Jim Carrey. Batman's sidekick, Robin, was initially set to appear in *Batman Returns*, but the role was written out; Marlon Wayans had been cast by Burton for the role and remained signed on for a potential sequel. (Schumacher also recast that role for *Batman Forever*; Leonardo DiCaprio was offered the Boy Wonder in recasts but passed, ultimately leaving the role to Chris O'Donnell.)

Batman Forever opened on June 16, 1995, to a record-setting $52.8 million, breaking *Jurassic Park*'s opening weekend record. (That record was broken two years later, when *The Lost World: Jurassic Park* opened to $72.1 million.) *Forever* ended up outgrossing *Batman Returns*, with $336.53 million worldwide. It didn't take a detective dressed like a bat to solve this riddle: a sequel was green-lit immediately.

Schumacher returned for the fast-tracked *Batman & Robin*. Kilmer, however, would not, after struggling to see eye to eye with the director during production on *Forever*. Instead, Kilmer left Gotham to focus on a promising new version of *The Island of Doctor Moreau*.[2]

On the hunt for a new Batman, Schumacher once again considered Baldwin, but the Bat-signal eventually shone on *ER* star George Clooney. O'Donnell returned as Robin, and Alicia Silverstone joined the film as Batgirl.

In what could have been a pitch-perfect casting, Patrick Stewart was considered for Mr. Freeze before the script was written. Those plans changed when Schumacher decided he wanted a more "chiseled" version of Victor Fries. Schumacher and writer Akiva Goldsman thus reimagined the role for Arnold Schwarzenegger. Uma Thurman joined the film as Poison Ivy/Dr. Pamela Isley. With the Bat-family in place and the villains plotting certain treachery, *Batman & Robin* started filming on September 12, 1996. Confident in its team and product, not to mention a guaranteed box office hit, Warner Bros. began developing a sequel to the film while it was still shooting.

ACTION!

Schumacher was immediately hired for a fifth film in the franchise as *Batman & Robin* dailies made their way back to the studio. Goldsman was also asked to return, but ultimately decided against it. Mark Protosevich was

2 We all know how that "promising" version went. If you don't, I highly recommend watching the documentary *Lost Soul: The Doomed Journey of Richard Stanley's Island of Dr. Moreau* (2014).

then brought on board to write the screenplay for *Batman Unchained*. A relatively unknown writer at the time, Protosevich went on to write *The Cell* (2000), *Poseidon* (2006), *I Am Legend* (2007), and *Oldboy* (2013).[3] Now, with a screenwriter on board, the film was slated for a mid-1999 release.

Unchained would see a return to the darker side of Gotham: Scarecrow would be the main villain, and Harley Quinn would be introduced. Protosevich, however, wrote Quinn as the Joker's daughter, who was out for revenge against Batman for the death of her father in Burton's *Batman*. Nicolas Cage was attached to play the role of Jonathan Crane/Scarecrow and Courtney Love was eyed for Harley.

Clooney, O'Donnell, and Silverstone were all set to return to the streets of Gotham, but they weren't the only familiar Bat-faces: the script would have seen Scarecrow release his fear toxin on Batman, and in the middle of Batman's toxic hallucination, we would have seen the return of Jack Nicholson's the Joker, Danny DeVito's the Penguin, Michelle Pfeiffer's Catwoman, Jim Carrey's the Riddler, and Tommy Lee Jones's Two-Face.[4] Batman would have to conquer his fears of the past in order to truly move on.

CUT!

The release of *Batman & Robin* not only put a freeze on *Unchained*, but also derailed the Bat franchise for years. While it had a $42 million opening weekend, the film saw a 63 percent second-weekend box office drop-off. It was ripped to shreds by critics and fans alike for its overly cartoonish take on the Caped Crusader.

George Clooney swore off the cowl (and Bat nipples) as a result of the film, and Schumacher lost his passion for the character.

After *Batman & Robin* made less than the previous three Bat-flicks, Warner Bros. decided to put their focus on developing a live-action *Batman Beyond*, as well as an adaptation of Frank Miller's *Batman: Year One*. Neither film ended up getting out of the Batcave.

After the . . . *ahem* . . . poisonous *Batman & Robin*, it took eight years for the Dark Knight to return to the big screen. But he did so to the tune of $375 million in Christopher Nolan's *Batman Begins*.

3 Find out more about how the *Oldboy* production went for Protosevich on pages 67–71.

4 Regardless of how *Batman & Robin* turned out, it's hard to find a Bat-fan who wouldn't want to see this sequence play out on the big screen.

PETER JACKSON'S

A NIGHTMARE ON ELM STREET: THE DREAM LOVER

THE PLAYERS

Director
Peter Jackson

Screenwriters
Peter Jackson,
Danny Mulheron

Producers
Fran Walsh,
Bob Shaye

FADE IN

New Line Cinema had an actual nightmare on their hands after the release of *A Nightmare on Elm Street 5: The Dream Child*, in 1989. *The Dream Child* had been rushed to theaters after part four, *The Dream Master*, mastered the box office in 1988.

Having opened to a franchise-record $12.8 million, *The Dream Master* slashed the box office for weeks before finally falling out of the top ten in its seventh week of release. That fourth entry ended up grossing $49 million at the box office and found itself in the top twenty highest-grossing films of 1988. Unfortunately, the studio (and fans) were about to get a huge wake-up call.

FLASHBACK

Development on the fifth *Elm Street* began immediately, as did promotion. A poster for *The Dream Child* was released before there was even a clear story or screenplay. Curious *Elm Street* fans worldwide found themselves looking at Freddy Krueger holding a newborn baby in a crystal ball.

Fans didn't have to wait long for answers. The film was given an August 11, 1989, release date. For those of you keeping score at home, *The Dream Master* was released on August 19, 1988. The locked-in release date for *The Dream Child* thus put a massive crunch on the schedule and story. Director Stephen Hopkins was given only eight weeks to finish the film: four weeks for filming and four weeks for editing, no time for polishing the script and very little time for sleeping.

Elm Street fans made their way to theaters on August 11 and discovered their favorite horror icon's new plan to terrorize teens was to return through the dreams of an unborn baby. The premise for *The Dream Child* is a good allegory for the entire production process of part five: a studio attempts to return to terrorizing teens through an undeveloped concept and ultimately fails.

The Dream Child stayed asleep at the box office with an opening weekend of $8 million. Unlike *The Dream Master*, part five came in at number three, falling behind Ron Howard's *Parenthood* and James Cameron's *The Abyss*. The film fell out of the top ten after just three weeks in release. *The Dream Child* was more of a nightmare child that grossed a disappointing total of $22 million and found itself as the lowest-grossing *Elm Street* film up to that point.[1] The house that Freddy built was in desperate need of a remodel.

ACTION!

New Zealand native Peter Jackson was making quite the name for himself with his low-budget splatter-fest films *Bad Taste* (1987) and *Meet the Feebles* (1989). *Bad Taste* saw aliens invade the New Zealand village of Kaihoro for the sole purpose of harvesting humans as ingredients for the aliens' own fast-food franchise. *Meet the Feebles* saw a variety of puppets experience the horrific and sleazy side of the entertainment business while working on a variety show. Both were unique and horrific in their own ways, and that's exactly what New Line Cinema needed.

After hearing a number of pitches for the fifth *A Nightmare on Elm Street* sequel, Bob Shaye and New Line Cinema brought Jackson in to give his take on the Dream Demon. Impressed with his hunger, vision, and penchant for gore, Shaye hired Jackson to write the screenplay for *A Nightmare on Elm Street 6*. Collaborating with *Feebles* actor/cowriter Danny Mulheron, Jackson went off to write *The Dream Lover*.

Viewed more as a punch line now, the duo set out to give the *Elm Street* franchise a meta-style approach:[2] *The Dream Lover* sees Freddy Krueger as

1 Five years later, *Wes Craven's New Nightmare* opened theatrically. The brilliant "meta" approach to reinvent the franchise landed with a dud. It still sits as the lowest-grossing *Elm Street* film, with just $18 million total. To be fair, it shared its October 14, 1994, release date with *Pulp Fiction*.

2 This was years before *New Nightmare*, proving once again how ahead of the curve Jackson was as a filmmaker.

a joke to the teens of *Elm Street,* where the once-terrifying slasher hasn't been taken seriously for years.[3] Kids now take sleeping pills to fall asleep on purpose just to be able to taunt, tease, and beat the aged, decrepit horror icon.

During one of these trips, Krueger once again reclaims his strength and terror over Elm Street by using the comatose body of an Elm Street parent. Drawn back to Freddy's original dreamscape, the son of the possessed parent has to venture into the nightmare world to end Freddy's terror for good.

The Dream Lover aimed to bring a "meta" approach fans could connect with, as well as the gore and horror both fans and the studio wanted from the franchise. We're not talking about *A Happy Dream on Elm Street,* however—this is *A Nightmare on Elm Street.* Things rarely work out for new faces on the block.

CUT!

New Line passed on *The Dream Lover* and moved forward with a different, final approach to the franchise—one that introduced 3-D and the Goo Goo Dolls to Elm Street. Written by Rachel Talalay and Michael De Luca, *Freddy's Dead: The Final Nightmare* was released on September 13, 1991. The film had an opening weekend of $12.96 million, beating *The Dream Master*'s franchise opening record by more than $80,000. It remained the biggest opening for the franchise until *Freddy vs. Jason* opened on August 15, 2003, with $36 million.

While the *Elm Street* party was over for Jackson, he did stick with horror a little longer to make the splatter comedy *Braindead* (released in the US as *Dead Alive*). The New Zealand native returned to the New Line fold in 1997 to begin development on what later became the award-winning *The Lord of the Rings* trilogy.

The House That Freddy Built quickly became known as The House That Frodo Rebuilt.

In 2018, Jackson expressed an interest in returning to his splatterfest roots. Coincidentally, New Line also expressed their desire to reboot the *Elm Street* franchise again, after 2010's remake failed to live up to expectations.

Perhaps Jackson and New Line should give *The Dream Lover* one more look?

3 This aligns perfectly with how fans and critics viewed the slasher as well.

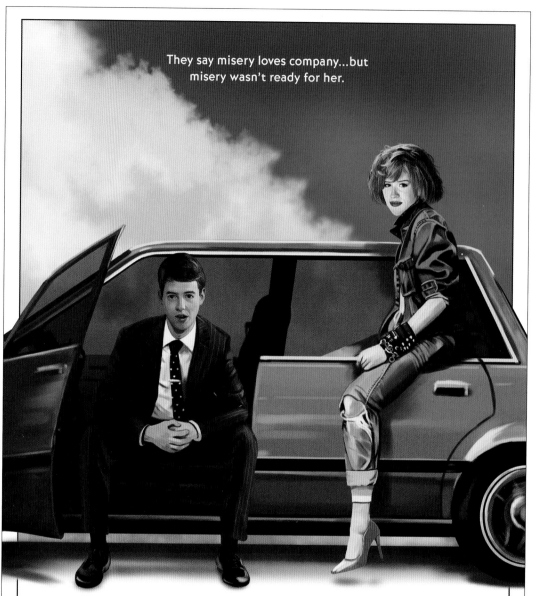

They say misery loves company...but
misery wasn't ready for her.

A JOHN HUGHES PRODUCTION

OIL & VINEGAR

PARAMOUNT PICTURES PRESENTS
A JOHN HUGHES FILM
"OIL & VINEGAR" Starring MATTHEW BRODERICK · MOLLY RINGWALD
Music by IRA NEWBORN · Director of Photography BOBBY BYRNE · Executive Producer NED TANEN
Produced by JOHN HUGHES · Written by JOHN HUGHES · Directed by HOWARD DEUTCH A PARAMOUNT PICTURE

POSTER BY DAVE O'FLANAGAN

JOHN HUGHES'S
OIL AND VINEGAR

THE PLAYERS

Director
Howard Deutch

Screenwriter
John Hughes

Starring
Molly Ringwald,
Matthew
Broderick

FADE IN

John Hughes was a beloved filmmaker who left a lasting effect on the kids who grew up in the 1980s and the 1990s. His movies, and his name, were seemingly everywhere at the time. But for every finished film that bore the Hughes name, there were plenty more that never made it to the big screen. We're going to focus on the time period of 1984 to 1986. More specifically, we're going to discuss *Sixteen Candles*, *The Breakfast Club*, *Pretty in Pink*, and *Ferris Bueller's Day Off*.[1] Every single one of those films is someone's favorite movie of all time.

There was almost one more added to that stretch.

FLASHBACK

After writing *National Lampoon's Vacation* and *Mr. Mom*, Hughes set his focus on being behind the camera in 1984 for his directorial debut, *Sixteen Candles*. The film follows lead character Samantha (Molly Ringwald) throughout her exceptionally embarrassing sweet sixteenth, which includes her family forgetting her birthday, out-of-control grandparents, and the regrettable comic interloping of Long Duk Dong. Notably, the film marked the first collaboration for Hughes and Ringwald. Armed with a budget of $6.5 million, *Sixteen Candles* ended its theatrical run with $23 million. Hughes had a hit on his hands and was already well on his way to another one.

Before filming ended on *Sixteen Candles*, Hughes approached Ringwald and Anthony Michael Hall about joining his next film, another high school film based around detention. Filming on *The Breakfast Club* began two months before *Sixteen Candles* hit theaters. Judd Nelson, Emilio Estevez, and Ally Sheedy joined Ringwald and Hall, and they all became known collectively as the Brat Pack.

1 During 1984 to 1986, Hughes also wrote *Weird Science* and *National Lampoon's European Vacation*.

The Breakfast Club follows the five as they meet for Saturday detention, learning about themselves and each other throughout the day. *The Breakfast Club* is one of the most recognizable, and quoted, films of all time. Hughes had to fight to make it because of his lack of filmmaking experience (remember: *Sixteen Candles* hadn't yet wrapped, much less been released), but it went on to become a box office hit, raking in more than $50 million worldwide on a $1 million budget.[2]

A new iteration of the Hughes Brat Pack hit theaters in 1986. Written by Hughes and directed by Howard Deutch, *Pretty in Pink* followed Ringwald's Andie as she juggled school, work, and family problems with a love triangle between her childhood love interest, Duckie (Jon Cryer), and the new guy in school, Blane (Andrew McCarthy). Released at the end of February 1986, *Pink* had another Hughes film nipping at its heels. The third directorial effort from Hughes, *Ferris Bueller's Day Off*, was set to open theatrically on June 11, 1986.

Take a second to think about that.

John Hughes had *Pretty in Pink* and *Ferris Bueller's Day Off* heading to theaters three months apart. Just casually dropping two of the most beloved films of all time that close together.

Cool cool cool.

Ferris Bueller opened number two at the box office, losing out to Rodney Dangerfield's *Back to School*. Bueller, however, ended the year among the top ten grossing films for 1986. The film follows high school slacker Ferris Bueller (Matthew Broderick) as he skips school with his two best friends, Sloane Peterson (Mia Sara) and Cameron Frye (Alan Ruck), and eludes the dean of students, Edward R. Rooney. Set and filmed in Chicago, Ferris and his friends end up at Wrigley Field, the Sears Tower, the Art Institute of Chicago, and in the middle of a major parade in downtown Chicago. The character also breaks the fourth wall throughout the film, informing the audience of his thoughts.[3]

2 At one point a sequel was rumored. Details are scarce, but the film would have either been a ten-year reunion film, or have featured the children of the Breakfast Club.
3 After the credits, Ferris tells the audience the movie is over and to "go home." This was spoofed after the credits of 2016's *Deadpool*. Same bathroom, same robe.

ACTION!

Pretty in Pink and *Ferris Bueller* proved to be successful for not only Hughes and Deutch but also for another filmmaker: *Back to School's* Alan Metter. Their cinematic paths were about to cross on a project titled *Oil and Vinegar*, and Ringwald and Broderick were along for the ride.

Compared to *The Breakfast Club, Oil and Vinegar* was a two-person dialogue piece that would have brought two stalwarts of Hughes's filmography together for the first time: Broderick would have played a man driving across the country to his wedding; on the journey, he picks up the hitchhiking Ringwald. The pair end up stranded in a hotel room and spend the entire night discussing life and what brought them together. We can only imagine how this would have turned out. Ringwald's freewheeling spirit would have convinced the uptight Broderick he was marrying the wrong person and heading toward a life of misery . . . Or, would the more settled version of Broderick convince Ringwald she would need to find a purpose worth settling down for?

CUT!

Alan Metter was approached to direct the film but took the *Back to School* box office win a little too much to heart: he refused to play second fiddle to John Hughes, so he turned the film down. Deutch then approached Hughes, asking if he could direct the film—and this is where the oil

skids happened. Hughes wanted to save the script for himself. After a clash that impacted production on *Some Kind of Wonderful*, things turned some kind of agreeable, and Deutch was finally offered the film. However, he eventually walked away from the project, as did Hughes.

The script remains untouched "on the shelf," available, possibly, for a new filmmaker to tackle it and put the finishing touches on this twenty-years-in-the-making "waiting of age" film.

THE LITTLE MERMAID

THE PLAYERS

Director
Sofia Coppola

Screenwriter
Caroline
Thompson

Starring
Maya Hawke

Based on
"The Little
Mermaid" by
Hans Christian
Andersen

FADE IN

Long before Disney broke ground by casting Halle Bailey as Ariel in their live-action remake of *The Little Mermaid*, Sofia Coppola was looking to break ground with her own unique take on the classic fairy tale.

The story of a daughter looking to forge her own path in life is one that resonated well with the award-winning filmmaker.

FLASHBACK

Coppola, living in the shadow of her father's own legendary filmography, made waves in 1999 with her feature film debut, *The Virgin Suicides*.[1] Based on the book by Jeffrey Eugenides, the film took the 1999 Cannes Film Festival by storm. Three years later, Coppola returned with the Academy Award–nominated *Lost in Translation*. Nominated for Best Picture, Best Director, Best Original Screenplay, and Best Actor (Bill Murray), the film went on to win Best Original Screenplay.

Coppola next turned her attention, and style, to the French Revolution: Kirsten Dunst, with whom Coppola had worked on *The Virgin Suicides*, returned to star as a young Queen Marie Antoinette in Coppola's New Wave history lesson, *Marie Antoinette*. Inspired by the dreamy, free-flowing filmmaking of Terrence Malick and Miloš Forman, *Marie Antoinette* once again drew Coppola the attention of the Academy. The film won the Academy Award for Best Costume Design, as well as three BAFTA nominations (Best Production Design, Best Costume Design, and Best Makeup and Hair) and a Palme d'Or nomination at the 2006 Cannes Film Festival.

After three films and a bevy of awards, Coppola tackled an elegant ad campaign for Christian Dior starring Natalie Portman. It seemed all paths

1 The Criterion Collection edition of *The Virgin Suicides* was released in 2018. It included Sofia's directorial debut, the short film *Lick the Star*. Coming in at fourteen minutes, the short revolves around a sinister plan to poison high school boys with arsenic, a debate about slavery and the book *Flowers in the Attic*, and has a cameo from filmmaking great Peter Bogdanovich.

were leading to the sea for the filmmaker: beauty, elegance, and a strong focus on female characters. Her fourth film landed her poolside, tackling a father/daughter relationship in the middle of Hollywood.

Somewhere follows actor Johnny Marco (Stephen Dorff) as he lives his newfound Hollywood lifestyle in the famed Chateau Marmont. After his ex-wife suffers a breakdown, Marco's eleven-year-old daughter Cleo (Elle Fanning) is left in his care. Premiering at the Venice International Film Festival in 2010, *Somewhere* took home the festival's Golden Lion award for Best Picture.

Coppola stayed in Hollywood for her *Somewhere* follow-up, *The Bling Ring*. Inspired by the real life Bling Ring, the film follows a group of fame-obsessed teenagers who track celebrities and rob their homes. (The gang was chronicled in the 2010 *Vanity Fair* article "The Suspects Wore Louboutins" by Nancy Jo Sales.) *The Bling Ring* featured a young ensemble cast of Emma Watson, Katie Chang, Israel Broussard, Claire Julien, and Taissa Farmiga. Coppola favorite Kirsten Dunst appeared as herself in the film. Released in summer 2013, *The Bling Ring* was one of the first releases from newly launched distribution and production house A24.[2]

After five films dealing with the trials and tribulations of teenage life, rocky father/daughter relationships, and neglect, and evidencing a stunning penchant for production design and charm, Coppola set her sights on a film that would combine all of the above and more.

Published in 1837, Hans Christian Andersen's "The Little Mermaid" follows a young mermaid who is willing to give up her under-the-sea life in order to become a human. The story is a dark fairy tale about love, loss, and compromise. It also serves as a warning to be careful what you ask for: The things you pursue in life may not be what they first appear to be.

ACTION!

In March 2014, Coppola signed on to direct a live-action version of *The Little Mermaid* for Universal Pictures.

This version leaned closer to the source material—sea-witch knives and all. The screenplay would be written by Caroline Thompson, who had made

2 *The Bling Ring* was one of the first five releases for A24. The other four? *A Glimpse Inside the Mind of Charles Swan III, The Spectacular Now, Spring Breakers,* and *Ginger & Rosa.*

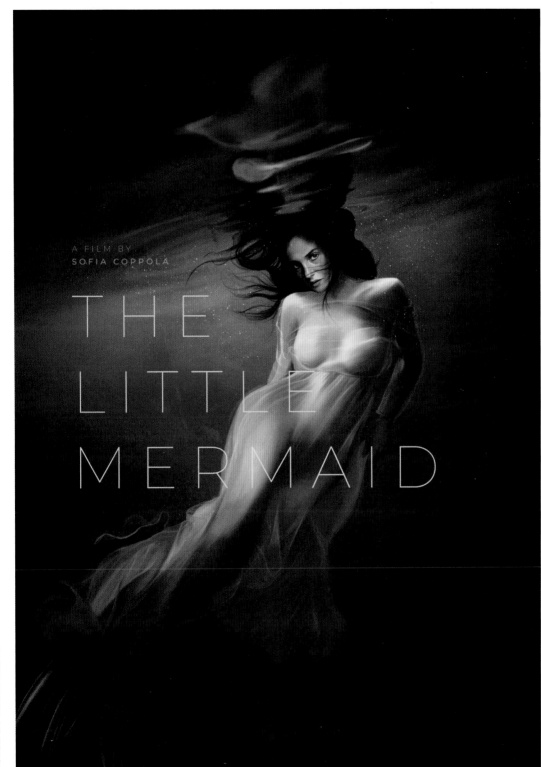

A FILM BY
SOFIA COPPOLA

THE
LITTLE
MERMAID

a career off of macabre love stories, including *Edward Scissorhands*, *The Nightmare Before Christmas*, and *Corpse Bride*.

Coppola had ambitious plans for the film: she wanted to shoot the movie underwater. (Coppola later claimed that "would have been a nightmare," but admitted that she and her team had done some underwater testing.) Coppola continued development on the film for another year. Then, in June 2015, she suddenly walked away from the project. Universal's *The Little Mermaid* found itself adrift.

CUT!

Citing the good old-fashioned "creative differences," it was later revealed that the biggest issue for Coppola's *Mermaid* was, in fact, Coppola's mermaid: the filmmaker and the studio couldn't agree on who to cast in the lead role. Universal wanted a more established actress, such as Chloë Grace Moretz, while Coppola was pushing for newcomer Maya Hawke. Unable to cast her choice and make the small, unique film she wanted, Coppola headed back to dry land.

In 2019, Hawke landed a breakout role for season three of the Netflix hit *Stranger Things*. She gave what has become a clear fan-favorite performance, so it's not hard to imagine Universal now wondering if they should have been the ones to introduce Hawke's mesmerizing talent to the world.[3]

After Coppola walked away, Moretz landed the role of *The Little Mermaid*. A year after accepting the role, however, she dropped out. With no lead actress, and no director attached, Universal's *The Little Mermaid* seems destined to sink to the bottom of the ocean.

Coppola returned to theaters in 2017 with her adaptation of Thomas P. Cullinan's *The Beguiled*. The film reunited her once again with Dunst and Fanning. It also starred Colin Farrell and Nicole Kidman. *The Beguiled* won Coppola the Best Director Award at the 2017 Cannes Film Festival—making her only the second female director to win that award.

Ironic that a major theme of *The Little Mermaid* is losing your voice but gaining your soul back after making a personal sacrifice.

3 She also briefly pops up in a memorable scene in Quentin Tarantino's *Once Upon a Time in Hollywood* (2019).

DAVID FINCHER'S
NESS

THE PLAYERS

Director
David Fincher

Screenwriter
Ehren Kruger

Producers
Todd Murphy and
Todd McFarlane

Starring
Matt Damon,
Rachel McAdams,
Casey Affleck

Based on
*Torso: A True
Crime Graphic
Novel* by Brian
Michael Bendis
and Marc
Andreyko

FADE IN

A torso is discovered during an innocent game of tag, setting in motion a cat-and-mouse game between Eliot Ness and the Torso Killer in 1930s Cleveland. This is the plot of Brian Michael Bendis and Marc Andreyko's six-issue comic book series, *Torso*, which was originally published by Image Comics in 1998.

In 2006, while busy working on the thriller *Zodiac*, David Fincher signed on to direct an adaptation of *Torso* for Paramount. This set in motion his own cat-and-mouse game with the project, which ended up leaving the corpse of an unmade movie for all of us to find.

FLASHBACK

While working as a cartoonist for Cleveland's the *Plain Dealer*, Bendis had unlimited access to the *Plain Dealer*'s files on the Cleveland Torso Murders. An unknown killer terrorized Cleveland from 1935 to 1938 with a string of brutal dismemberments. The victims were both male and female and ranged in age from early twenties to midforties. A majority of the bodies were found headless, but in other instances only the head was recovered. Sometimes referred to as the Mad Butcher of Kingsbury Run, the Torso Killer was never identified or brought to justice.

It's a horrific true crime story ripe for adaptation, especially for a film-maker with a history of adapting tales of serial killers for both the big and, eventually, the small screen.

In 1995, Fincher teamed up with screenwriter Andrew Kevin Walker for the graphic serial killer thriller *Se7en*. With a budget of $33 million and starring Brad Pitt, Morgan Freeman, Gwyneth Paltrow, and Kevin Spacey, *Se7en* follows two detectives on the hunt for a killer inspired by the seven deadly sins.[1] Released on September 22, 1995, *Se7en* took the top spot at the weekend box office with $13.9 million. It stayed at number one for four weeks and ended its run with a worldwide total of $327 million. Four weeks

1 One such kill ruined spaghetti until 1998.

at number one, an Academy Award nomination (Best Film Editing), BAFTA nomination (Best Original Screenplay), and an MTV Movie Award—"Most Desirable Man" win for Pitt—*Se7en* proved to be a massive success.[2]

Fincher once again tackled the serial killer genre twelve years later, with the true crime thriller *Zodiac*. Based on Robert Graysmith's book, the adaptation was written by James Vanderbilt and stars Robert Downey Jr., Jake Gyllenhaal, Mark Ruffalo, and Chloë Sevigny. *Zodiac* follows the manhunt and investigation into the Zodiac Killer murders that haunted and transfixed the San Francisco area in the late sixties. The $65 million thriller opened March 2, 2007, to the tune of $13.39 million. In the real true crime story of the weekend, *Zodiac* came in second place behind the Tim Allen/Martin Lawrence/John Travolta motorcycle movie *Wild Hogs*. *Zodiac* fell 50 percent in its second weekend, down to $6 million, and an additional 50 percent its third weekend. Fincher's latest crime story fell well out of the top ten in its fourth weekend of release.

Signing on to *Torso* a year before the release of *Zodiac*, and aging backward on postproduction on *The Curious Case of Benjamin Button*, Fincher was now ready to head back in time to Cleveland for his next project.

ACTION!

In December 2008, Fincher gave some early details on the adaptation: the cult filmmaker stated the film was a "complete reimagining" of the graphic novel.

Arlington Road and *The Ring* screenwriter Ehren Kruger was brought on to write the screenplay. He took a more nonlinear approach, akin to Akira Kurosawa's *Rashomon*. Kruger's script opens on election night 1947, where Chicago reporter Walt Cahill is trying to lock in an interview with Cleveland candidate for mayor Eliot Ness:

"BACK HOME WE DON'T PLAY COPS AND ROBBERS! WE PLAY CAPONE AND NESS!"

Ness grants Cahill the interview that goes nowhere until Cahill finds himself in the elevator with a mysterious man in an overcoat. This seemingly random encounter ends with Cahill teased with the one case that has haunted Ness his entire life: the Torso Murders.

2 So much so that the studio wanted a sequel called *Eight* that would bring Freeman back as a detective with psychic abilities. Retirement does funny things to the mind.

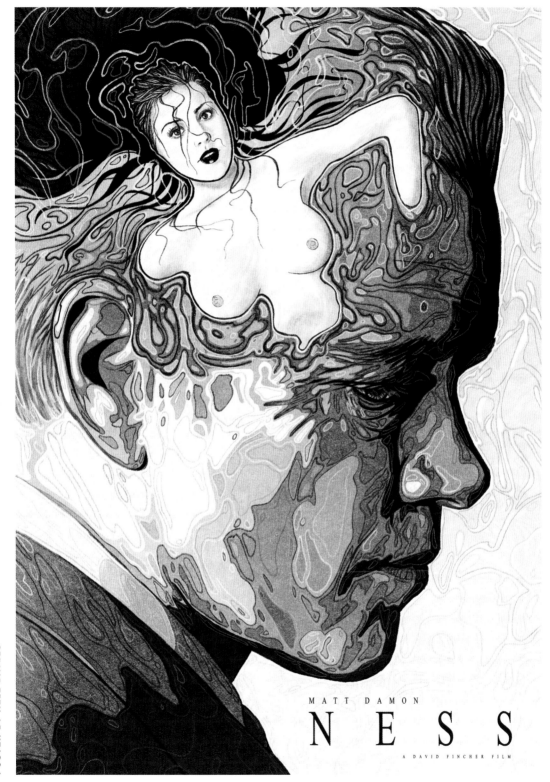

MATT DAMON

NESS

A DAVID FINCHER FILM

From here, the screenplay launches into flashbacks/fast-forwards of Torso discoveries; to Walt diving into the Ness/Torso connection; to Ness rising to power in Cleveland; to his pursuit of the Torso Killer. It's 128 pages of classic detective work mixed with a burlap bag of body parts.

Fincher put together an untouchable cast of talent for the film. Matt Damon signed on to play the safety director himself, Eliot Ness, and Casey Affleck and Rachel McAdams were both rumored for supporting roles but were never confirmed.

As prep continued for the seemingly untouchable *Ness*, Paramount was prepping their own burlap bag for the film.

CUT!

While on paper *Ness* sounded like a sure bet, Paramount was still feeling the sting from *Zodiac*'s box office performance. The $65 million thriller brought back a total of $84 million worldwide. That wasn't exactly a blockbuster performance, and Paramount really wanted Fincher to direct a chef project they were developing with Steven Knight.[3]

When you put budgetary concerns together with a "We'd kind of prefer it if you made this instead" mentality, and then sprinkle in the fact that Paramount had until December 2008 to get the film in production before losing the rights, you have a bit of a predicament. Which is to say nothing of rumors of disagreements between the director and the studio on *Benjamin Button*. It seemed like the Torso Killer was about to have another victim.

Ultimately, it did.

Paramount let the rights to *Torso* revert to Bendis and Andreyko. The pair ended up writing their own adaptation of the graphic novel. David Lowery (*Ain't Them Bodies Saints, A Ghost Story*) was hired in 2013 to write and direct the film, but that version also failed to get off the ground. The last attempt was in 2017, when Paul Greengrass (*United 93, The Bourne Ultimatum*) signed on for the film, once again set up at Paramount. There's been no movement since.

Fincher turned his attention to adapting Facebook's origin story for 2010's award-winning *The Social Network*. The film garnered eight Academy Award nominations, winning three of them: Best Original Score, Best

3 More on that below.

Adapted Screenplay, and Best Film Editing. It also won four Golden Globes and three BAFTAs. As for his serial killer itch? Fincher turned to Netflix to get his fix in with the 2017 series *Mindhunter*, based on the book *Mindhunter: Inside the FBI's Elite Serial Crime Unit* by retired FBI agent John E. Douglas and coauthor Mark Olshaker.

Ness would have landed fans somewhere between the true crime *Zodiac* and the gore of *Se7en*. However, much like the case itself, some mysteries will likely never see a proper resolution.

OVEREXPOSED: DAVID FINCHER

Fincher is notably picky about the projects he puts his name on, and rightfully so: he had a miserable experience making *Alien 3*. Throughout the years, his name has been connected to a variety of exciting projects, even including *Star Wars Episode 7* at one point. Let's look back at three films Fincher was connected to.

BURNT: Remember that chef project Paramount really wanted Fincher to do? The screenplay was written by *Eastern Promises* screenwriter Steven Knight and would star Keanu Reeves as a diva chef whose ego and hard lifestyle destroy his career. He sets out to reclaim his career and and his new restaurant three Michelin stars. I know what you're thinking: "That sounds a bit like Jon Favreau's *Chef*." This was a completely different movie, however, and a movie that Fincher and Keanu were not a part of. John Wells instead directed the script and Bradley Cooper played the chef in 2015's *Burnt*.

THE LOOKOUT: In 2003, Fincher entered negotiations to direct Scott Frank's thriller screenplay *The Lookout*. The film follows a man suffering the fallout of a devastating car accident (the crash leaves him with memory loss). A local criminal befriends him and soon uses him as the lookout for the bank robbery he's planning. Plans don't go the way anyone saw them going. At one point, Tom Hanks and Sam Mendes had their eyes on the project. *The Lookout* would have been Fincher's *Panic Room* follow-up.

Instead, he walked away, leaving the script in Frank's hands. *The Lookout* was released in 2007, starring Joseph Gordon-Levitt, Jeff Daniels, Isla Fisher, and Matthew Goode.

20,000 LEAGUES UNDER THE SEA: This one is almost as shocking as Fincher taking a meeting for *Star Wars*: The filmmaker surprised the internet in 2010 by announcing a $200 million adaptation of Jules Verne's *20,000 Leagues Under the Sea* with Disney producing/distributing. It was no shock to anyone, however, when the project crumbled nearly five years later. Casting differences and corporate control ended up killing the project for Fincher. The filmmaker initially wanted to cast Brad Pitt as Captain Nemo, followed by Daniel Craig, Matt Damon, and finally Channing Tatum. Disney had their eye on one name: Chris Hemsworth. Proving he's still not ready to play the action/adventure blockbuster studio game, Fincher went back to character-driven thrillers with his adaptation of Gillian Flynn's *Gone Girl*.

STEVEN SODERBERGH'S
CLEOPATRA 3-D

THE PLAYERS

Director
Steven Soderbergh

Screenwriter
James Greer

Starring
Catherine Zeta-Jones, Hugh Jackman, Ray Winstone

Music by
Guided by Voices

FADE IN

Long before the days of his iPhone filmography, Steven Soderbergh had a penchant for pushing cinematic boundaries, ranging from the traditional bubble-bursting release of his 2005 mystery, *Bubble,*[1] to his blockbuster capers featuring Danny Ocean and company. An award-winning filmmaker with one of the most diverse styles and ranges in the film industry, it's no surprise that he set his sights on pushing the musical genre to the edge in 2008 with a 3-D musical-event film based on the life of Cleopatra.

FLASHBACK

Sex, Lies and Videotape, Soderbergh's directorial debut, astounded critics and fans worldwide by winning the coveted Palme d'Or at Cannes in 1989; the director was twenty-six years old at the time. Alongside Soderbergh's Palme d'Or win, James Spader won Best Actor at Cannes as well. The dramatic thriller about sexual repression, family affairs, and a large videotape collection also garnered one Academy Award nomination (Original Screenplay), two BAFTA nominations (Best Original Screenplay, Best Supporting Actress [Laura San Giacomo]), and three Golden Globe nominations (Best Screenplay, Best Actress [Andie MacDowell], Best Supporting Actress [Giacomo]). As you can imagine, that kind of out-of-the-gate success brings plenty of attention, pressure, and expectations. Sometimes those things unite beautifully for an auteur; other times, well, they result in *Kafka* (1991), *King of the Hill* (1993), *The Underneath* (1995), and *Schizopolis* (1996)—all underwhelming, critically and financially, but still very much in line with the vision of an auteur. Some of Soderbergh's critics wondered if he had lost sight of things, but the filmmaker was about to answer that question with a string of critical darlings.

1 *Bubble* was unique, at least for Soderbergh, in that it was shot entirely without a traditional script and exclusively features nonprofessional actors.

Starting with the Elmore Leonard adaptation of *Out of Sight* in 1998, Soderbergh launched into a career reawakening that saw the beginning of a partnership with George Clooney, five Academy Award nominations for *Erin Brockovich* (with Julia Roberts winning Best Actress along with the BAFTA, the Golden Globe, and the SAG awards for the same nomination), and five more Academy Award nominations for *Traffic* (it won four of them and netted Soderbergh his first Best Director Oscar).

Erin Brockovich and *Traffic* were both released in 2000, and thus, Soderbergh had his name on ten Academy Award nominations at the 2001 Academy Awards, and was nominated for Best Director on both films. That's a big deal.

Soderbergh next set his sights on winning the box office with a remake of *Ocean's Eleven*. The film was so successful, it spawned its very own franchise made up of *Ocean's Twelve* (2004), *Ocean's Thirteen* (2007), and the female-focused *Ocean's Eight* (2018). In between the box office juggernauts of the *Ocean* franchise, he squeezed in the 2002 remake of Tarkovsky's *Solaris*, the previously mentioned *Bubble,* and 2006's Clooney/Cate Blanchett period romance *The Good German*. Across his twenty-year career, Soderbergh had tackled drama, romance, the caper film, the experimental film, comedy, action, science fiction, and the period piece. He only had a few more genres to go before completing the filmmaking genre sweep,[2] and he was about to knock one of them off the list in 2008.

ACTION!

After wrapping on a few more films (*The Informant!, Che*, and *The Girlfriend Experience*), it was announced that Soderbergh would head to ancient Egypt for his next film: *Cleopatra 3-D*. The film would star Catherine Zeta-Jones as Cleopatra; Hugh Jackman as her lover, Marc Antony; and Ray Winstone as Julius Caesar. The music for the film would be written and composed by "Game of Pricks" rockers Guided by Voices and written by their former bass player James Greer.[3] The biggest, and most exciting, aspect of the film was that it would be shot in 3-D. In an interview with *Esquire* in 2009,

2 Musical, horror, and western were the big three remaining. He made the psychological horror film *Unsane* in 2018.

3 James Greer wrote Soderbergh's horror film *Unsane* and Jackie Chan's horror film *The Spy Next Door*.

CLEO

A 3D MUSICAL BY STEVEN SODERBERGH

Soderbergh gushed about his desire to make a "fun musical" and bring back the "technical proficiency" of the live-action musical.

The future of *Cleopatra 3-D* was as bright as the golden necklace around her neck. Until it wasn't . . .

CUT!

Jackman walked away from the project in early 2009 due to other schedule commitments. With no financing, no Marc Antony, and no distributor, the film was put on the back burner. And that's where it has stayed since, or at least the *film version* of *Cleopatra*. In 2012, it was reported that Zeta-Jones and Soderbergh were planning on taking the show to Broadway, but there have been no further developments since. Soderbergh and Zeta-Jones later collaborated on the 2011 virus thriller *Contagion*.

JOHN CARPENTER'S
SHADOW COMPANY

THE PLAYERS

Director
John Carpenter

Screenwriters
Shane Black and
Fred Dekker

Producer
Walter Hill

Starring
Kurt Russell

FADE IN

After science fiction thriller *They Live* consumed the majority of his 1988, John Carpenter was looking to return to set as soon as possible. His last few films (*Big Trouble in Little China, Prince of Darkness*) hadn't hit the mark, at least financially, like some of his earlier offerings had. He set his sights on a project that moviegoers wouldn't be able to ignore: a zombie action movie written by Shane Black and Fred Dekker.

The filmmaker just needed to … live out the rest of the year before things could really get rolling on his next project, *Shadow Company*.

FLASHBACK

Inspired by the Ray Nelson story "Eight O'Clock in the Morning," *They Live* follows the drifter Nada (Roddy Piper) as he discovers the world has been taken over by aliens. These aren't *War of the Worlds* or *The Thing* type aliens; their goal is to mainly keep the human race subdued with subliminal messaging such as:

"SUBMIT TO AUTHORITY" "NO IMAGINATION" "STAY ASLEEP" "SUBMIT"

Starring "Rowdy" Roddy Piper, Keith David, and Meg Foster, *They Live* wrapped filming in April 1988 and opened theatrically seven months later on November 4.

The film had an original release date of October 21; a certain slasher in a white mask, however, was already scheduled to return to theaters that day.[1] *They Live* pushed their release back two weeks in order to avoid direct competition. While the film opened at number one, it did so with only $4.8 million, beating out the $3 million opening of the rock documentary *U2:*

1 *Halloween 4: The Return of Michael Myers* featured the return of killer Michael Myers (a character created by Carpenter and Debra Hill). The fourth film had an opening weekend of $7 million.

Rattle and Hum. Halloween 4: The Return of Michael Myers tallied more than $2 million in its third week of release.

With *They Live* out in the world, it was time for the horror master to begin squad'ing up for his next film.

In August 1987, the Universal Monsters returned to the big screen with a twist. *Night of the Creeps* director Fred Dekker teamed up with screenwriter Shane Black for the horror-comedy *The Monster Squad*, the "squad" being a group of preteens obsessed with monster movies. Their knowledge, and courage, are put to the test when Count Dracula brings Frankenstein's Monster, the Wolfman, the Mummy, and the Gill-Man to their small town. Horror invading a small town—seems to be a theme for these two, huh?

Years before collaborating on *The Monster Squad*, Black wrote the screenplay for the action-horror film *Shadow Company*. After the script found its way into the hands of John Carpenter, Black and Dekker tackled script revisions together. The three, along with producer/filmmaker Walter Hill, put the wheels in motion to bring this incredible, dream-team collaboration out of the shadows.

ACTION!

Shadow Company follows the recovery of the bodies of six Special Ops soldiers from a Cambodian temple two decades after the end of the Vietnam War. These soldiers are known as the Shadow Company. The bodies are sent to the small town of Merit, California, and once again laid to rest, this time with 100 percent less Cambodian spookiness. It's here where we meet our hero, veteran Jake Pollard (who would have been played by Carpenter mainstay Kurt Russell).

If you're keeping track on your "head-scratch" bingo card: not only were Carpenter, Dekker, Black, and Walter Hill teaming up for this movie, but they were also bringing Snake Plissken himself along to kill some zombies. *Sigh*.

Pollard knows a few things about the Shadow Company: 1) They were experimented on by the government, and 2) There was a seventh member of the Shadow Company who went missing before the rest of the company was killed.

Spoiler Alert: That seventh member is Russell's Pollard.

Pollard stocks up on weapons and heads into the "ready for Christmas" town of Merit. It's a Shane Black script, so *of course* the story is set around

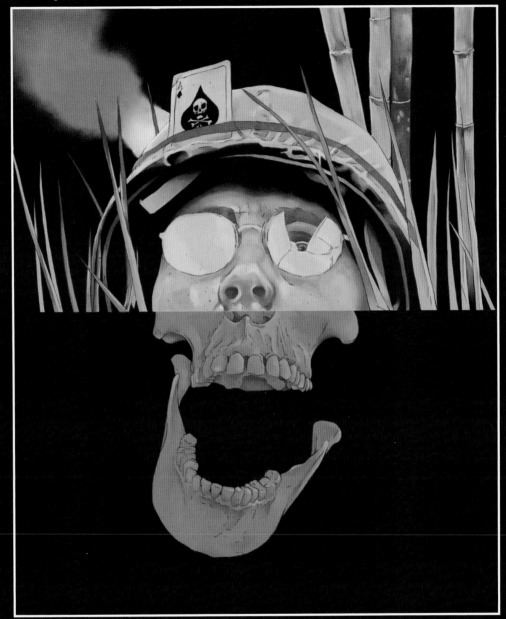

Impervious to FEAR, PAIN, CONSCIENCE, even... DEATH.

JOHN CARPENTER'S
SHADOW COMPANY

UNIVERSAL PICTURES PRESENTS A LONE WOLF CO. PRODUCTION JOHN CARPENTER'S 'SHADOW COMPANY' STARRING KURT RUSSELL MUSIC BY JOHN CARPENTER AND ALAN HOWARTH EDITED BY FRANK E. JIMENEZ
DIRECTOR OF PHOTOGRAPHY GARY B. KIBBE ASSOCIATE PRODUCER SANDY KING CO-PRODUCER BY LARRY FRANCO EXECUTIVE PRODUCER WALTER HILL SCREENPLAY BY SHANE BLACK AND FRED DEKKER PRODUCED BY MICHELLE MANNING AND SHANE BLACK DIRECTED BY JOHN CARPENTER

POSTER BY BEN TURNER

Christmas. By the time Pollard arrives, the Shadow Company has already pulled themselves out of their graves and begun their brutal onslaught of the town.

Joy. To. The. World.

Pollard takes out the Shadows one by one until a final, massive heavy-weapon shoot-out ends the film. Much like he did with *They Live*, Carpenter would have presented social commentary on the screen. In the late eighties, the country was still living with the horrors and fallout of the Vietnam War. Veteran displacement and homelessness ran rampant across the country,[2] not to mention that whole "villain" outlook that many troops came home to. A film about Vietnam veterans literally returning and waging war on small-town America during the "most wonderful time of the year" would have been eye-opening to say the least. Unfortunately, this incredible team-up proved too good to be true.

WHAT HAPPENED?

Due to multiple issues during preproduction, *Shadow Company* found itself buried alive. There's no telling if these issues were creative differences or budgetary; regardless, I feel like in the court of cinematic greatness, everyone involved should be put on the stand to explain what happened. Why were *we*, the moviegoing public, robbed of a John Carpenter zombie action movie?

Carpenter instead went on to make the Chevy Chase–led *Memoirs of an Invisible Man*. Russell and Carpenter reunited ten years later for *Escape from L.A.* Black went on to write several hit films, including *Lethal Weapon 2* and *The Last Boy Scout*.[3] In 2018, Black and Dekker reteamed, and swapped roles as writer and director, for *The Predator*.[4]

Carpenter hasn't directed a film since 2010. He did, however, express interest in making another film in 2018. Maybe with some rewrites, the four can reunite and finally bring *Shadow Company* to life.

2 Veteran homelessness is still a major problem across the country. There are a number of organizations that lend a helping hand to those in need, including Disabled American Veterans (DAV), National Coalition for Homeless Veterans, and Volunteers of America.

3 Danielle Harris would appear in *The Last Boy Scout* three years after starring as Jamie Lloyd in (drumroll . . .) *Halloween 4: The Return of Michael Myers*.

4 Fun fact: At HorrorHound Weekend Indianapolis in 2016, Dekker was a guest. We talked many times that weekend about his filmmaking and my filmmaking. At one point, his phone rang and he showed me who was calling: *Shane Black*. Dekker humblebragged to my face. It was amazing.

GET IT WHILE YOU CAN

THE PLAYERS

Director
Jean-Marc Vallée

Screenwriters
Theresa and
Ron Terry

Starring
Amy Adams

FADE IN

After wrapping production on the Jake Gyllenhaal–led *Demolition* in 2014, Jean-Marc Vallée wasted no time setting up his next feature film. Having earned multiple Academy Award nominations for his last two features, Vallée once again set his focus on a story that would likely lead to a bevy of nominations: the life of Janis Joplin. Vallée cast Amy Adams to star as the singer in *Get It While You Can*, but he would have to try just a little bit harder to get the film off the ground.

FLASHBACK

Due to the success of his 2005 coming-of-age film, *C.R.A.Z.Y*, Vallée was hired by Martin Scorsese and producer Graham King to direct *The Young Victoria*. The film followed the early life of Queen Victoria, as well as her marriage to Prince Albert, and was nominated for three Academy Awards (Best Art Direction, Best Makeup, Best Costume—winning Best Costume for Sandy Powell), two British Academy of Film and Television Arts (BAFTA) Awards (Best Costume Design, Best Makeup and Hair—winning both), and one Golden Globe (Best Actress [Emily Blunt]).

Vallée followed up the film with 2011's *Café de Flore*. *Café* landed thirteen Genie Award (the Canadian Academy Awards) nominations, winning three. After the success of both *Café* and *C.R.A.Z.Y*, Vallée landed *Dallas Buyers Club*, the film that gained him the attention of a wider American audience and put him firmly on the "must hire" short list of directors.

Club came with its own history of development issues long before Vallée and Mathew McConaughey signed on to the film. Picture this: Ron Woodroof played by Woody Harrelson, Brad Pitt, or Ryan Gosling.[1] *Dallas Buyers Club* is the true story of Ron Woodroof, an electrician diagnosed with AIDS who helps others impacted by the disease get the medication

1 Craig Gillespie (*Lars and the Real Girl* and *I, Tonya*) was originally in negotiations to direct, with Ryan Gosling starring.

they need. Jennifer Garner, Jared Leto, Steve Zahn, and Denis O'Hare starred alongside McConaughey. The film was nominated for six Academy Awards, winning three of them: Best Makeup and Hairstyling, Best Actor (McConaughey) and Best Supporting Actor (Leto). McConaughey and Leto both won Independent Spirit Awards for their performances, as well as the Golden Globes for the same nominations.

After *Club*, Vallée headed out to the Pacific Crest Trail for an adaptation of Cheryl Strayed's memoir *Wild: From Lost to Found on the Pacific Crest Trail*. Starring Reese Witherspoon, *Wild* follows Witherspoon's Cheryl as she hikes one thousand miles, reflecting on, and learning from, her self-destructive past. The astonishing film showed a gritty, realistic look at recovery, pain, and acceptance. *Wild* landed two Academy Award nominations for Best Actress (Witherspoon) and Best Supporting Actress (Laura Dern), a BAFTA nomination (Witherspoon), a Golden Globe (Witherspoon), and a Screen Actors Guild nomination (Witherspoon). Screenwriter Nick Hornby landed a Writers Guild of America nomination for Best Adapted Screenplay.

Showing a talent for not only bringing real-life stories to the screen, but also for real-life stories of struggle and drug addition, Vallée's planned *Wild* follow-up seemed like a perfect match. Instead, it proved to be a ball and chain.

ACTION!

In November 2014, *Deadline* reported that Vallée had signed on to direct Amy Adams in the Janis Joplin biopic *Get It While You Can*. Written by Theresa and Ron Terry, Adams had been attached to the idea of bringing Joplin to life since 2000. Adams planned to sing the songs herself, and Vallée seemed to be the perfect hybrid director to bring Joplin's story to life. In order to do so, however, they needed rights and money.

CUT!

With production initially scheduled to start in mid-2015, the *Get It While You Can* filmmakers found themselves in a holding pattern. The Terrys had optioned the *Get It* screenplay to Silver Reel Partners and LKL Prod. The producers attempted to restructure the loan but were met with stricter regulations, making it impossible to renew the option. On top of that, there were a number of competing Joplin biopics in some form of production.

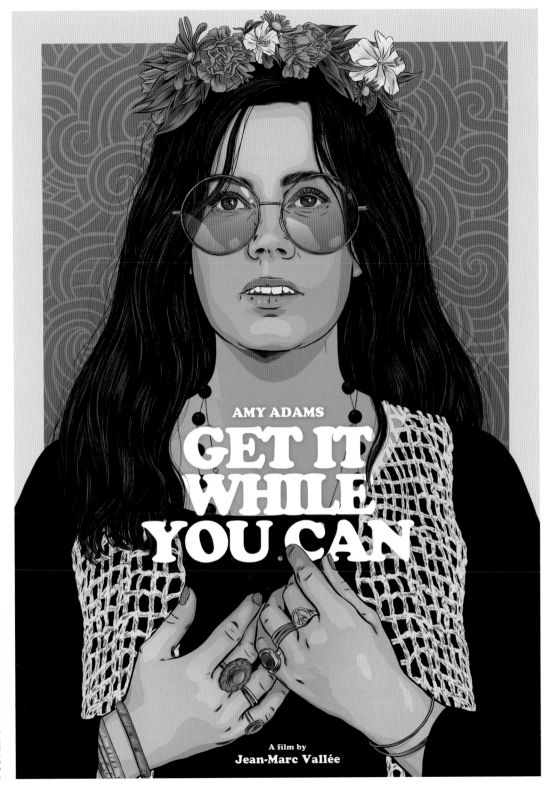

AMY ADAMS

GET IT WHILE YOU CAN

A film by
Jean-Marc Vallée

There has been no shortage of filmmakers and producers trying to bring Joplin's life to the big screen. Aside from *Get It While You Can*, none of them have sounded as intriguing or true to legend as Sean Durkin's long-in-development *Joplin*. The *Martha Marcy May Marlene* director signed on to direct the film in the middle of 2012 for producer Peter Newman.

Adapted from a number of different sources, the screenplay is from Clara Brennan and Andrew Renzi, and follows the last six months of Joplin's life, before she died of an overdose. Unlike *Get It*, Newman holds the rights to her music, as well as the biography *Piece of My Heart* and plenty more. The ground was laid for the quintessential Janis Joplin movie, and actress Nina Arianda was originally cast as Joplin—but she was a woman left lonely in 2016 after Michele Williams entered talks to join the film as the troubled singer.

The package for the film went up for auction at Sundance 2017; news on the *Joplin* front, however, has gone cold, giving everyone itching for this exciting project the kozmic blues.

A combination of the two led Vallée and Adams to walk away and focus on a different collaboration: an award-winning adaptation of Gillian Flynn's *Sharp Objects* for HBO.

It's amazing to think that had the pair made the film, the award-winning *Sharp Objects* would have been adapted by a different team. Instead, we got a masterful adaptation that led to more award-winning limited series from Vallée and company, proving that in the film industry, if something doesn't appear to be happening, move on to something that is.

NICOLAS WINDING REFN'S
THE BRINGING

THE PLAYERS

Director
Nicolas Winding
Refn

Screenwriter
Brandon and
Philip Murphy

FADE IN

It was February 2013. Guests at Los Angeles's Cecil Hotel had noticed low water pressure in their showers, not to mention a strange taste in the water. After multiple complaints, a maintenance worker made his way to the roof to check the water tanks. It's here where he made the grisly discovery of twenty-one-year-old Elisa Lam, dead, floating in the tank. Lam arrived in LA on January 26 and went missing on January 31, the day she was to check out of the Cecil. The only lead the LAPD had to go on was bizarre surveillance video of Lam in the elevator. She appeared to not only be interacting with *something*, more important, she seemed to be running from it.

The Elisa Lam story is not only the stuff nightmares are made of, but also horror films as well. So it came as no surprise when Sony Pictures announced they were making a horror film inspired by the story called *The Bringing*, written by Philip and Brandon Murphy. The surprise came a few months later when Dutch filmmaker Nicolas Winding Refn entered talks to direct the film.

FLASHBACK

Audiences were first introduced to Refn's work with his 1996 debut, *Pusher*, a crime thriller about a drug pusher in over his head with a violent crime lord (the film features an early performance from Mads Mikkelsen). *Pusher* spawned two sequels, the first being 2004's *With Blood on My Hands: Pusher II*.[1] *I'm the Angel of Death: Pusher III* was released in 2005, followed by a British remake from Luis Prieto.

In between the *Pusher* films, Refn completed two other feature films. The crime drama *Bleeder* was released in 1999 and featured *Pusher* stars Kim Bodnia and Mads Mikkelsen once again choosing the path of violence. Four

1 Mads Mikkelsen returned for the sequel and won Best Actor at the 2005 Bodil Awards (the Dutch Academy Awards).

years later, the horror-loving director took his first stab at genre material with *Fear X*.

Fear X starred John Turturro and was based on an original screenplay by novelist Hubert Selby Jr. The film followed Turturro's character, Harry, as he investigates the seemingly accidental death of his wife, Kate (Deborah Kara Unger), and the dark turn his investigation takes trying to uncover the truth. *Fear X* had a successful festival run including screenings at Sundance, the Melbourne International Film Festival, and Sitges, where it was nominated for Best Film. Commercially, the film led to devastating results for Refn's production company, sending it into bankruptcy.[2]

After returning to the world of *Pusher*, Refn set his attention on a different kind of crime film with 2008's *Bronson*. He cast Tom Hardy as Michael Peterson, better known as Charles Bronson. Peterson was known as one of the United Kingdom's most dangerous criminals, so he spent the majority of his time in prison in solitary confinement (Peterson/Bronson was a big fan of Hardy's casting, preparation, and subsequent imitation[3]). While not a huge financial success, *Bronson* was a critical success that helped get Refn out of the *Fear X* red.

Valhalla awaited.

Refn reunited with *Pusher* star Mikkelsen for the Viking drama *Valhalla Rising*. Set in 1000 A.D., *Rising* follows a pagan warrior named One Eye and the child slave The Boy as they travel with a band of Christian crusaders to the Holy Land. Instead, they find the horrors of an unknown world waiting for them. *Valhalla Rising* premiered at the Venice International Film Festival in 2009. Once again, Refn landed critical success but, financially, the film barely put a scratch on the $5 million budget. Refn once again found critical success, but financial success and his mainstream breakthrough continued to elude him.

Then Ryan Gosling came calling.

2 *Gambler*, a documentary from Phie Ambo, follows Refn's attempt to repay a 5.5 million-crown debt from *Fear X*. The film is a raw look at the stress and devastation filmmaking (and creative gambles) can have on lives. Refn's wife, Liv Corfixen, also appears prominently in the film. Corfixen made her own Refn documentary in 2014 titled *My Life Directed by Nicolas Winding Refn*. The film followed the production, stress, and release of *Only God Forgives*.

3 So much so, Bronson actually shaved off his trademark mustache and sent it to Hardy to wear in the film. Where's *that* documentary, Phie?

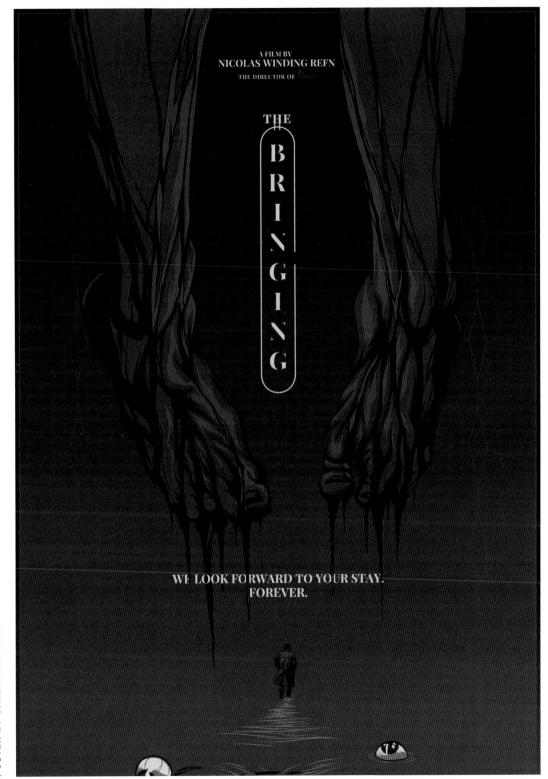

POSTER BY JAREN HEMPHILL

Published in 2005, James Sallis's novel *Drive* was optioned almost immediately by producers Marc Platt and Adam Siegel. The novel had a simple setup: the Driver is a Hollywood stuntman by day and a getaway driver for criminals at night. The brutal narrative weaves back and forth between the Driver's strict moral compass and his violent, immoral surroundings. Academy Award–nominated screenwriter Hossein Amini was hired to adapt the screenplay for Platt and Siegel. In 2008, the film landed a director and star.

Imagine this one: Neil Marshall's *Drive*, starring Hugh Jackman.

That almost happened.

A few months later, Marshall and Jackman were no longer attached to the film. Platt reached out to Gosling about taking on the role of the Driver. Gosling was coming off of the Gregory Hoblit thriller *Fracture* and Craig Gillespie's kooky romance *Lars and the Real Girl*. He was looking for character-focused projects, and *Drive* was the perfect fit. In a move usually given to massive movie stars, Gosling was given full control over selecting a director. There was only one filmmaker he wanted: Nicolas Winding Refn.

Following a festival run filled with rave reviews, *Drive* hit theaters in September 2011. Made on a $15 million budget, the film finished its worldwide theatrical bow in the $80 million range. A success with critics and at the box office, *Drive* also became an award darling with four BAFTA Film Award nominations, one Academy Award nomination (Best Sound Editing), and a spot on multiple "Best of" lists for 2011.

After the massive success of *Drive*, Refn and Gosling left Los Angeles and headed to the Far East for their next collaboration. *Only God Forgives* finds Julien (Gosling), pushed by his mother Crystal (Kristin Scott Thomas), on a brutal quest for revenge to find the people who killed his brother. Refn described the film as a "Western thriller with a modern-day cowboy." Upon its release in 2013, *Forgives* proved to be a far more polarizing film for critics and audiences worldwide.

ACTION!

Refn planned on following *Only God Forgives* with a dive into a genre he loved: horror.

I Walk with the Dead was to be an all-female horror film starring Carey Mulligan and written by Polly Stenham. The filmmaker had been developing

the project since 2011, and he was closer than ever to making it a reality . . . until the Elisa Lam story exploded online.

Sony and the Murphy brothers chose to use the story as a springboard for a film set in, and around, the infamous murder hotel. *The Bringing* would follow a PI who is brought on to investigate the hotel after the mysterious events surrounding Lam's death. And it wouldn't stray from creating its own opinion and lore behind Lam.

The screenplay opens with the Lam footage, then transitions into a brutal opening scene, where two drugged-up lovers are killed in the shower.

From here, we meet our private investigator, the down-on-his-luck John Brooks.[4] He's brought on to investigate what happened to Elisa Lam at the Cecil by the Lams themselves. As Brooks begins his investigation, he dives into the files and footage of Lam, including a scene straight out of Scott Derrickson's *Sinister*, where Elisa Lam turns and stares at Brooks when he's not looking.

A tidal wave of horror tropes including devil worship, serial killers, and Elisa Lam's angry spirit guides us through the remainder of the screenplay, which ultimately ends with the spiritual resurrection of Richard Ramirez. Littered with cliché scares and a questionable use of real-life people and footage, *The Bringing* screenplay is the skid row version of James Wan's *The Conjuring*. That being said, the setting and history of the Cecil through Refn's grimy Los Angeles lens explains why he actively pursued landing the project.

CUT!

The Bringing could have been Refn's neon, ghost-soaked version of *The Shining*, but it wasn't meant to be.

Talks between Refn and the studio fell apart a few months after they began. Sony continued development on the film until 2016, when they dropped the project altogether. While *The Bringing* failed to bring the case of Elisa Lam to life, producers of *American Horror Story* were influenced by the terrifying tale for their Cecil Hotel–inspired fifth season, "Hotel."

As for Refn, he returned to development on *I Walk with the Dead*. The film was retitled *The Neon Demon* in 2014 and no longer starred Mulligan, but instead featured Elle Fanning, Christina Hendricks, Keanu Reeves, Jena Malone, and Abbey Lee.

4 At one point in *The Bringing's* brief history, Michael Peña was set to play this role.

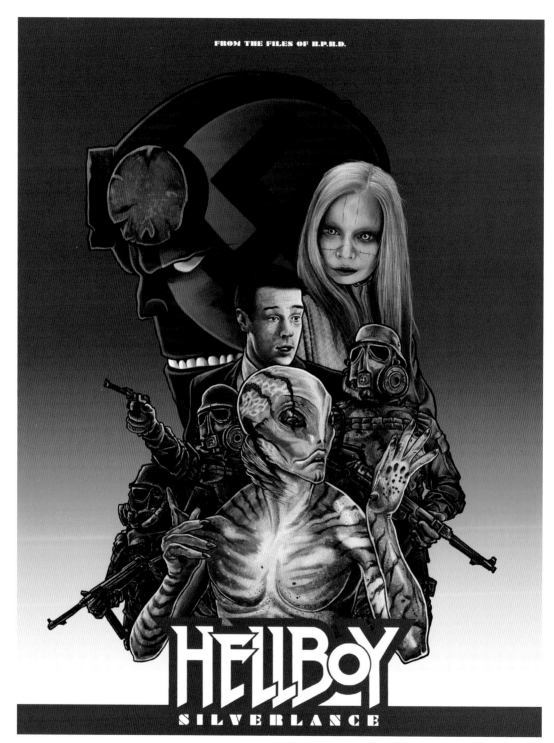

FROM THE FILES OF B.P.R.D.

HELLBOY
SILVERLANCE

Sony Pictures Entertainment, Guillermo del Toro and Peter Briggs presents HELLBOY-SILVERLANCE
Guillem Bosch · Illustration · www.guillembosch.es

POSTER BY GUILLEM BOSCH

HELLBOY: SILVERLANCE

THE PLAYERS

Director
Peter Briggs

Screenwriter
Peter Briggs and
Aaron Mason

Producer
Guillermo
del Toro

Starring
Doug Jones,
Rupert Evans,
Anna Walton

FADE IN

After two hellish adventures on the big screen, Universal Pictures were looking to expand their *Hellboy* franchise past big red himself. They had an entire universe to pull from and a vast lineup of side characters making up the Bureau for Paranormal Research and Defense (B.P.R.D.). One such character, Abe Sapien (Doug Jones), had already proven himself to be a fan favorite. The aquatic, egg-eating, and book-reading agent appeared prominently in the first two *Hellboy* films, even finding himself with a romantic interest in *Hellboy II: The Golden Army*.

As Guillermo del Toro teased the future of the *Hellboy* franchise, Universal itself began development on an Abe Sapien–focused spin-off that would reconnect to *The Golden Army* and expand the B.P.R.D lore. However, instead of being the exciting start of a cinematic Mignola-verse, the Abe Sapien spin-off soon found itself swimming with the fishes.

FLASHBACK

Hellboy II: The Golden Army is the 2008 sequel to Guillermo del Toro's *Hellboy*. Released in 2004, *Hellboy*, starring Ron Perlman, Selma Blair, Doug Jones, Rupert Evans, John Hurt, and Jeffrey Tambor, brought Mike Mignola's Dark Horse Comics property to the big screen for the first time ever.

Hellboy follows Agent John Myers as he joins the secret organization B.P.R.D. On arrival, Myers immediately discovers that paranormal creatures exist and that some of them are good guys, including the tabloid sensation Hellboy, whom he has been tasked with "babysitting." He soon meets the rest of the team: Professor Broom, Abe Sapien, Liz Sherman, and Tom Manning.

Hellboy made his Dark Horse debut in 1994's *Seed of Destruction* storyline. Originally pitched to DC Comics, *Hellboy: Seed of Destruction* featured Mike Mignola's story concept and art; legendary comic book writer John Byrne handled script duties. *Destruction* launched a world rich with Lovecraftian horror, dysfunctional heroes, and demonic entities still active to this day, and served as the major influence for del Toro's 2004 adaptation.

Hellboy opened wide on April 2, 2004, and took the number one spot at the box office. Bringing home $23 million, the film fought off Kevin Bray and The Rock's *Walking Tall. Hellboy* fell to number two in its second weekend of release, dropping 53 percent with a $10 million gross. An interesting tidbit here: *The Passion of the Christ* made $15 million, winning back the top spot it won weeks before. *Christ* landed at number five when *Hellboy* opened, so why the 40 percent jump in box office? *Hellboy*'s second weekend of release just happened to fall on Easter weekend. Audiences had their pick of heaven or hell, and they chose heaven.

Hellboy ended its theatrical run with a worldwide total of $99 million. Standing red-handed with a production budget of $66 million, the film was far from a blockbuster hit—but it was plenty for a lesser-known comic character and publisher, especially once the film hit home video. Two months after *Hellboy* opened in theaters, a sequel was announced by Revolution Studios. Del Toro and Perlman both returned to the Mignola-verse, with plans already underway for a trilogy. It was time for Guillermo and Mignola to maneuver through the labyrinth of sequel development.

ACTION!

After flirting with adapting specific tales from the *Hellboy* universe,[1] del Toro and Mignola decided to create an original concept for the sequel. The pair had to wait longer than anticipated for the sequel to come to life—Revolution Studios was no longer involved in the sequel, after losing their distribution deal with Columbia Pictures. Originally slated for a 2006 release, *Hellboy II* had to find a new home, preferably one with a history of making monster movies. The project was soon picked up by Universal Pictures, but production remained stagnant until the success of *Pan's Labyrinth*. With an armload of Academy Awards for del Toro in tow, and a direction del Toro, Mignola, and Universal were happy with, *Hellboy II* was given a 2008 release date.

The sequel saw the return of Hellboy, Abe Sapien, and Liz Sherman. Agent Myers is nowhere to be found, but the bureau brings in a new babysitter for Red: Johann Kraus, a spirit with psychic abilities who lives in a containment suit. Prince Nuada has returned to piece the crown back together. However, his twin sister, Princess Nuala, escapes with the third piece, setting

1 One flirtation involved having Hellboy face off against the Universal Monsters.

in motion an adventure filled with troll markets, a near-death experience for Hellboy, pregnant Liz, and Barry Manilow.

Opening on more than three thousand screens on July 11, *Hellboy II: The Golden Army* raked in a $35 million opening. This marked a $12 million jump from the first *Hellboy*, but the sequel had its work cut out for it in its second weekend. Christopher Nolan's *The Dark Knight* was scheduled to open on July 18—and open it did. The highly anticipated sequel scored a massive $155 million opening, resulting in a 70 percent box-office drop for *The Golden Army*.[2] The *Hellboy* sequel finished its theatrical run with $160 million worldwide.

While far from a box office juggernaut, the *Hellboy* films were consistent, entertaining films from a fan-favorite director. So instead of getting the hell out of Dodge, Universal doubled down on their plans. Development not only began on *Hellboy III*, but also on a B.P.R.D. spin-off film that focused on Abe Sapien. Del Toro would produce the film and Peter Briggs, who helped bring *Hellboy* to the screen in 2004, would write with an eye on directing. Perlman's Hellboy was scheduled to make a brief appearance in the film.

So—what exactly was the spin-off?

Hellboy: Silverlance (later retitled *Silverlance: From the Files of B.P.R.D.*) would see Abe troubled by his psychic connection to Princess Nuala, so he researches her and her brother, Prince Nuada. Here, Abe discovers the history of the brother and sister, and in doing so, somehow brings Prince Nuada back to life. Agent Myers would have returned for the spin-off, as well as for more supernatural action. *Silverlance* would have been the first of multiple *From the Files of B.P.R.D.* projects.

Development of both *Hellboy III* and *Silverlance* continued until 2017, when del Toro unfortunately told the world via tweet that *Hellboy III* was dead. *Silverlance*, however, remained holding on for dear life at the studio. But how do you make a *Hellboy* spin-off if the original trilogy is dead?

Well, stranger things have happened.

2 Setting a record at the time, *The Dark Knight* knocked *Spider-Man 3* to second place, again. Keep in mind that in 2008, films weren't yet opening to a billion dollars every weekend.

CUT!

Or, rather, *Stranger Things* happened. Talks of a *Hellboy* reboot began in 2016, ironically the same year the nostalgic blockbuster series hit Netflix. Because of the looming decision, Briggs and company were informed they would no longer be able to use characters from *Hellboy II: The Golden Army*. If they wanted to do a spin-off, it would have to be something else entirely. They focused their attention on B.P.R.D. and the supernatural villain the Black Flame.

And then the flame went out.

On May 8, 2017, Millennium Media announced they were rebooting *Hellboy* with *Stranger Things* star David Harbour as the Right Hand of Doom. *Silverlance* was officially laid to rest next to the body of Guillermo del Toro's *Hellboy III*. Two years later, Neil Marshall's *Hellboy* reboot hit theaters dead on arrival. Being a franchise filled with multiple resurrections, I wouldn't be surprised if we see Red's big grinning mug on screens once again sometime in the future.

There's a lot more hell to give.

TIM BURTON'S
MONSTERPOCALYPSE 3-D

THE PLAYERS

Director
Tim Burton

Screenwriter
John August

FADE IN

In March 2010, Tim Burton saw a monstrous opening for his live-action remake of Disney's *Alice in Wonderland*. The film had a worldwide box office opening weekend of $220 million, making it the second largest non-summer or -holiday release, behind Francis Lawrence's *The Hunger Games*. After eighty-five days of release, *Alice in Wonderland* became only the sixth film at the time to cross $1 billion at the box office. It was also only the second Disney film to hit that mark, again, at the time (since *Alice's* release, Disney films have crossed the billion-dollar mark twenty-three times, at least as of fall 2019).[1]

Burton could be late to any important date after those box office numbers. It was a monster-sized hit for the cult filmmaker that led him to a monster-sized project.

FLASHBACK

Screenwriter John August stepped on to the Hollywood scene with his screenplay *Go* in 1999. Told from three different points of view, *Go* follows a group of young people living in California and their encounters with drugs and sex over a twenty-four-hour span. Directed by *Swingers* filmmaker Doug Liman, the film put August on every studio's wish list.

From there, August went on to write *Titan A.E.*, *Charlie's Angels*, and *Charlie's Angels: Full Throttle.* He also created the show *D.C.* for the WB in 2000. In 1998, August read, and connected with, Daniel Wallace's

1 Seven of those came in 2019 alone: *Captain Marvel*, *Avengers: Endgame*, *Aladdin*, *Spider-Man: Far from Home*, *The Lion King*, and presumably, *Frozen 2* and *Star Wars: The Rise of Skywalker*. *Endgame* became the highest-grossing film of all time, topping *Avatar*'s record. *Far from Home* was the first Spider-Man movie to gross a billion dollars at the box office.

unpublished manuscript *Big Fish: A Novel of Mythic Proportions*. Reeling from the recent death of his own father, August convinced Columbia Pictures to acquire the rights to the novel for him to adapt, which they did in September.

Steven Spielberg came on as director in 2000. He pursued Jack Nicholson for Edward Bloom Sr., the role Albert Finney eventually played in the 2003 version. August and Spielberg developed multiple versions of the screenplay in order to appeal more to Nicholson. After swimming upstream on the project, Spielberg left to focus his attention on *Catch Me If You Can*.

After miserable experiences on his 2001 remake of *Planet of the Apes*, Burton wanted to return to smaller films. He was also dealing with the death of his father in 2000 and the death of his mother in 2002. The script for *Big Fish* not only offered Burton the chance to tell an emotional story about parents, but it also offered him something he hadn't had in years: the chance to tell a truly unique tale on the big screen. He signed on to direct the film in April 2002. *Big Fish* was to be the first of many collaborations between Burton and August.

After the release of *Big Fish* in 2003, the pair teamed up for two films released in 2005. They brought an everlasting box office gobstopper to Warner Bros. with the big-screen return of Willy Wonka on July 15. *Charlie and the Chocolate Factory* also reunited Johnny Depp with his *Edward Scissorhands/Sleepy Hollow* director. The trio of Burton, August, and Depp again shared the big screen on September 23, 2005, with the release of the stop-motion animated film *Corpse Bride*.

The pair worked on separate projects after their double-release year: Burton again teamed with Depp for *Sweeney Todd: The Demon Barber of Fleet Street*, while August wrote and directed *The Nines*, starring Ryan Reynolds. From there, Burton and Depp traveled to *Wonderland*.

In summer 2010, Burton and August began work on a monstrous new collaboration.

ACTION!

Released in 2008 by Privateer Press, the Monsterpocalypse board game is a miniature-based, strategy tabletop game focusing on battles between giant robots and giant monsters. The game is played on a variety of maps, each

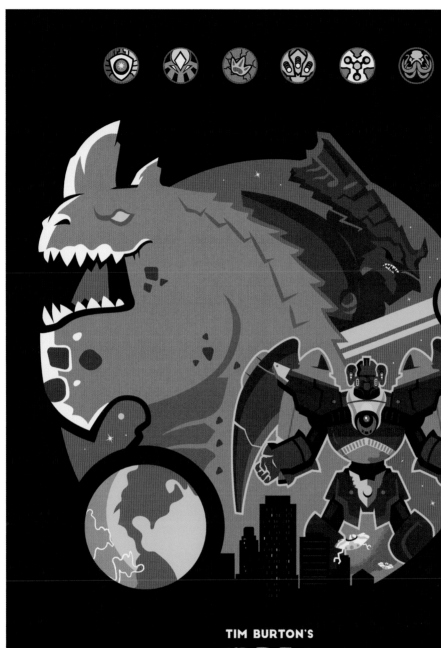

with its own destruction-destined structures. The robot player must fight the monster player to the death, before the latter destroys the entire city.

August began writing the screenplay in 2010, with Monsterpocalypse creator Matt Wilson serving as consultant (and coproducer). Burton eyed the project as a *Transformers*-esque property of epic proportions.

The film would have seen giant alien monsters attack Earth. They retreat once the humans fight back—or at least we think they leave. Instead, the monsters burrow themselves deep into the earth and begin to send signals into space. Not to be outdone by these skyscraper-sized beasts, we develop skyscraper-sized robots to fight them, if they ever return.

Burton and Warner Bros. began to strategize a late 2012 release for their 3-D tentpole.

CUT!

While Burton and the studio were prepared for battle, they weren't ready to wage war against a rival studio's competing project that had seemingly sprung up overnight like an alien invasion. In 2006, Guillermo del Toro signed on to direct *A Killing on Carnival Row*, a spec fantasy/horror screenplay from screenwriter Travis Beacham. The pair developed the film together over the next few years, but it never materialized into a movie.[2] Beacham began developing a new film to write. In 2010, it was announced that Legendary had purchased a twenty-five-page treatment from Beacham. The title of the project? *Pacific Rim*.

Del Toro was snow-deep in prep on his adaptation of H. P. Lovecraft's *At the Mountains of Madness* for Universal Pictures. Del Toro met with Legendary about the possibility of collaborating on a future film project. *Pacific Rim* was one of the projects discussed.

Very much intrigued by the concept of robots fighting kaijus, del Toro wanted in. Unable to direct the film due to his commitment on *Mountains*, he struck a deal to produce and cowrite *Pacific Rim* with Beachem; he would only direct *Pacific Rim* if for some reason *At the Mountains of Madness* didn't come together . . . and it didn't.

2 *Carnival Row* has since been developed and produced into a series for Amazon Studios. Premiering in fall 2019, *Carnival Row* landed a second season pickup in July 2019.

Now with del Toro directing, *Pacific Rim* won the big monster battle and started filming in November 2011, while *Monsterpocalypse* quietly burrowed itself into development hell. Burton and August shifted their focus to two different properties, and, just like in 2005, the prolific pair again had two movies hit the big screen in 2012: *Dark Shadows* and *Frankenweenie*.

In 2016, Fede Alvarez (*Evil Dead/Don't Breathe*) signed on to cowrite and direct a new version of *Monsterpocalypse* that he billed as "*Apocalypse Now* meets a world of monsters." As of summer 2019, the project was still in active development.

OVEREXPOSED!
TIM BURTON

DINOSAURS ATTACK!: Burton, like many other directors, has adapted comic books and turned animated Disney films into live-action spectacles, but he might be one of the only filmmakers to have adapted trading cards into a movie.[1] In the mid-nineties, he set out with screenwriter Jonathan Gems to adapt a Topps trading card series called *Dinosaurs Attack! Dinosaurs* follows, well, dinosaurs who are somehow transported through time into the present day. This obviously causes big-time problems for humans and their cities.

The pair developed the project until they decided it was too close to *Jurassic Park*, a film Burton and Warner Bros. attempted to acquire back when the book was published in 1990. Burton and Gems chose to adapt a different Topps series instead: *Mars Attacks!*

RIPLEY'S BELIEVE IT OR NOT: In 2005, Burton signed on to direct Jim Carrey in *Ripley's Believe It or Not*, a film about the adventures of columnist Robert Ripley. After a year of starts and stops on production due to budget and script issues, Burton walked away from the project to direct an adaptation of *Sweeney Todd* starring Depp. Carrey stayed on board the film and nearly made it with Chris Columbus. Believe it or not—well, believe it, the movie was never made.

GEEK LOVE: Burton purchased the rights to Katherine Dunn's novel *Geek Love* in the nineties. *Geek Love* follows a traveling carnival where the owners breed their own circus freaks with chemicals. It's a stunning novel filled to the brim with horror, and with imagery that must have fluttered like mutated butterflies in Burton's brain. While not much is known about Burton's plans, there were whispers about him using stop-motion to adapt the novel. At first thought, you might think Geek Love doesn't scream "Jack Skellington technique," but *The Nightmare Before Christmas* style would have been the perfect way to bring Dunn's horrific creations to the screen.

1 It's basically Tim Burton and Rod Amateau. Amateau directed 1987's *The Garbage Pail Kids Movie*. The $1 million gross-out adaptation is considered one of the worst movies ever made.

STEVEN SPIELBERG'S
OLDBOY

THE PLAYERS

Director
Steven Spielberg

Screenwriter
Mark Protosevich

Starring
Will Smith

Based on
Old Boy by
Garon Tsuchiya
and Nobuaki
Minegishi

FADE IN

The Internet, and the film world in general, was thrown into a frenzy in late 2008 when it was announced that Steven Spielberg and Will Smith were plotting a remake of Korean Director Park Chan-wook's *Oldboy*. An instant classic with a cult following, *Oldboy* would have not only been something entirely different for the box office titans, it would have been something extremely intriguing for moviegoers everywhere.

FLASHBACK

Spielberg was just coming off the release of *Indiana Jones and the Kingdom of the Crystal Skull*. *Skull* premiered at the 2008 Cannes Film Festival on May 18 (where it decidedly did not win the Palme d'Or) and was released worldwide on May 22. It was the second-highest-grossing film of 2008, bringing in a worldwide total of $786 million (Christopher Nolan's *The Dark Knight* was number one with $997 million). *Crystal Skull* also managed to become the highest-grossing film of the franchise—before inflation, of course.

Smith saw the release of two of his films in 2008. First up, Smith starred as the drunken, foul-mouthed superhero John Hancock in Peter Berg's *Hancock*. Originally titled *Tonight, He Comes*, the film was almost directed by Tony Scott and Michael Mann, who were both attached during the project's early development. *Hancock* was initially an R-rated character study about a suicidal, destructive superhero. When Berg came on board, the decision was made to tone down the darkness and make the project a more lighthearted fit for Smith.

Hancock was released on July 2, 2008. It was Smith's fifth film to open on the Fourth of July weekend—and his most successful. It was also his eighth straight film to open number one at the box office. The film ended with a worldwide total of $624 million.

On December 19, Smith's drama *Seven Pounds* released into theaters. Directed by Gabriele Muccino, the film focuses on a man with a secret embarking on a journey of redemption by changing the lives of seven

strangers. The film was a financial success, but it snapped Smith's streak of number one openings: it opened at number two with $16 million, falling behind Peyton Reed's *Yes Man*, which opened with $18 million.

Combined, that's a strong 2008 for Spielberg and Smith. One might look at it and think they felt invincible—or look at it and think, "Maybe they just wanted to change things up." In most people's experience, when they want change, they buy new clothes or get a haircut; they don't eat octopuses alive and hammer people in the head.

Released in 2003, *Oldboy* tells the story of the imprisoned Oh Dae-su, who has been locked in a room for fifteen years without explanation. Once released, Dae-su pursues his captors and falls in love with a sushi chef. He also eats a squirming octopus. And beats a ton of people with a hammer.

Oh yeah, he also gets tricked into having sex with his long-lost daughter.

ACTION!

Initially announced as a remake, Spielberg and Smith later clarified that it would be a "reworking" of the thriller and stay closer to the original manga that ran from 1996 to 1998. The big differences between the manga and Chan-wook's film? Our hero (Oh Dae-su in the film, Shinichi Goto in the manga) is jailed for only ten years in the manga, there's no hallway hammer scene, and probably the most important difference—and the clear reason why Spielberg and Smith wanted to stray closer to the manga? The daughter reveal is only in the film. In the manga, she's a bar hostess named Eri who just so happens to be a pawn for Goto's nemesis.

After a collaboration with screenwriter Mark Protosevich on *I Am Legend*, Smith approached him to write the screenplay. Protosevich himself stated Spielberg wanted to make it a hard-hitting, gritty adaptation that would keep the original ending (right . . .).

With Spielberg and Smith's blessing, Protosevich went off to hammer out a treatment.

CUT!

Mandate Pictures and DreamWorks were working hard to free the rights from captivity, but in the process, could not see eye to eye on what to do with the project. As a result, DreamWorks completely walked away from

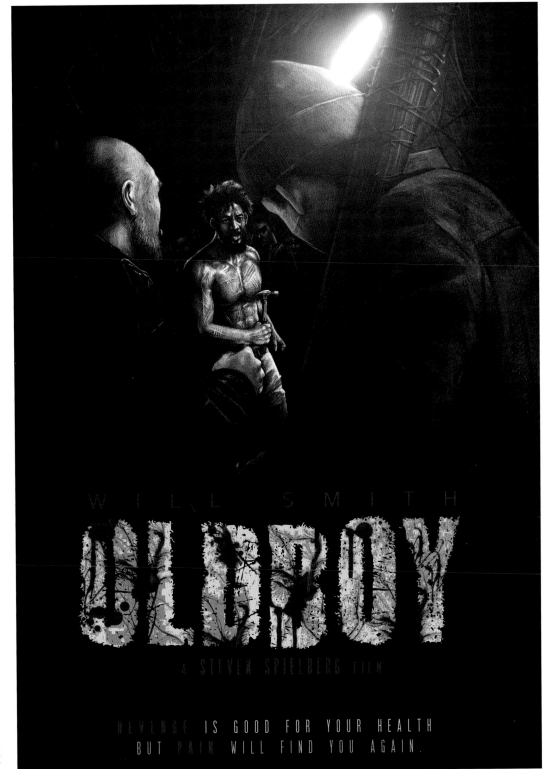

the film. Spielberg and DreamWorks went hand in hand at the time, so he walked away as well.

Spielberg turned his attention to a different kind of "old boy": Hergé's Tintin, whom Hergé originally created back in 1929. In 1984, Spielberg and producer (now president of Lucasfilm) Kathleen Kennedy secured the rights to the comic book series *The Adventures of Tintin*. He commissioned *E.T.* screenwriter Melissa Mathison to write the screenplay as "Indiana Jones for kids." Unfortunately, the screenplay didn't capture the magic he was hoping for, and so he moved forward on *Indiana Jones and the Last Crusade*. This move would cost Amblin Entertainment the rights to the comic. At one point, Roman Polanski almost made the film (which . . . would have been . . . something . . .). It took eighteen years, but DreamWorks and Spielberg at last regained the rights to *Tintin*. *The Adventures of Tintin* was finally released in 2011, ending a journey that took the filmmaker nearly thirty years.

Smith returned to the *Men in Black* franchise for Barry Sonnenfeld's *Men in Black 3* (with Spielberg returning as executive producer), which made $624 million worldwide. This third *MIB* film follows Smith's Agent J and Tommy Lee Jones's Agent K as they pursue an alien named Boris the Animal (played by Jemaine Clement).

As for Protosevich? Still intent on the remake, producers asked him to write the screenplay. On July 11, 2011, Mandate Pictures announced Spike Lee would direct the film. Josh Brolin was cast as the lead, Elizabeth Olsen as his long-lost daughter, and Sharlto Copley as the nemesis. The remake opened on November 27, 2013. It opened number eighteen at the box office and ended its worldwide box office gross at *just* $5.2 million.

Regardless of what their final version would have looked like, it's hard to imagine a Spielberg/Smith movie grossing only $5 million worldwide. If anything, it just proves this remake should have stayed locked up in a dirty studio room.

OVEREXPOSED!
STEVEN SPIELBERG

When you're one of the busiest and most successful filmmakers in Hollywood, you're going to have a pile of unmade films. We're going to briefly dig into three other "almost films" from the legendary director.

THREE AMIGOS: Spielberg almost directed *Three Amigos* instead of John Landis, in the early 1980s. Spielberg's version of the film would have looked very different from the one that exists today: instead of the three leads being Steve Martin, Chevy Chase, and Martin Short, Spielberg was going to cast Robin Williams and Bill Murray alongside Martin. Spielberg, however, ultimately decided to direct a movie about a small, Reese's Pieces-loving alien who just wants to phone home.

CAPE FEAR: In the early nineties, we were robbed of yet another Spielberg/Murray team-up. *Cape Fear* follows a recently released convicted rapist who stalks the family of the lawyer who got him put away. Spielberg wanted to cast Murray as the sinister Max Cady and Harrison Ford as lawyer Sam Bowden. The director struggled with the dark material and opened up to his friend Martin Scorsese, who happened to be struggling with his own movie at the same time. The friends decided to swap projects: Scorsese got *Cape Fear* and Spielberg won seven Oscars for *Schindler's List*.

ROBOPOCOLYPSE: Slated to hit theaters on July 3, 2013, Spielberg's adaptation of Daniel H. Wilson's *Robopocolypse* ran out of steam close to production. The film, set ten to twenty years in the future, tells of the all-out war between humans and AI.

Chris Hemsworth, Anne Hathaway, and Ben Whishaw were cast in the film with *The Cabin in the Woods/The Martian* screenwriter Drew Goddard writing. Budgetary concerns led to the film being indefinitely postponed. The last update on the project happened in March 2018 when Spielberg handed directing duties over to Michael Bay.

Lovers at first sight... If y'know what I mean.

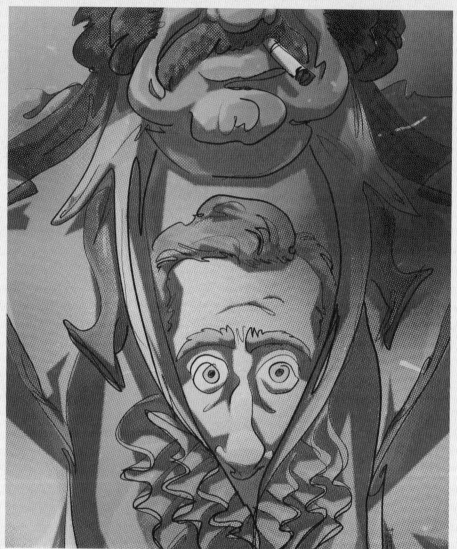

The
TONY CLIFTON
story

UNIVERSAL PICTURES PRESENTS A SHAPIRO WEST PRODUCTIONS A FILM BY ANDY KAUFMAN & TONY CLIFTON "THE TONY CLIFTON STORY"
EXECUTIVE PRODUCERS ANDY KAUFMAN & GEORGE SHAPIRO & HOWARD WEST PRODUCED BY GEORGE SHAPIRO & HOWARD WEST STORY BY ANDY KAUFMAN & BOB ZMUDA SCREENPLAY BY ANDY KAUFMAN & BOB ZMUDA DIRECTED BY ANDY KAUFMAN

THE TONY CLIFTON STORY

THE PLAYERS

Screenwriters
Andy Kaufman
and Bob Zmuda

Starring
Andy Kaufman,
Tony Clifton

FADE IN

Okay, okay, o-KAY . . .

Comedy is a subjective artform. It's been said that everyone has their own style they like. That could be the R-rated, "hard comedy" stylings of Seth Rogen or Danny McBride, or the softer, "Neflix-ier" comedy of Adam Sandler. Maybe you're more into the oldies, like the Three Stooges or the Marx Brothers. Comedy that puts the audience in the shooting gallery—the kind where whatever comedian you're watching feels like they can grab you by your throat and scream in your face at any point in time—is less subjective and more divisive.

That's Tony Clifton. Loud, abrasive—in your face.

On the other side of the coin is Andy Kaufman. Awkward, funny—next to your face.

They hated each other, yet they *were* each other. Let's dive into the sordid history of the two larger-than-life characters and the movie they almost made together, together.

FLASHBACK

Kaufman brought his own unique perspective to comedy; he didn't set out to tell jokes, he set out to entertain the crowd by any means necessary. Whether that be as Foreign Man lip-syncing to the *Mighty Mouse* theme or by antagonizing legendary wrestler Jerry "The King" Lawler, Kaufman found a way to get a rise out of audiences.

Kaufman made his national television debut on *The Dean Martin Comedy World* in 1974. More than a year later, he appeared on the very first episode of *Saturday Night Live* to perform his Mighty Mouse act. That appearance catapulted Kaufman into the public eye, and he made twelve more

appearances on *SNL* before viewers voted him off the show. Yes, *Saturday Night Live* was the original *Survivor*.

Kaufman made his film debut as a possessed police officer in Larry Cohen's 1976 horror film *God Told Me To*, a film that is just as wild as Kaufman himself.[1] After appearing on TV screens in a variety of shows over the next two years, Kaufman landed the role of Latka Gravas in the sitcom *Taxi*.[2] The award-winning sitcom ran from 1978 to 1983, with Kaufman appearing in fourteen episodes per season (each season averaged twenty to twenty-four episodes).

When Kaufman joined the show, he agreed to do so if another comic could also guest star. That other comic was the brash Tony Clifton, a character created and played by Kaufman. Clifton was an obnoxious entertainer who purposely annoyed and taunted his audience, as well as anyone brave enough to hire him. Kaufman had Clifton open for his comedy shows, which confused audiences and the media even more. Was he real? Or was he Kaufman?

Yes and no.

Clifton was often portrayed by Kaufman, but to help confuse, and obviously ruffle as many feathers as they could, Andy's brother Michael and writing partner Bob Zmuda also played the character. It's a truly remarkable routine, but one that didn't fool everyone. The producers of *Taxi* were well aware that Kaufman was (usually) Clifton, but they agreed to the deal anyway. Clifton's cameo ended with him being fired and escorted off the set of *Taxi* before filming even began. Kaufman, of course, arrived on set the next day, "normal" as can be.

While Clifton's "career" struggled, Kaufman's continued to soar on television, and the big screen came calling once again. The Clifton creators wanted both Kaufman and Clifton to experience the big screen. After Kaufman teamed up with *National Lampoon* writer Ed Bluestone to pitch a Tony Clifton film, Kaufman's manager, George Shapiro, landed Zmuda and Kaufman a deal at Universal Pictures. Kaufman insisted Zmuda get a writing

1 This film has everything: mass killings, extraterrestrial impregnation, a hermaphrodite killer, and Andy Kaufman going crazy at a Saint Patrick's Day Parade.
2 Kaufman and the *Taxi* creators adapted his character Foreign Man into the Latka character for the show.

credit for the film, since he was the co-creator of the disgraced lounge singer. Bluestone refused, however, and walked away from the project.

From there, Kaufman and Zmuda set out to bring the Tony Clifton story to the big screen on their terms.

Or Tony's terms.

ACTION!

Zmuda and Kaufman's screenplay sets out to do the one thing Kaufman and Clifton always do in their performances: play against expectations. One might go into this script expecting Clifton to play the heel to Kaufman's good-guy comedian. Well, here smart writing comes to save the day.

The Tony Clifton Story starts out in Philadelphia. After a unique experience in a massage parlor lands him a compliment on his singing voice from a gaggle of call girls (in no way influenced by the wad of $20 bills he was throwing around), Clifton naively believes he can become the next great lounge singer. We cut to Los Angeles and meet rising comedian Andy Kaufman, who books a role on the sitcom *Taxi*, as well as a cross-country comedy tour.

The tour ends in heartbreak for Kaufman when his girlfriend walks away from him and the tour in Philadelphia. Zmuda takes his down-in-the-dumps friend to a local bar to drink off his feelings and get a fresh start.

They get Clifton instead.

After seeing the singer perform at the bar, Kaufman brings Clifton with him back to Los Angeles to help close out the tour. Clifton bombs during the opening, to the point where the audience wants his head on a stick. Seeing what they have in Clifton, Kaufman and Zmuda begin pushing him more into the spotlight.

While this works well for Kaufman and Zmuda, Clifton is miserable and intends to go in a different direction with his career. That direction? A dramatic remake of *The Hunchback of Notre Dame* called *Hunchback*. Kaufman supports the idea, or at least appears to support the idea to Clifton's face. Behind the scenes, he plans to turn the film into a comedy—without Clifton knowing.

Clifton finds out and quits the film. Not *Hunchback*—he quits the actual film, *The Tony Clifton Story*. The movie breaks the fourth wall as Kaufman informs the audience Clifton died during filming and that Kaufman himself,

despite their lack of similarities in appearance, would play the role for the remainder of the film.[3]

But Clifton didn't die from cancer; he dies a few scenes later when a cannibal tribe kills him after his plane crashes. Clifton merchandise goes through the roof, and Zmuda and Kaufman are once again raking in the Clifton benefits. But in true Kaufman form, Clifton wasn't killed by the tribe. Instead, they mistook him for Frank Sinatra and made him their leader. With the tribe at his command, Clifton invades his own funeral, riding an elephant. Clifton fights Kaufman until—wait for it—the real Tony Clifton comes back into the movie, shocking everyone involved.

A huge musical sequence finishes the film, complete with grave diggers shoveling dirt to the rhythm, corpses sitting up and singing, and Kaufman being pursued by a group of Clifton look-a-likes he hired. Much like the two men the movie focused on, the script was hilarious, bizarre, and brilliant. It would have surely gone down as one of the greatest comedies ever made. *Would* have . . .

CUT!

When Kaufman and Zmuda set out to make *The Tony Clifton Story*, the studio had little faith in Kaufman's talents as a leading man. He had just appeared in the box office bomb *In God We Tru$t*. Before greenlighting *Clifton*, the studio wanted to make sure he could lead a film. They offered him the starring role as a robot in the science-fiction comedy *Heartbeeps*. Zmuda pleaded with Kaufman not to take the picture, but thinking it was their best option to get the film made, Kaufman accepted. The future of *The Tony Clifton Story* relied on a movie about—checks notes—robots who fall in love and try to start a life outside of being household servants.

Yep.

Heartbeeps has a 0 percent rating on *Rotten Tomatoes*.[4]

Proving Universal right, *The Tony Clifton Story* was rejected. *Heartbeeps* ultimately ended up being Kaufman's final movie role as well.

3 Clifton "died" from cancer at Los Angeles's Cedars-Sinai Hospital. Five years after the script was written, Kaufman died, in real life, from cancer at Los Angeles's Cedars-Sinai Hospital.

4 Stan Winston did receive an Academy Award nomination for his makeup work on the film.

JUSTICE LEAGUE: MORTAL

THE PLAYERS

Director
George Miller

Screenwriters
Kieran Mulroney
and Michele
Mulroney

Starring
Armie Hammer,
Common, Adam
Brody, Megan
Gale, D. J.
Cotrona, Hugh
Keays-Byrne,
Zoe Kazan,
Santiago Cabrera,
Teresa Palmer,
Jay Baruchel,
Anton Yelchin

FADE IN

A year after Warner Bros. released his seventh feature film, *Happy Feet*, legendary filmmaker George Miller was ready to suit up for the studio again with the company's very first live-action *Justice League* movie. Which, in itself, is astonishing to think about.

Leading up to 2007, the studio had released *ten* movies featuring the World's Finest: Batman and Superman. Miller's film would feature the big-screen debuts of Wonder Woman, Green Lantern, Martian Manhunter, the Flash (Barry Allen *and* Wally West), and Aquaman. This was before the days of Marvel's five-film lead-up to *The Avengers* (and DC's two-film lead-up to Zack Snyder's *Justice League*). The studio was confident in viewers already knowing these characters, and especially confident if their debut came at the hands of a filmmaker like Miller.

FLASHBACK

Miller's stunning directorial debut, *Mad Max*, was released in 1979. The dirt-covered dystopian introduction to a character, and soon-to-be franchise, maintains relevance today. The tale of revenge follows outback policeman Max Rockatansky (Mel Gibson) as he tracks down the gang that murdered his wife and child and becomes known as the "Road Warrior." That development leads us into Max and Miller's second film, *The Road Warrior*, in 1981.[1] While Max continues on his journey of saving people in the outlands of dystopian Australia, the sequel also finds him taking on a gang of marauders terrorizing an innocent community. *The Road Warrior* all but assured a third film would happen later down the road.

1 Sometimes known just as *The Road Warrior*, sometimes as *Mad Max 2*, and other times as both: *Mad Max 2: The Road Warrior*.

After a brief journey into *The Twilight Zone*, Miller returned to the *Mad Max* franchise in 1985 for *Mad Max Beyond Thunderdome*, which he codirected with George Ogilvie. *Thunderdome* introduced Tina Turner into the fold as Aunt Entity, the ruthless leader of Barter town. The film not only carried on the legacy of Max, but also of franchise producer Byron Kennedy, who was killed in a helicopter accident prior to the film.

Miller left the dystopian future he had been living in for eight years in 1987 to make the dark fantasy *The Witches of Eastwick*. Based on John Updike's novel of the same name, *Eastwick* showed a lighter, more comedic side to the filmmaker. Starring Cher, Michelle Pfeiffer, Susan Sarandon, and Jack Nicholson, the film was nominated for two Academy Awards (Best Sound and Best Original Score for John Williams). Miller reunited with Sarandon in 1992 for the family drama *Lorenzo's Oil*.

Miller returned to his lighter side in 1995, cowriting Chris Noonan's *Babe*. Adapted from Dick King-Smith's novel *The Sheep-Pig*, *Babe* follows a talking pig who wants to be a sheepdog. The film was nominated for seven Academy Awards (including Best Adapted Screenplay) and grossed more than $250 million worldwide. Three years later, Miller cowrote and directed a sequel, *Babe: Pig in the City*, which found the talking pig on an adventure in a fictional city called Metropolis (Miller was still ten years away from his own adventure in the city of Metropolis).

In 2003, Miller began production on the CGI family film *Happy Feet*. The film, about singing emperor penguins and one tapdancing penguin (played by Elijah Wood), made extensive use of motion-capture technology—a direction Miller and Warner Bros. initially considered for their *Justice League* movie. *Happy Feet* was a massive hit at the box office and won the 2007 Academy Award for Best Animated Film.[2]

With Miller and Warner Bros. doing happy business together, the studio offered the filmmaker a super project in 2007—the kind of project that would do the visionary filmmaker justice.

2 Miller returned to cowrite, produce, and direct *Happy Feet Two* after the Hall of Justice collapsed.

GEORGE MILLER'S

JUSTICE LEAGUE: MORTAL

ARMIE
HAMMER

D.J.
COTRANA

MEGAN
GALE

ADAM
BRODY

COMMON

SANTIAGO
CABRERA

HUGH
KEAYS-BYRNE

AND JAY
BARUCHEL

RICO JR

ACTION!

Created by silver-age comic book writer Gardner Fox,[3] the original *Justice League* lineup consisted of Superman, Batman, Wonder Woman, Green Lantern, Martian Manhunter, the Flash, and Aquaman. It's no surprise, then, that screenwriters Kieran Mulroney and Michele Mulroney chose this team for the League's first big-screen adventure. With a possible writers' strike looming, Warner Bros. and Miller jumped into preproduction on the $250 million blockbuster.

Miller approached casting from the mindset of wanting his cast to grow into the roles of the League, as opposed to casting established, A-list names. Armie Hammer landed the role of Batman; Common went green for Green Lantern; Adam Brody landed the role of Barry Allen's Flash; Megan Gale lassoed the role of Wonder Woman; D. J. Cotrona would be the new Superman; Hugh Keays-Byrne scored Martian Manhunter; Zoe Kazan was cast as Iris Allen; Santiago Cabrera fished out the role of Aquaman; Teresa Palmer would play Talia al Ghul; Jay Baruchel landed the main villain role of Maxwell Lord; and Anton Yelchin speed-forced his way into the film as Wally West's Flash.

The Mulroney script featured the League, at least initially, all acting as individuals instead of a team. We're introduced to Maxwell Lord's restaurant franchise, Planet Krypton, in the first few scenes of the film. This sets up a repeating location/concept that appears throughout the film. Batman's spy satellite, Brother Eye, is hacked, revealing the weaknesses of every meta-human on Earth. As you can imagine, this causes extreme issues for the heroes—and among the heroes (I mean, you think you know a guy who dresses up like a bat until you find out he's been spying on you, for the sole purpose of being able to defeat you if you ever turn bad).

We then launch into an action-packed film that sees Maxwell Lord use his psychic abilities to control Superman, proceeding to use him as his very own Supes action figure and fighting any hero that gets in his way. This includes fighting Aquaman and his sea creature army, nearly killing Wonder Woman, and taking on Green Lantern, who is forced to create a Green Superman with his Lantern powers to contend with the Man of Steel. Batman, clearly over

3 Not only did Fox co-create a number of DC characters AND introduce the multiverse into the DC universe, he also wrote a number of stories for *Weird Tales* and *Amazing Stories*.

his friends' fighting and Maxwell Lord using his toys without permission, ends the psychic possession of Superman by snapping Maxwell's neck.[4]

Batman saves the day again . . . Except he doesn't.

Maxwell's mind jumps into the computer system and merges with Talia al Ghul, who orders the Omac War to start. Talia dies soon after this, and things go from bad to worse for our heroes when it's revealed Maxwell Lord had been infecting his Planet Krypton customers with an Omac virus. Basically, if you ate anything at Planet Krypton, even at the salad bar, you ingested nanobots that would one day turn you into a big armored super-soldier controlled by Maxwell Lord.

Maxwell's mind breaks out of the computer and travels inside the mind of Barry Allen. Barry quickly realizes the only way to stop this is if he sacrifices himself, so he proceeds to run as fast as he can around the world until he burns up. By doing so, he destroys Maxwell's mind and the Omac army. And since there were two Flashes conveniently placed in this film, we now have young Wally West available to join the newly formed Justice League.

It's a road map for an epic blockbuster that would have seen exciting interactions and fights between some of our favorite heroes. Preproduction continued on the film until the studio asked for changes in the script.

That's easier said than done when Hollywood was in the middle of a major writers' strike.

CUT!

Between the writers' strike, location/tax credit issues, contract options running out, and talks of creative differences, one of the biggest things to happen to *Justice League: Mortal* was the impending release of Christopher Nolan's *The Dark Knight*.[5] The film was shaping up to be a box office behemoth, and Christian Bale was the Batman at the time. Not to mention, there were rumors that if he wanted it, Nolan could have made a *Justice*

4 This is a play right out of Zack Snyder's *Man of Steel*. Remember when everyone was like, "Superman wouldn't do that!"? Well, George Miller's Batman *would* do that. Now picture Armie Hammer doing that to poor Jay Baruchel. *Oof.*

5 Nolan's *The Dark Knight* impacted a lot of films in this book—either box office numbers or future films. There's a reason it's so loved and respected, groundbreaking and genre-shifting, and its impact was felt across the industry . . . but not always in a good way. You either die a hero or you live long enough to see yourself become the villain?

League movie of his own after he finished his Bat trilogy. Sprinkle in the fact that Warner Bros. were well aware of the machine Marvel Studios were building, and thus the idea of starting out swinging with a full team movie seemed . . . irresponsible.

But would it have been?

Just like Fox did in the comics, Miller's *Justice League* could have introduced moviegoers to the multiverse. Earth One could have been Nolan's gritty, grounded universe, and Miller's colorful take could have been on another. It's not a crazy approach, and fans have been eating the multiverse up for years in the comics. The studio could have made it work. In fact, as of July 2019, it's the kind of approach WB is taking now with their DC universe, after the Zack Snyderverse didn't go as planned.

There's a new *Batman* movie due out in 2021 from Matt Reeves that will be its very own Batfilm.[6] There's a *Birds of Prey* movie coming out in 2020 from Cathy Yan, featuring Margot Robbie's Harley Quinn from David Ayer's *Suicide Squad*. That film had its own Jared Leto version of the Joker, who shouldn't be confused with Joaquin Phoenix's Joker from Todd Phillips's 2019 film, *Joker*.[7] Leto's Joker may or may not be discussed in James Gunn's 2021 *Squad* reboot *The Suicide Squad* that—by the way —will also feature Robbie's Harley Quinn.[8] Oh yeah, and Matt Reeves's new Bat trilogy will surely introduce a new Clown Prince of Crime at some point. (I think my brain just developed a multiverse of its own explaining all of that.)

Once his Justice League fell apart, Miller returned to two familiar franchises: 2011's *Happy Feet Two* and the cinematic world that started it all, *Mad Max: Fury Road*. The latter received ten Academy Award nominations, winning six of them.

As for the Justice League? After *Man of Steel* and *Batman v Superman*, Snyder and Warner Bros. "United the League" in 2017's *Justice League*. The lineup of Superman (Henry Cavill), Batman (Ben Affleck), Wonder Woman

6 Robert Pattinson is playing Batman in this new trilogy. His gritty, violent role in the Safdie Brothers' *Good Time* helped the actor secure the role.

7 *Joker* shattered October box-office records when it opened theatrically October 4, 2019. The stand-alone film made $96 million its opening weekend. By October 25, *Joker* passed *Deadpool 2's* $785 million to become the highest-grossing R-rated film ever, with more than a billion dollars worldwide. The film also garnered eleven Oscar nominations.

8 Given the history between Gunn and Leto, I highly doubt Leto will be involved in this round of *Suicide*.

(Gal Gadot), Aquaman (Jason Momoa), the Flash (Ezra Miller), and Cyborg (Ray Fisher) took on Steppenwolf (Ciarán Hinds) and his Parademons.

The future of the *Justice League* seems murky, after the disappointing box office results of its big-screen debut. The studio has briefly discussed rebooting the franchise altogether, which could be confusing since Gadot's and Momoa's solo franchises have been huge moneymakers for the studio. Maybe the studio can just ask Barry or Wally to "Flashpoint everything" and wipe the slate clean?

Justice League: Mortal is just one of many potential Justice League films that have been discussed through the years. Some solo League members who almost hit the big screen in a different way:

JOSS WHEDON'S WONDER WOMAN: Before Whedon brought *The Avengers* to the big screen, he planned on tackling *Wonder Woman* in 2006. The script was set in the modern day and followed Diana as she learned to live as an Amazonian without her powers. In the end, she saves the day, and potential sequels are set up. Whedon left the project, however, once it became clear that Warner Bros. was not a fan of his script. Six years later, he shattered box office records with Marvel's *The Avengers*.

THE FLASH: The Scarlet Speedster might be one of the fastest members of the Justice League, but he's definitely been among the slowest to make it to the big screen. In 2004, David Goyer (*Blade: Trinity*, *Batman Begins*) was announced as writer and director of *The Flash* solo movie. Goyer dropped out in 2007. Shawn Levy (*Night at the Museum*) signed on to direct the film in February 2007 and dropped out that October. David Dobkin (*Wedding Crashers*) replaced Levy as director, but the film never materialized.

That leads us to Miller's Flash-ventures. His solo spin-off was originally supposed to hit theaters in 2018, with Phil Lord and Chris Miller attached as writers/directors. They then declined the offer to direct, so the honor went to Seth Grahame-Smith, who later dropped out due to creative differences. Rick Famuyiwa (*Dope*) signed on in June 2016, but due to creative differences, left the film that October. Finally, the wheel of *The Flash* stopped spinning in 2018, when it was announced that *Game Night*'s (and *Spiderman: Homecoming* screenwriters) John Francis Daley and Jonathan Goldstein would direct the movie. In early 2019, Daley and Goldstein left the film due to—you guessed it—creative differences. In August 2019, *It* and *Mama* director Andy Muschietti confirmed that *The Flash* will be his *It Chapter Two* follow-up. Shooting is expected to begin in 2020 with a July 1, 2022 release.

BATMAN: YEAR ONE: Darren Aronofsky (*Pi*, *Requiem for a Dream*) nearly made an adaptation of Frank Miller's *Batman: Year One* in the early 2000s. Miller was going to write the screenplay, which would be influenced by the comic but not a straight adaptation. Concept art was completed for the film, and early casting talks were happening. In a Bat-twist, Aronofsky only discussed two names when it came to the role of Batman: Joaquin Phoenix and Christian Bale. It wasn't meant to be, however. Aronofksy abandoned the project in 2002, opening the door for Christopher Nolan's "*Year One*-esque" *Batman Begins* . . . starring Christian Bale.

JACK BLACK'S *GREEN LANTERN*: After Black's 2003 hit *School of Rock*, Warner Bros. cooked up the idea of a different kind of big-screen debut for Green Lantern. What if the Power Ring found a washed-up reality host instead of a hero? And what if the script was written by the guy who created Triumph the Insult Comic Dog? It would have taken the meta "comic geek helping a superhero find his super-footing" road long before DC's *Shazam!* in 2018. There was an entire musical sequence of Muppet-like aliens teaching Black's Lantern the way of the Corps, as well as Black's Lantern using his powers to make a fanny pack and a giant condom—because, well, you can make whatever you can dream up while wearing the Power Ring. Obviously, Warner Bros. got cold feet about an R-rated *Green Lantern* comedy starring Black.

ROB ZOMBIE'S
THE BLOB

THE PLAYERS

Director
Rob Zombie

Screenwriter
Rob Zombie

Starring
Sheri Moon
Zombie

FADE IN

Prior to the release of *Halloween II*, Rob Zombie was looking to get out of the horror genre with his next project. He had his eyes on a few original concepts when an out-of-this-world offer came down on him: Zombie was offered the chance to do a remake of the cult classic horror film *The Blob*. Zombie saw it as an opportunity to explore the more science-fiction side of the genre. And it could serve as the perfect jumping-off point to break free of the horrific restraints he had been feeling.

But could he truly get away?

FLASHBACK

A lifelong horror fanatic, Zombie made his directorial debut in 2000 with his exploitation-horror film *House of 1000 Corpses*. The movie followed a group of friends writing a book about unique roadside attractions. The trip leads them to Captain Spaulding's Museum of Monsters and Madmen,[1] where they learn about the local legend Dr. Satan. They also come face-to-face with the violent Firefly family and Dr. Satan himself.

A true throwback horror film, the release was shelved by Universal until 2003 due to fears of an NC-17 rating. Zombie eventually repurchased the rights and sold the film to Lionsgate. It was finally released in theaters in April 2003, grossing $3 million in its opening weekend and finishing with a total gross of more than $16 million worldwide.

After gaining their money back on day one of the *Corpses* release, Lionsgate wanted to stay in the Zombie/Firefly business. The sadistic family returned in 2005 as *The Devil's Rejects*. In the change-of-pace sequel, the killer family is on the run from the police after they discover the true horrors of the clan. Drawing inspiration from violent crime films and Westerns such as *Bonnie and Clyde* and *The Wild Bunch*, *The Devil's Rejects* ended with a

1 Legendary actor Sid Haig played the role of Captain Spaulding. He passed away on September 21, 2019, five days after the premiere of *3 from Hell*—the third and final film to feature Spaulding.

massive shoot-out, putting an end to the Firefly story once and for all (*or so we thought*…). Released on July 22, 2005, *Rejects* grossed $7.1 million, once again recouping its budget on opening weekend. It ended its theatrical run with a total of $19 million.

Zombie left the Firefly family for the Myers family in 2007, setting in motion the next phase of his filmmaking career.

ACTION!

In 2009, Zombie signed on to write and direct the remake of Irvin Yeaworth and Russell Doughten's original 1958 classic *The Blob*. *The Blob*, originally titled *The Molten Meteor*, was the feature-film acting debut of Steve McQueen, and premiered as the B movie in a double feature with Gene Fowler Jr.'s *I Married a Monster from Outer Space* (*The Blob* spread its way to the main feature spot shortly after release). The film follows a jelly-like life-form from another planet that consumes everyone it encounters, causing it to expand into a monstrous mass of horror. *The Blob* proved itself a box office success, and later even spawned a 1972 sequel called *Beware! The Blob!*

Chuck Russell (*A Nightmare on Elm Street 3: Dream Warriors*) directed a remake of his own in 1988. Cowritten by Frank Darabont, the remake took a much more horrific approach to the gooey mass. Instead of an alien creature from space, Russell's *Blob* was a biological weapon. Released in August 1988, the film failed to spread over the North American box office, grossing just $8.2 million.

Zombie set out to reinvent *The Blob* in his own way. With the announcement of his involvement, Zombie made his approach immediately clear: "My intention is not to have a big red blobby thing. That's the first thing I want to change."[2]

Concept art released in 2018 by artist Alex Horley revealed a glimpse of just how Zombie's *The Blob* would have spread. The concepts reveal gooey bodies attacking others, almost as if the titular blob were some kind of zombie-like virus/hive-mind mass. The art promised a gory, violent remake that only Zombie could deliver. With a production budget of $30 million and an eye toward an R-rating, *The Blob* was ready to expand into full production.

Then *Halloween* happened.

2 A bold approach to a movie called *The Blob*.

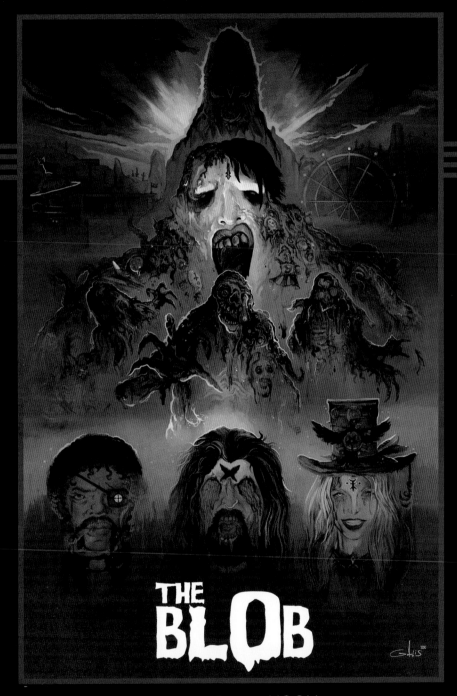

THE
BLOB

Rob ZOMBIE · Sheri MOON
A ROB ZOMBIE fiml based on the classic sci-fi HORROR the BLOB

CUT!

Michael Myers added another victim to his long list: Zombie cited his experience making the *Halloween* films and his lack of desire to make another remake afterward as his reasons for dropping out of *The Blob*. Creative disagreements didn't help, either. Zombie walked away from the film, and filmmaking entirely, for the next few years following *Halloween*, expressing a desire to focus on his music career. He returned to set in 2012 with the phenomenal witchcraft horror *The Lords of Salem*.

News of *The Blob* remake spread again in 2015, when Simon West (*Lara Croft: Tomb Raider*, *Con Air*) was announced as the new director. Samuel L. Jackson signed on to star in the film, which was set to go into production by fall 2015—but never did. West was still attached to direct the film in 2017, but no further word has come out.

This remake appears to be stuck in containment.

SHANE CARRUTH'S
A TOPIARY

THE PLAYERS

Director
Shane Carruth

Screenwriter
Shane Carruth

Producers
David Fincher and
Steven Soderbergh

FADE IN

In 2009, Twitter saw two tweets about filmmaker Shane Carruth that set the film world on fire. The first was from actor David Sullivan, who had appeared in Carruth's debut film, *Primer*.

> **"SHANE CARRUTH'S NEXT PROJECT,**
> ***A TOPIARY*, IS IN THE EARLY STAGES**
> **OF PRE-PRODUCTION."**

The second one came with a little more attention. It was from filmmaker Rian Johnson.

> **"TO ALL WHO ASKED: SHANE IS ALIVE AND**
> **WELL AND HAS A MIND-BLOWING SCI-FI SCRIPT.**
> **LET'S ALL PRAY TO THE MOVIE-GODS THAT**
> **HE GETS IT MADE SOON."**

A Topiary immediately hit "most anticipated" lists across the web, and an official website was launched in 2010. The website said just one thing: "Over and over you have been promised adventure but have not found it."

Substitute "adventure" with "*A Topiary*," and you now describe the wait for the much-anticipated follow-up to *Primer*.

FLASHBACK

Released in 2004, *Primer* took message-board film theorists by storm with its extremely methodical approach to time travel. The film follows four men working on a prototype electromagnetic machine in their garage, with the goal of reducing the weight of objects (and thus to reduce shipping costs). Two of the men, Abe and Aaron, soon discover that the prototype can be used as a time machine. What follows is a detailed deep dive into science, time-travel logistics, and convoluted games of cat-and-mouse one-upmanship, as the pair escalate their plans from playing the stock market to more nefarious, overreaching schemes.

I'M NOT INTO THE WHOLE "DESTINY, THERE'S-ONLY-ONE-RIGHT-WAY" THING. —ABE, *PRIMER*

With a budget of just $7,000, Carruth shot the film over five weeks in 2002. Working with a skeleton crew, Carruth starred in the film, alongside family and friends. Oh, he also edited the film, did visual effects, and composed the score. It's an astonishing accomplishment. *Primer* premiered at the 2004 Sundance Film Festival and became the toast of Park City: when the no-budget feature entered the snowy landscape of Utah, it was a scrappy sci-fi underdog with the occasional lighting or sound issue; when it left, it was the Grand Jury Prize winner and had a distribution deal lined up with ThinkFilm.

That's the kind of success that lands a filmmaker a major studio franchise these days. But for Carruth, things went quiet. He went back to Dallas and began work on new projects. The film world patiently waited to see what was next for the *Primer* filmmaker.

And they kept waiting.

And waiting.

Then, five years later, word of *A Topiary* hit.

ACTION!

A Topiary is a *massive* project.

First of all, the screenplay comes in at 245 pages. It even comes with a *pre*-script note explaining how the script works. One of the first things you learn in screenwriting is that one script page traditionally translates to one minute of screen time. That's not always the case with screenplays, as personal style and flow can vary script to script, and it's certainly not the case with *A Topiary*. Carruth dispels that notion with a note at the beginning of the screenplay, informing the reader that the script calls for heavy description and detail. He also breaks down how the film is split into two connecting stories, with the first act compared to the "previously on" section of a TV show, so you know you're in for wild ride right off the bat.

A Topiary is broken into two parts: the adults' story and the kids' story. The first half follows Acre Stowe, a thirtysomething Department of Transportation worker. Acre begins to notice "starburst patterns" everywhere.

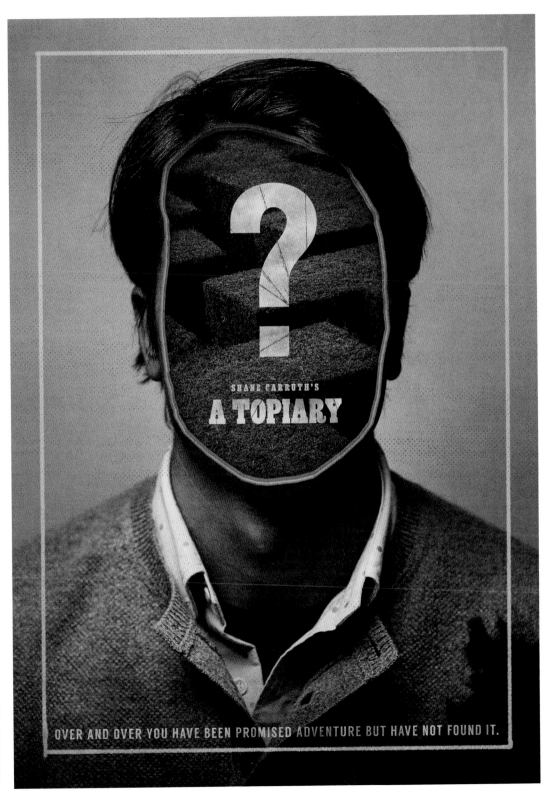

This leads to striking visual cues not only for Acre, but for us, the viewers, as well: Carruth planned to show these patterns over a black screen throughout the film.

Acre finds other believers in the patterns, which eventually turns into a cult of sorts. Acre's story ends on page 68 of the screenplay with a discovery (or, a lack thereof).

IT'S A DEAD END.
-ACRE, *A TOPIARY*

From page 68 on, we follow ten boys, ranging from age seven to twelve. They stumble across a machine that can somehow build robotic creatures. The creations pick up strength as the group of friends discover another group, who have built their own creatures from a similar machine. These creatures are referred to as "Choruses." It's a mind trip of a film that would have resulted in hours of deep dissecting even before the end of the screenplay.

A Topiary ends by venturing into multiple different worlds, all under attack by their own Choruses.

Rian Johnson may have called it mind-blowing (Carruth later provided special effects and time-travel knowledge for Johnson's film *Looper* in 2012), but it's truly a brain-shattering script. Not just in scale, but in substance and imagery. Carruth needed $20 million to bring the film to life, a far cry from the $7,000 he had for *Primer*. In an attempt to help raise funding, David Fincher and Steven Soderbergh came on the film as executive producers. The filmmaker cut a sizzle trailer consisting of his own effects work mixed with footage from Steven Spielberg films.

From there, Carruth hoped the patterns would align into a budget and a green light.

CUT!

After bringing the budget down to $14 million, Carruth took *A Topiary* as low as it could go. When that version of the film couldn't gain traction, he finally had a "No." That denial didn't come from investors or studios—it came from the filmmaker himself.

After years of trying to make the film, Carruth walked away.

He instead made *Upstream Color* in 2013. *Color* starred Carruth and Amy Seimetz as two people infected by an organism with hypnotic abilities, and it premiered at the 2013 Sundance Film Festival.

A Topiary not only remains one of the greatest films never made, but also has some of the best odds among that list to still see life one day. The screenplay has become a cult sensation on its own. There's no telling when, or if, this would even happen.

One thing is for sure: We'll be ready *if* it does.

GLADIATOR 2

THE PLAYERS

Director
Ridley Scott

Screenwriter
Nick Cave

Starring
Russell Crowe

FADE IN

Let's relive the last few minutes of *Gladiator*: Russell Crowe's Maximus has just killed Joaquin Phoenix's Commodus, causing quite the "commodus" in Gladiator Stadium. Maximus, who is not an eternal warrior (yet?) stumbles around from his own fatal injuries. Everyone is silent (except Lisa Gerrard and Hans Zimmer), Maximus frees his men and reinstates Senator Gracchus—and then he dies, reuniting with his family.

It's a beautiful scene with a stirring soundtrack that perfectly wraps up the previous 155 minutes of hell.[1] So, with this reminder that Maximus died at the end of *Gladiator*—and before we even ask *how* a sequel could be possible—let's talk about *why* they considered a sequel.

FLASHBACK

Well, because *Gladiator* made a ton of money and won a bunch of awards. Released in 2000, the film grossed a total of $457 million worldwide. *Gladiator* was nominated for seven Academy Awards and won five of them, including Best Picture and Best Actor (Crowe). It also won four BAFTA awards and two Golden Globes. It was a gigantic success for everyone involved—but they wanted more.

How do you give people more *Gladiator* if the Gladiator himself is dead?

ACTION!

One possible road for a sequel to take is sunny as can be and looks safe—it shouts "modest box-office return," and maybe "Best Costume Design Nomination." The other road is dark and morose. There are demons waiting to take possession of your soul as soon as you head in that direction. There's also an eerie humming coming from the sky, basically screaming, "Head this way, and you're as dead as Maximus."

Which road do you take?

1 171 minutes if you go with the extended cut.

If you're Ridley Scott, you take the sunny road and hire *Gladiator* screenwriter John Logan to write another story set in ancient Rome. If you're Crowe, who just finished winning an Academy Award for playing Dead Maximus, you throw your sunglasses on and speed down road number two. That road takes you to Australia and puts you face-to-face with singer Nick Cave—and you ask him to find a way to bring Maximus back to life.

Singer-songwriter Cave formed Nick Cave and the Bad Seeds in 1983. In 1988, he cowrote, scored, and starred in John Hillcoat's *Ghosts… of the Civil Dead*. The pair reunited for Hillcoat's violent 2005 Australian Western *The Proposition*. It was after the release of *The Proposition* that Crowe offered his very own proposition to the singer:

"At my signal, write *Gladiator 2*, bring Maximus back to life, and unleash hell."

And unleash hell Cave does. The screenplay opens with Maximus waking up in mud, his armor having been ripped off his body by a couple of thieves. A figure appears, scares them off, and reveals himself to be Mordecai, the keeper of peace.[2] From here, Maximus finds a temple where seven dissolute old men sit around a makeshift table.[3]

At this table, one of the men, Jupiter, informs Maximus that one of their own, Hephaestus, has turned his back on them and is spreading the word of a "higher being." Jupiter promises to reunite Maximus with his family if he tracks Hephaestus down and kills him. When Maximus does track the old god down, he finds himself back in Rome. *Alive*. And his son, Marius, is also alive, preaching the word of Jesus.

Lucius, Commodus's nephew, is brutally killing Christians all over the Roman countryside. Maximus joins the fight, and the Christians take on the Romans in a huge battle in the woods. Maximus and Marius kill Lucius. At this point, the story *could* end with Maximus living out his life as the father he never otherwise could have been, with the son who previously died at the age of seven. A happy ending for our *Gladiator* family.

But that's not at all how the story does end.

2 Back to these thieves: Mordecai scares one of the thieves off. He kills the other one . . . because he's the keeper of peace?

3 Their names: Jupiter, Apollo, Pluto, Neptune, Mars, Mercury, and Bacchus.

Maximus looks around at the carnage and wipes dirt on his hands, only to find himself on a different battlefield, surrounded by hundreds of crusaders in the Middle East.

Then he's on another battlefield. This one snowy, bloody, and more modern.

Then another battlefield, surrounded by armored tanks and automatic weapons; he finds himself in Vietnam, surrounded by choppers, flame-throwers, and carnage.

Then the movie ends after one more time jump: current day, inside the Pentagon. Maximus is now the secretary of defense. And we're (theoretically, at least) completely blindsided by this epic "war through the ages" montage we just saw.

CUT!

Nobody was blindsided by Crowe's decision to move on from Cave's script—not even Cave himself. In an interview with Marc Maron, Cave stated the following: "I enjoyed writing it very much because I knew on every level that it was never going to get made." [4]

Considering it was only Cave's second professional screenplay at the time, it's an interesting read. It's an ancient Rome–set story that at times can feel familiar yet fresh thanks to a unique "war vs. religion" theme and the twenty-minute "war through the ages" sequence. Only Nick Cave could lift us out of the confines of a "sword and sandal" epic and drop us right in the middle of Ken Burns's *Vietnam*.

In late 2018, it was announced that *Gladiator 2* would officially be moving forward with Ridley Scott and screenwriter Peter Craig (*The Hunger Games: Mockingjay Part 1* and *Part 2*). This version of the sequel will also feature the return of the young Lucius. Something, however, tells me he won't be a Christian-killing Roman in this one.

4 Episode 403 of *WTF with Marc Maron*.

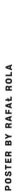

Anthony Hopkins in

The Diary of

Jack the Ripper

DIRECTED BY
William Friedkin

WILLIAM FRIEDKIN'S

THE DIARY OF JACK THE RIPPER

THE PLAYERS

Director
William Friedkin

Screenwriter
Christopher De Vore

Starring
Anthony Hopkins

Based on
The Diary of Jack the Ripper by James Maybrick

FADE IN

In spring 1995, director William Friedkin was working on two wildly different projects. *Jade*, his erotic thriller starring David Caruso, was a few months away from release. He was also wrapping up negotiations for what he planned to be his fifteenth feature film. The cult director was hoping to return to horror once again with an adaptation of *The Diary of Jack the Ripper*. *The Guardian*, his most recent (and, ultimately, his last) foray into the genre, had been plagued by a revolving door of script pages and production troubles.

On paper—and in the trades—*The Diary of Jack the Ripper* looked to be a return to horrific form for the director, but as we all know, looks can be deceiving.

FLASHBACK

By 1970, Friedkin had made a name for himself with his first four feature films: *Good Times* (1967), *The Birthday Party* (1968), *The Night They Raided Minsky's* (1968), and *The Boys in the Band* (1970).[1] The films had their fans, but they also had one critic—at least one critic Friedkin focused on. After discussing his filmography to date with legendary filmmaker Howard Hawks, Hawks told Friedkin his films were "lousy." The filmmaker convinced Friedkin to make a "good chase" film—and so he did.

The French Connection opened in fall 1971. The film immediately received rave reviews and is considered to have one of the best car chase sequences in the history of cinema. And *Connection* kept its foot on the gas all the way

1 Based on Matt Crowley's play of the same name, *Band* is an essential, and important, release in the history of LGBTQ cinema. Ryan Murphy (*Glee, American Horror Story*) announced plans to adapt the musical for Netflix in 2018.

to awards season: it was nominated for three Golden Globes, winning for Best Director and Best Actor (Gene Hackman), as well as eight Academy Awards in 1972, winning for five (Best Picture, Best Director, Best Actor [Hackman], Best Adapted Screenplay [Ernest Tidyman], and Best Film Editing [Gerald B. Greenberg]).

Armed with an arsenal of awards, Friedkin turned his head toward another adaptation. William Peter Blatty's *The Exorcist* was published in 1971 by Harper & Row. The novel follows two priests as they attempt to exorcise the demon out of the twelve-year-old daughter of a Hollywood actress. Blatty signed on to adapt the screenplay for Friedkin, who wanted to immortalize aspects of the book that were based on real life, specifically the exorcism of one "Roland Doe."

The Exorcist was released in December 1973, and it was an instant hit with audiences. Theaters were lined with moviegoers waiting to be scared out of their minds. Reports of fainting soon trickled out to the masses. *The Exorcist* had instantly staked a claim as one of the scariest movies ever made—and that still holds true to this day. The award-winning Friedkin had managed to deliver a film that has scared the pants off of multiple generations of filmgoers. Like it or not, he was now officially a master of horror. It would be seventeen years until he attempted to scare audiences again.

After *The Exorcist*, Friedkin churned out six other features before returning to horror in 1990: the underappreciated *Sorcerer*, *The Brink's Job*, the cult favorite *Cruising*, *Deal of the Century*, *To Live and Die in L.A.*, and *Rampage*. The filmmaker attempted to make nannies as horrifying as exorcisms with *The Guardian*, wherein a couple hire a nanny to care for their new baby and discover she might be Hamadryad (a mythological being that lives in trees and can die when the tree dies).

It's not exactly straight horror material. And it originally wasn't supposed to be. *Evil Dead*'s Sam Raimi was initially supposed to make the film, which would have been a more tongue-in-cheek-style thriller without the tree approach.[2] The story and screenplay changed multiple times throughout production, eventually resulting in a disappointing reception for the final film. Friedkin himself even stated he doesn't think *The Guardian* works. The director's much-heralded and promoted return to horror had backfired.

2 Which is probably for the best. We've all seen what Raimi can do with trees.

He followed up *The Guardian* with the basketball thriller *Blue Chips*, which also disappointed at the box office. Friedkin then again set his sights on the erotic-thriller genre, which he had first successfully navigated with *Cruising*. He jumped right into production on *Jade*, written by Joe Eszterhas and produced by Robert Evans. In *Jade*, an assistant DA investigates a brutal murder, where the suspect might be someone with whom he has a strong connection. The film was slated for a fall 1995 release, but given his recent luck, Friedkin couldn't afford to waste any time setting up his next film.

ACTION!

In 1992, Michael Barrett brought a journal into the public eye that appeared to be written by a former Liverpool cotton merchant named James Maybrick. Maybrick had died in 1889, poisoned by his wife, or "the whore," as she was described in the pages of the journal. Barrett wasn't presenting a journal about a man killed by his wife, however; what he was presenting was the diary. The diary that revealed who Maybrick truly was: Jack the Ripper.

Historians the world over reveled at the thought of this discovery. One of the most infamous serial killers of all time had finally been unmasked … Or had he? It was later revealed that Barrett forged the diary, ripping all hope that the Ripper had been identified away … until Barrett then flipped his own script again, affirming that he was lying about the forgery and that the diary was authentic. Much like Jack the Ripper, Michael Barrett's constant back-and-forth routine left authorities and historians in the dark. Regardless, Maybrick's, or Barrett's, diary was the kind of big-screen material that could attract major talent.

And it did. Friedkin was set to direct; Anthony Hopkins would star as James Maybrick; and Christopher De Vore wrote the screenplay. Let's break that all down.

The director of *The Exorcist* and the screenwriter of *The Elephant Man* were going to make a Jack the Ripper movie starring Hannibal Lecter. It would have been absolutely terrifying.

CUT!

Instead, this Jack the Ripper film was left lifeless in a back-studio alley.

The Diary of Jack the Ripper's biggest barrier to moving into production wasn't debate over whether or not the diary was authentic—it was a second Ripper film in development at a rival studio. That film was to be based off of Alan Moore and Eddie Campbell's graphic novel *From Hell*.

As we all know, *From Hell* was released in 2001, and *The Diary of Jack the Ripper* remained in development hell. What could have been one of the most horrifying films in years—and another chance for Friedkin to scare a new generation—turned into yet another genre "what if." As of 2003, Friedkin was still holding out hope to be able to make the film, but there hasn't been any movement since, making this project another White Chapel victim.

THE WACHOWSKIS'
PLASTIC MAN

THE PLAYERS

Directors
The Wachowskis

Screenwriters
The Wachowskis

Starring
Keanu Reeves

FADE IN

Before the explosion of high-profile, box-office-topping comic book films, lesser-known adaptations and characters had their day at the multiplexes: *Ghost Rider* hit screens in 2007, followed by a sequel in 2011. Jonah Hex saw his movie land in 2010. Even Iron Man, when he debuted in 2008, was considered a B-list character for Marvel.

Before connected universes and billion-dollar franchises, studios were much more willing to take long shots. In 2008, it was rumored that visionary filmmakers Lana and Lilly Wachowski would stretch their talents to tackle just such a long shot: DC's underwear-wearing Plastic Man.

Yes, *that* Plastic Man.

How could that costume ever be successfully translated to the big screen (much less his stretching powers)? It's basically a long-sleeve V-neck shirt held together by fishnet strings, and he wears white sunglasses, and his underwear is basically his outerwear. Decisions were made when he was created, and now the rest of us have to live in the DC universe with him.

So, let's dive in and find out exactly how the Wachowskis were going to pull this off, shall we?

FLASHBACK

Plastic Man made his comics debut in 1941, when he appeared in Quality Comics' *Police Comics No. 1*. Created by Jack Cole, Patrick "Eel" O'Brian was a crook who got a chemical bath during a robbery gone wrong. Taken in by monks at a monastery, O'Brian soon learns that the chemical has given his body all of the properties of rubber. A former criminal turned bouncing ball of energy, Eel renounces his criminal ways and becomes the superhero Plastic Man.

His powers? He can do anything with his body—like, say, bend backward and dodge bullets.

When it released in 1999, *The Matrix* showcased rubberlike traits itself, as it bounced all over the box office competition, bringing home a worldwide

total of $463 million. The science-fiction film follows a computer hacker who learns the reality of his, well ... reality. Played by Keanu Reeves, Neo discovers that the real world has been ravaged by machines, and that sinister agents are out to end the human rebellion, once and for all. A rebellion that he is now the face of, alongside Laurence Fishburne's Morpheus and Carrie-Anne Moss's Trinity. *The Matrix* won four Academy Awards and landed five BAFTA nominations, winning two (Best Science Fiction Film, Best Director).

The highly anticipated sequel, *The Matrix Reloaded*, arrived in theaters four years later, in 2003, grossing a stunning (at the time) $37.5 million on its Thursday night opening. It finished the weekend with $91.7 million, and ultimately went on to wrap up its world tour with $742 million. That's a $300 million jump from the first film. Unlike the first film, however, *The Matrix Reloaded* did not land any major awards nominations, much less awards. But it did get nominated for Best Kiss at the MTV Movie & TV Awards, and it also ... has vampires and werewolves in it? So ... take that, Academy.

Six months after *Reloaded* hit worldwide, *The Matrix Revolutions* was released across sixty countries on November 5, 2003. In this explosive finale to the series, Neo takes on a bunch of Smiths, and he and his rebellion win the war, ultimately rebooting the Matrix to save both man and machine alike.[1] Although our heroes saw victory inside the film (at great cost), out in the real world, it was a much different story—yet, just as costly. *Revolutions* grossed a (relatively) disappointing $427 million worldwide. That's a $300 million drop in worldwide totals. *Revolutions* would also be locked out of both award and Best Kiss nominations.

The Wachowskis then shifted gears to adapt the 1960s animated property *Speed Racer* for the big screen. Starring Emile Hirsch, Christina Ricci, John Goodman, Susan Sarandon, and Matthew Fox, *Racer* follows young Speed Racer (Hirsch) as he attempts to be the best driver in the WRL (World Racing League). Speed travels the world with his family and girlfriend, Trixie (Ricci), under the watchful eye of Racer X (Fox). After its own race in development hell, *Speed Racer* was finally released in 2008. With a budget

1 Speaking of *Matrix* reboots: In August 2019, Lana Wachowski signed on to direct a new *Matrix* film set to begin production in 2020. Reeves and Moss are both slated to return.

landing at a little over $120 million, *Racer* failed to make a mark at the box office—its worldwide total was $93.9 million.

Two months after the release of *Speed Racer*, rumors started to stretch across the internet about the Wachowskis' next film.

ACTION!

The Wachowskis originally wrote their *Plastic Man* script in 1995. Back then, Warner Bros. and Amblin Entertainment were both on board to produce the film. Steven Spielberg himself was even going to help bring the quirky superhero movie to life.

What were their plans for the film?

Written with its tongue all the way in its cheek, the *Plastic Man* screenplay is definitely aimed to attract laughs more than to raise questions about scientific accuracy. In the film, it's Daniel O'Brian instead of Patrick, and there's an environmentalist villain called Icarus Argon. After O'Brian breaks into Argon's labs, he becomes a test subject, with side effects that include rubber skin and red underwear. The entire film takes place over two days, as Argon becomes a true villain, out to turn the city into nothing but sludge, and O'Brian becomes a true hero out to clear his name and spread some good.

A little too outlandish, at the time, for the studio,[2] not to mention what kind of visual effects wizardry—and budget—it would take to make a man stretch naturally and convincingly on the big screen, Warner Bros. passed on the film. Fast-forward thirteen years: the Wachowskis have the visual effects proofs in *The Matrix* franchise and in *Speed Racer*, which together shows that *Plastic Man* can not only be made—it could also *work* on the big screen. Sprinkle in the rumors that Neo himself, Reeves, was ready to sign up to play Plastic Man, and you have a very interesting superhero movie.

Or do you?

CUT!

The film bounced around for a while, but development on it slowed to a halt not long after the Reeves rumors hit. There's no telling if the box office failure of *Speed Racer* hurt the film or if the Wachowskis just weren't that interested in making the film in the first place. Something that 100 percent

2 This coming from the studio that–checks notes–released *Batman Forever* in the same year.

didn't help? The massive success of Christopher Nolan's *The Dark Knight*. If you're Warner Bros. and you're considering giving Nolan the keys to the DC universe, you don't green-light a slapstick superhero film about a man with a rubber body.

The Wachowskis returned to the big screen in 2012 with the science-fiction film *Cloud Atlas*. As for *Plastic Man*? Rumors of a new film hit the web in 2018, when Warner Bros. hired writer Amanda Idoko to write a new version of *Plastic Man* for the silver screen. Chances are, this version could actually get made—especially after the success of another tongue-in-cheek DC superhero film: *Shazam*.

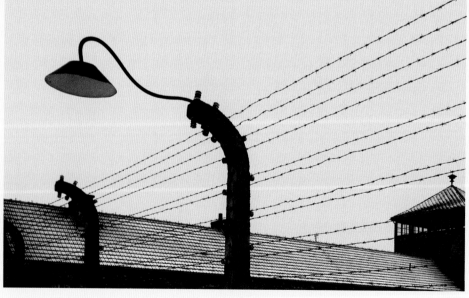

a film by Jerry Lewis

THE DAY THE
CLOWN
CRIED

a film by JERRY LEWIS "THE DAY THE CLOWN CRIED" starring JERRY LEWIS • HARRIET ANDERSSON • ANTON DIFFRING
edited by WIC KJELLIN production designer MAX DOUY director of photography RUNE ERICSON
story by JOAN O'BRIEN and CHARLES DENTON screenplay by JERRY LEWIS
produced by NAT WACHSBERGER directed by JERRY LEWIS

THE DAY THE CLOWN CRIED

THE PLAYERS

Director
Jerry Lewis

Screenwriters
Jerry Lewis,
Joan O'Brien, and
Charles Denton

Producer
Nat Wachsberger

Starring
Jerry Lewis

FADE IN

When discussing movies that were almost made, it's hard to leave *The Day the Clown Cried* out of the conversation. It's not only one of the most known about unmade films, but it also might be the most infamous: A movie about a clown leading children to the gas chamber. Fascinating? Sure. Great? Well, that "great" might be a bit of a stretch.

It's hard to imagine the world getting a movie about Nazis and the Holocaust from one of the greatest comedians to ever live, but here we are. Let's unpack the day—well, years—Jerry Lewis spent trying to make a clown cry, a project and experience that saw him abandon the film industry for nearly a decade.

FLASHBACK

Long before he became one of the first mainstream Hollywood filmmakers to attempt to bring the Holocaust to the big screen, Lewis was one of the original kings of comedy. He rose to fame performing with fellow comedian and improviser Dean Martin. The duo were a hit on several television programs in the late 1940s, which led them to land a larger deal with NBC in 1950. That same year, they turned their ensemble film careers into wildly successful partner films with projects like *The Stooge* (1952), *Living It Up* (1954), *Hollywood or Bust* (1956), and thirteen other successful entries. After 1956, the duo went their separate ways.

Lewis's first solo film was 1957's *The Delicate Delinquent*, a movie that he also produced and wrote.[1] Three years later, Lewis made his directorial

1 *The Delicate Delinquent* was originally a vehicle that was developed for Martin and Lewis before the partnership ended. Lewis was uncredited as the writer on the project; screenwriter Don McGuire received credit for the film, instead.

debut with 1960's *The Bellboy*. The film follows a hotel bellboy named Stanley (Lewis) who finds himself in hilarious predicaments with guests and other hotel folks. *The Bellboy* pays tribute to the old Stan Laurel silent comedies, resulting in Lewis's performance largely being pantomimed. The movie proved to be a huge success for Lewis, setting up his next two directorial efforts: 1961's *The Ladies Man* and *The Errand Boy*.

Formerly known primarily as a successful comedian, singer, and actor, Lewis was now proving himself as a director. Three films into his directing career, however, life was about to get downright nutty for the megastar.

Written by Lewis and Bill Richmond, *The Nutty Professor* follows the nerdy, awkward Professor Kelp as he invents a serum that turns him into a handsome jerk, Buddy Love. The film is a masterful parody of *The Strange Case of Dr. Jekyll and Mr. Hyde* that's still highly regarded to this day.

After a string of critically acclaimed comedies ended the sixties for Lewis, he entered the seventies with his mind on World War II. He directed and produced the war comedy *Which Way to the Front?*, written by Gerald Gardner and Dee Caruso. The comedy follows rich playboy Brendan Byers, who refuses to accept his 4-F classification from the army and rallies other 4-Fs to fight the war with him. War in general is an odd subject to make a comedy about, and the critical and audience reactions echoed that sentiment.[2] The negative reaction to *Which Way*, however, didn't sway Lewis from following up with another World War II–set film. At first glance, *The Day the Clown Cried* might seem like prime Lewis material: he was set to play a clown named Helmut Doork who brings joy to sad children. The complicating factor here is that the children are imprisoned in a concentration camp.

ACTION!

The Day the Clown Cried was originally written by Joan O'Brien and Charles Denton. Once Lewis signed on to direct and star in the film, he began rewriting it. While it was developed as a drama, Lewis not only wanted to ramp up the horrors of the Holocaust but also to give the material some comic relief with his Helmut performance.

2 Steven Spielberg learned this same lesson nine years later with his John Belushi/ Dan Aykroyd-starring war comedy, *1941*, which was likewise a critical and commercial disappointment.

As the script begins, Helmut, a former Ringling Brothers clown, finds himself down on his luck at the start of World War II. After multiple accidents as a lower-level clown, including a drunken outburst about Germany and Adolf Hitler, the Gestapo throw Helmut into a Nazi camp for political prisoners.

The years pass. The war rages on, as does Hitler's Holocaust. Loads of Jewish prisoners are sent to Helmut's camp. He performs for some of the children, but quickly learns that interacting with the prisoners is not allowed. A stubborn clown, even in his old age, Helmut continues to perform for the children. This decision leads to the brutal death of Helmut's only friend, Johann Keltner.

Afterward, the SS relent and allow Helmut to perform for the children—but only to help get them on the trains leading to Auschwitz. He ends up on the train with them, unknowingly headed to their deaths. Once at Auschwitz, Helmut is forced to lead the children into the gas chamber. Unwilling to face the end of his life as a Nazi pawn, and to avoid deceiving the only group of people still entertained by him, Helmut solemnly walks into the chamber, holding the hand of a young girl.

The loss of innocence is a central theme of the film. Obviously, many children lost their innocence, and their lives, in a horribly senseless manner. But there's also Helmut's naive reluctance to accept that his life has, figuratively and practically, been over for years; his entire life and career have been about bringing joy to people through performance, even in the most trying of circumstances. He sheds that innocent denial, however, before his life literally ends in Auschwitz. In his final moments, he gives everything he can to make death easier for the children; seeing that his joy and gifts are now a weapon of the Nazis, he only has one choice to make: defy the Nazis and take their power away, if only for a small moment.

The Day the Clown Cried began shooting in 1972, setting in motion a lifetime of headaches for the beloved Lewis.

CUT!

As if location issues and film equipment arriving late weren't challenging enough, Lewis had to deal with a lack of money coming in for *Clown*. Producer Nat Wachsberger not only owed money to O'Brien for the story rights, but he also owed money to the production. In order to finish the

film, Lewis paid $2 million out of his own pocket. But rights issues, and ongoing financial complications, resulted in more costly delays. Lewis kept a personal copy of the film so that it wouldn't be entirely lost to history; it was a valiant effort.

Rumors of a Cannes Film Festival premiere in 1973 were proven false, as O'Brien, the proper rights holder, definitively refused to approve Lewis's film. The legend of the movie grew over the years, irking Lewis in the beginning but fascinating him later in life. In the process, movie lovers of all stripes became captivated with trying to catch a glimpse of the film.

That glimpse may only be a few years away. Lewis donated a copy (of his copy) of *Clown* to the Library of Congress in 2015. He had one rule: The film could not be screened before June 2024. While no time line is known, the Library of Congress does in fact intend to screen the film at their Audio-Visual Conservation Center in Virginia. So keep your June 2024 calendar free.

After the devastating fallout of *The Day the Clown Cried*, Lewis took an eight-year break from filmmaking. He returned in 1980's *Hardly Working*, where he plays a circus clown who has trouble holding down jobs in the real world—a film that some might say serves as a wink to the comedian having been unable to hold down such a serious subject ten years earlier.

ALFRED HITCHCOCK'S
KALEIDOSCOPE

THE PLAYERS

Director
Alfred Hitchcock

Screenwriters
Benn Levy and
Alfred Hitchcock

FADE IN

Alfred Hitchcock is considered one of the greatest filmmakers ever to live—a true master of horror, suspense, and thrills responsible for some of the most well-known films in cinematic history. Sometimes that can be a blessing and a curse: a blessing if you have films like *Vertigo*, *Psycho*, and *The Birds* in your filmography; a curse if you release movies like *Marnie* and *Torn Curtain* after those iconic films.

After both *Marnie* and *Torn Curtain* failed to live up to the Hitchcockian-sized expectations, Hitchcock wanted to take audiences back to the days of *Psycho*; he wanted to get audiences talking again.

The quest to reclaim past glory, however, can sometimes be clouded more with desire than with reality. How far was Hitchcock willing to go in order to reclaim his audience?

Judging by the sounds of *Kaleidoscope*, he was willing to go as far as he needed.

FLASHBACK

A filmography as iconic as Alfred Hitchcock's doesn't require an extreme deep dive. He changed the thriller genre forever with his boundary-pushing filmmaking. Look at *Psycho*, a film that literally had promotional material in the theater forbidding spoilers. It also had moviegoers running for the aisles during its shower-scene death of Janet Leigh. It was shocking for a film released in 1960, and some might even say it's just as shocking now.

Psycho included many other extremes, at least at the time: the film opened with lovers in bed, featured Anthony Perkins as a cross-dresser, depicted brutal kills for the time, and included shots with Marion Crane in her bra and flushing a toilet.

Hitchcock fought with censors across the world in order to see the film released, and he, himself, handled the majority of the marketing for the film in order to preserve the twist. Critics would also have to see the film with the public in theaters, in an extra bid to #NotSpoilTheEndOfPsycho. The film

landed four Academy Award nominations, including a Best Director nod for Hitchcock and Best Actress for Janet Leigh. *Psycho* did not win any of the statues, but Leigh took home the Golden Globe for Best Supporting Actress.

The psychotic shine of the Hitchcock brand would soon take a public, and critical, beating with *Marnie* and *Torn Curtain*. Hitchcock once again became interested in only one thing: making a killing. And he set out to do just that in a new, extreme manner.

ACTION!

Kaleidoscope was to be an all-out slasher from the legendary director. The entire film would be like the shower scene from *Psycho*, multiplied by a factor of ten. The film would be set in New York City and follow bodybuilder Wille Cooper. Cooper is handsome, charming, and strong. He also just happens to be a serial killer. He has a set modus operandi: have sex with women by the waterfront and then kill them.

What would separate *Kaleidoscope* from the rest of Hitchcock's filmography? Aside from the hundreds of camera techniques he was developing for the movie, the film was going to be filmed entirely from the perspective of Wille Cooper; it would have been a point-of-view slasher film that put the audience in his shoes.[1]

After initially asking *Psycho* author Robert Bloch to write the screenplay for *Kaleidoscope*, Hitchcock had to turn to writer Benn Levy when Bloch found the material too disturbing. Hitchcock himself then wrote a version of the screenplay. The director shot an hour's worth of test footage for the film, which included naked women and New York scenery.

Kaleidoscope would have included scenes with rape, murder, and necrophilia. It was also rumored to have one of the most brutal opening kills ever to appear on-screen. It seemed the legendary director was once again ready for the old shock-and-awe treatment. The problem was, he was one of the only ones . . .

1 While *Kaleidoscope* wouldn't have been the first movie to take this approach–Michael Powell's 1960 film, *Peeping Tom*, is believed to be the first POV slasher film–it's hard to imagine the murder maestro not bringing something new to the table.

KALEIDOSCOPE

From the mind of Alfred Hitchcock

CUT!

Longtime friend and supporter François Truffaut was concerned over the subject matter in the film—and he wasn't alone. Universal refused to finance the picture, even though its budget called for less than $1 million. Hitchcock was at the end of his rope when it came to *Kaleidoscope*.

Bits and pieces of the screenplay ended up in his 1972 thriller, *Frenzy*. Hitchcock then moved to direct the comedic crime thriller *Family Plot* in 1976. While he failed to bring his seventies slasher to life, other violent, brutal slashers found their way to the big screen with 1974's *The Texas Chain Saw Massacre* and 1978's *Halloween*—both proving, in their own ways, that the master of horror was once again ahead of his time.

In 2012, Franck Khalfoun remade William Lustig's cult slasher film *Maniac*. The film starred Elijah Wood as Frank the maniac, and the entire film was from Frank's perspective. While not a bodybuilder, Frank does build a pile of bodies in the film. A fantastic remake that completely reimagines the original film, *Maniac* also gives a glimpse of what could have been with *Kaleidoscope*.

A CLOCKWORK ORANGE STARRING THE ROLLING STONES

THE PLAYERS

Director
Si Litvinoff

Starring
The Rolling
Stones

Based on
*A Clockwork
Orange*
by Anthony
Burgess

FADE IN

Before Stanley Kubrick set his sights on adapting Anthony Burgess's *A Clockwork Orange*, there was a wildly different version floating around—one that would have been unique in its very own way. And one that would have most likely not given as much satisfaction as the Kubrick classic.

Let's approach that version from the point of view that Stanley and Malcolm never made their version of the novel; let's try to picture just what *A Clockwork Orange* would have been like if Mick Jagger and the Rolling Stones had had their way in the early sixties.

Viddy well, reader. Viddy well.

FLASHBACK

In 1963, the Rolling Stones hired former Beatles client Andrew Loog Oldham as their manager. Oldham didn't want to re-create the Beatles with the Stones; he wanted to go against them in every aspect. John, Paul, Ringo, and George were clean-cut, suit-wearing darlings at the time, and Oldham made the Stones out to be the exact opposite.

He wanted the world to know that the Rolling Stones were the new bad boys of rock and roll. Which is easy enough to deliver from the image-management end, but the Stones still had to be able to *rock and roll*—and that they did.

Their first album, *The Rolling Stones*, was released in 1964. The twelve-song LP landed the band at number one on the UK Albums chart and topped out at number eleven on the US Billboard 200. There were two singles released from the album: "Not Fade Away" and "Tell Me." "Fade" landed at number three on the UK Singles chart and forty-eight on the Billboard Hot 100, while "Tell Me" landed at twenty-four on the Hot 100.

The same year, the Stones released their second studio album, *12 x 5*. That second album went gold and landed at number three on the Billboard 200. The two singles from *12 x 5* were "It's All Over Now" and "Time Is on My Side." "Over Now" peaked at twenty-six on the Billboard Hot 100, and "Time" at number six.

While the Stones were quickly rising up the music charts, two other notable events were happening.

First, Anthony Burgess released his ninth novel, *A Clockwork Orange*, in 1962. The dystopian tale follows Alex DeLarge as he maneuvers through a society overflowing with violence, particularly in the youth. As Alex and his droogs get into trouble and listen to a little Ludwig Van, Alex's leadership comes into question. It all comes to a head when the group robs a wealthy woman and betrays Alex afterward, leaving just him to face the consequences of the robbery, rape, and accidental (?) murder of the woman.

Alex is arrested and convicted of murder. A few years into his sentence, he undergoes the behavioral correction process known as the Ludovico Technique. This technique is developed both to curb violent thoughts and to make the patient ill simply at the *thought* of violence. After suffering through the Ludovico Technique, Alex is believed to have been cured of his violent tendencies and is released from prison. His past continues to catch up with him, however, as he encounters everyone we've seen him do wrong. Unwilling to live with his current state or with his past decisions, Alex attempts to kill himself.

His attempt is unsuccessful, and he's admitted into a mental institution, where the doctors cure him of the Ludovico impulses. He's once again ready for some ultraviolence, as well as a bit of the ol' in-and-out.

The book was met with controversy and was banned in schools across the United States.

The second notable event? Two years after the release of *A Clockwork Orange*, the Beatles starred in the feature film *A Hard Day's Night*.[1] Both events had the attention of Rolling Stones manager Oldham.

1 For more on *A Hard Day's Night*, check out the *Lord of the Rings* portion of this book on pages 163-167.

WRITTEN BY TERRY SOUTHERN

STARRING MICK JAGGER AND THE ROLLING STONES

A CLOCKWORK ORANGE

POSTER BY LAURA STREIT

ACTION!

In his quest to out-Beatle the Beatles, Oldham attempted to purchase the film rights for *A Clockwork Orange* from Burgess. Oldham had already sold the band as the edgier, more dangerous version of the Fab Four, so why not try to get the Stones their own edgier, more dangerous movie? Oldham wanted Mick Jagger as Alex DeLarge and the rest of the band as his droogs.

Well, you can't always get what you want: Oldham discovered the rights to *A Clockwork Orange* had already been purchased by producer Si Litvinoff, and so Oldham's dream of giving the Stones the Ludovico Technique came to an end.

In 1967, however, *Their Satanic Majesties Request* cover photographer Michael Cooper began working on an adaptation of *A Clockwork Orange* with Terry Southern. Southern had written *Dr. Strangelove or: How I Learned to Stop Worrying and Love the Bomb* for Stanley Kubrick. After a casting and directorial merry-go-round, Cooper found himself in the director's chair for the project. That version of the adaptation died when the UK's lead film censor, British Lord Chamberlain, rejected the controversially violent and subversive script.

Litvinoff retained the *Clockwork* rights, adding to Oldham's dream of casting Jagger as DeLarge. He approached *Midnight Cowboy* director John Schlesinger to helm the film, pitching Jagger as Alex and an original score from the Beatles. Litvinoff wouldn't fare viddy well in his attempt, and Schlesinger passed.

After failing to attract Schlesinger, Litvinoff finally locked in a director.

CUT!

Kubrick, at long last, signed on to direct the adaptation of *A Clockwork Orange*, but he had no interest in casting Jagger or in featuring any of the Rolling Stones in the film. The role of Alex DeLarge, instead, went to Malcolm McDowell. Released in 1971, Kubrick's *A Clockwork Orange* was met with the same controversy as the novel. The film was banned in multiple countries, and Kubrick himself banned repertory screenings until his death in 1999.

Jagger didn't have to wait long for his starring role after *A Clockwork Orange* didn't clockwork out. In 1970, he starred as Ned Kelly in director

Tony Richardson's *Ned Kelly*. The film was poorly received, and is one of Richardson's least acclaimed films.

Kubrick's *A Clockwork Orange*, controversy aside, was well received and acclaimed, garnering four Academy Award nominations, seven BAFTA nominations, a Directors Guild of America nomination, and three Golden Globe nominations.

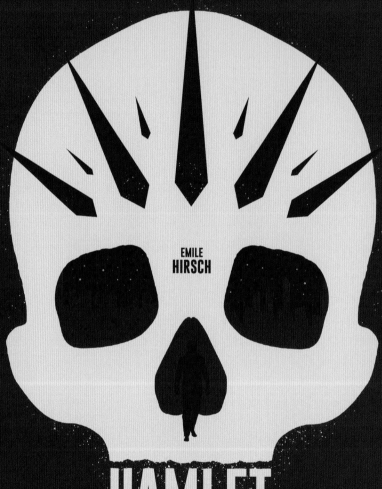

LISTEN TO **MANY**, SPEAK TO A **FEW**.

EMILE
HIRSCH

HAMLET

CATHERINE HARDWICKE

CATHERINE HARDWICKE'S

HAMLET

THE PLAYERS

Director
Catherine
Hardwicke

Screenwriter
Ron Nyswaner

Starring
Emile Hirsch

Based on
Hamlet by
William
Shakespeare

FADE IN

Before she began directing, Catherine Hardwicke was a highly sought-after production designer known for her work on the films *Tank Girl*, *Three Kings*, and *Vanilla Sky*. That background in design makes the tease of her tackling an all-out horror movie even more intriguing.

FLASHBACK

In 2003, Hardwicke made her directorial debut with *Thirteen*. Based on the experiences of actress Nikki Reed, *Thirteen* follows Tracy (Evan Rachel Wood) as she navigates her relationship with her mother (Holly Hunter) and experiments with sex, drugs, and crime alongside her best friend, Evie (Reed). The film premiered at the Sundance Film Festival, where Hardwicke won the Sundance Directing Award. Fox Searchlight acquired the film out of the festival. Holly Hunter landed an Academy Award nomination for her role as Tracy's mother, Melanie Freeland.

After replacing Fred Durst (yes, *that* Fred Durst),[1] David Fincher was attached to direct *Lords of Dogtown*, the fictionalized version of the award-winning documentary *Dogtown and Z-Boys*. Fincher stepped away from the director's chair but remained on as producer, with Hardwicke now signed on to direct. Her fictional version of *Dogtown* starred Emile Hirsch, Heath Ledger, Victor Rasuk, Johnny Knoxville, Nikki Reed, and others.

Hardwicke left the *Z-Boys* and went to . . . Bethlehem. *The Nativity Story* is a biblical drama that follows Mary (Keisha Castle-Hughes) and Joseph (Poe Dameron) as they travel to Bethlehem to give birth to the original "Lord of Btown."

1 After directing music videos for Limp Bizkit and Puddle of Mudd, Durst turned his attention to feature films with 2007's critically acclaimed *The Education of Charlie Banks* starring Jesse Eisenberg. From there his camera kept rollin', with Ice Cube in *The Longshots* (2008) and John Travolta in *The Fanatic* (2019).

From there, Hardwicke took on the story of another religious couple (at least in some circles): Edward and Bella.

Stephenie Meyer's novel *Twilight* was published in 2005. It was on the *New York Times* bestseller list within a month of release. A film adaptation had been guaranteed before it was even published, as it was optioned by MTV Films in 2004. Unable to develop a product everyone was happy with, MTV ceded the option to Summit Entertainment three years later.

Hardwicke was hired to direct, and *Step Up* screenwriter Melissa Rosenberg was brought on as screenwriter later that year. The pair worked tirelessly on the film, as a potential WGA writers' strike was approaching. After a massive casting process, Kristen Stewart and Robert Pattinson won the roles of Bella and Edward—and the rest is history.[2]

Twilight was a massive success when it released into theaters in 2008. Its worldwide opening landed at $392 million. A sequel was all but guaranteed for Hardwicke and company, but just ended up being guaranteed "for company." Citing budget restraints and scheduling issues, Hardwicke turned down the offer to return to the *Twilight* franchise for *New Moon*.

Instead, Hardwicke found herself free to pursue new projects, and with huge box office clout behind her.

ACTION!

In 2009, it was reported that Hardwicke would reteam with her *Lords of Dogtown* star Emile Hirsch for a new take on William Shakespeare's *Hamlet*. In this most famous of all tragedies, Hamlet mourns the death of his recently murdered father. Soon after the death, Hamlet's mother marries his uncle Claudius. When the ghost of Hamlet's father appears, telling him Claudius poisoned him, Hamlet sets out to find the truth, setting in motion a grisly drama filled with twists and turns—and, of course, murder.

The contemporary take on the tale would have been Hardwicke's *Twilight* follow-up and Hirsch's dramatic answer to *Speed Racer*. The pair was determined to make it a horrific reunion. Developing the updated *Hamlet* together, the duo brought on *Philadelphia* screenwriter Ron Nyswaner to write the screenplay.

What did the trio have planned for the classic Shakespeare story?

2 In an alternate-history version of *Twilight*, Bella is played by Jennifer Lawrence and Edward by Dave Franco. Both were up for the original film.

Hardwicke's *Hamlet* would take place at an East Coast liberal arts college. Hirsch's Hamlet would return home on break to find his father murdered. From there, the story was filled with the similar twists and turns of the original tragedy—just given a modern horror makeover. Both Hardwicke and Hirsch talked up the horror aspect of the film, even citing Stanley Kubrick's *The Shining* as a big influence.

CUT!

Despite having the box office receipts of *Twilight* on her résumé and one of the most promising young actors in Hollywood attached to her project, not to mention an Oscar-nominated screenwriter, Hardwicke could not find funding. She went on, instead, to make *Red Riding Hood*, starring Amanda Seyfried, a return to the "young adult horror" genre.[3] On the other side of the skull, Hirsch wouldn't get his horror kick in until 2016's *The Autopsy of Jane Doe*.

While it's disappointing that this version of *Hamlet* never made it to the big screen—well, never say never. Horror is riding its highest wave in years, and with companies like A24, Blumhouse, and more funding interesting genre projects with A-list talent, a Hardwicke/Hirsch "*Shining*-esque" version of *Hamlet* could easily get made down the road.

As Shakespeare would say, "If it be not now, yet it will come."

3 Shiloh Fernandez (*Evil Dead [2013]*) plays Amanda Seyfried's love interest in the film. Fernandez was also a finalist for the role of Edward in *Twilight*.

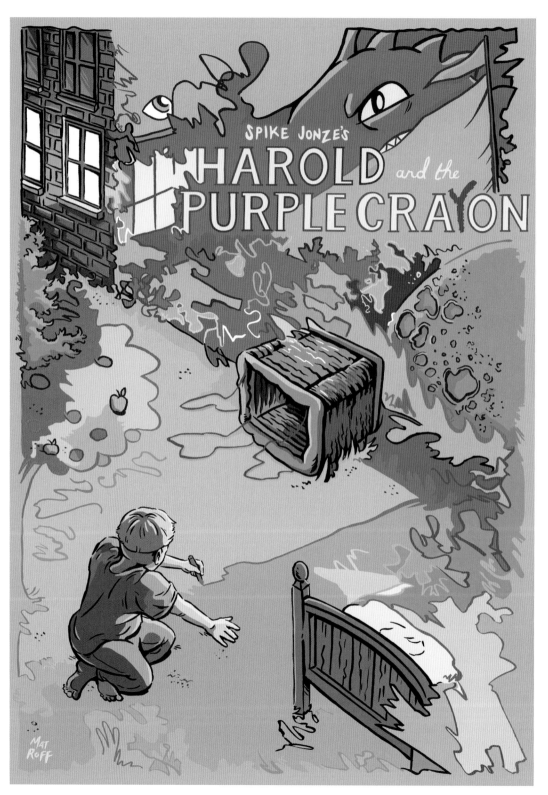

HAROLD AND THE PURPLE CRAYON

THE PLAYERS

Director
Spike Jonze

Screenwriter
Spike Jonze

Producer
John B. Carls

Based on
Harold and the Purple Crayon by
Crockett Johnson

FADE IN

Most cinematic journeys don't start with the Beastie Boys—more specifically, with the Beastie Boys as the stars of a fake 1970s cop show. But Spike Jonze hasn't taken the traditional journey. From music video auteur to a debut director offering a unique look inside the mind of John Malkovich to a seasoned director telling a beautiful love story between Joaquin Phoenix and an artificially intelligent operating system, Jonze has always been a creator forging his very own path with imagination and panache.

Just like a kid named Harold.

FLASHBACK

Jonze started out in the early nineties making skate videos, and eventually made a promotional video titled *Video Days* that found its way into the hands of Sonic Youth member Kim Gordon. Gordon was impressed, and the band hired Jonze to contribute footage for their music video for "100%."

In 1994, the Beastie Boys asked Jonze to direct the video for the lead single off their fourth studio album, *Ill Communication*. The song was "Sabotage," a more rock-heavy track for the hip-hop group at the time. Jonze and the Beasties spent their days hanging out in the studio or at an apartment watching reruns of famous cop/detective series from the 1970s, like *The Streets of San Francisco*, *Baretta*, and *Starsky & Hutch*. From these shows, Jonze spawned the idea of the group re-creating one for the "Sabotage" video. From there, they went full guerilla-filmmaking with the video—no permission and no rules.[1]

1 Hopefully they did go full insurance: they destroyed two cameras while making the video.

Their "Sabotage" music video was an instant hit, and later it was nominated for five MTV Video Music Awards at the 1994 VMAs:[2] Video of the Year, Viewer's Choice, Best Direction in a Video, Best Group Video, and Breakthrough Video. It lost out on all five awards, losing three of them to Aerosmith and the other two to R.E.M. What the "Sabotage" video *did* win, however, was the attention of producer John B. Carls.

Carls and author Maurice Sendak had a fresh new production deal with TriStar Pictures to make family-friendly content. The pair were looking for a director to adapt Sendak's *Where the Wild Things Are* into a feature film. Carls set his sights on the filmmaker who had just destroyed two expensive cameras while filming everything illegally—and who had his video censored for violence when it played on MTV.[3] Jonze, a bit of a wild thing in his own right, hit it off with the author and the producer.

Alongside *Where the Wild Things Are*, Carls and Sendak secured the rights to a number of other properties that could be developed under the agreement. While still primarily interested in adapting *Where the Wild Things Are*, the pair had their eyes on Jonze for another book they'd optioned: the story of a four-year-old boy and his purple crayon.

ACTION!

Originally published in 1955, *Harold and the Purple Crayon* tells the story of Harold, a curious four-year-old who can draw anything he wants with the purple crayon he carries around. Written and illustrated by Crockett Johnson, the book became an instant classic and soon grew into a seven-book series. Jonze was only interested in one of them.

Jonze officially came on board to write and direct the film in 1995. He planned to combine live action with animation in a way that had never been done before, and had a team of production designers and storyboard artists prepping the film. From all accounts, *Crayon* would have been a visual feast that was slated to include a third-act finale with Harold riding a cartoon

2 We laugh about this now, but once upon a time, the VMAs were instrumental in getting music videos, and their directors, out into the world. Mark Pellington (*The Mothman Prophecies*), Tarsem Singh (*The Cell*), F. Gary Gray (*Set It Off*), Jonathan Glazer (*Under the Skin*), Jonas Akerlund (*Lords of Chaos*), and Joseph Kahn (*Bodied*) have all won Video of the Year at the VMAs.

3 Family. Friendly. Content.

rocket into space in order to save a *real-life* space mission gone awry. If only Jonze had the right crayon for when *productions* go awry.

CUT!

Two months before principal photography was originally scheduled to begin, TriStar completely backed out of the film; a change-up in executive staff at TriStar resulted in Jonze's bold vision for the film being shut down. While not much is known about the script or story details, there are two minutes of black-and-white test footage available online.

Unwilling to compromise any further than he already had, Jonze walked away from the film and returned to the world where he had more control: music videos. Jonze's strong visual sense and quirky sense of humor led to continuous offers to direct studio comedies,[4] but Jonze knew what he wanted to make: he was holding out hope to make a bizarre comedy about John Malkovich from a relatively unknown writer named Charlie Kaufman. And he would; Jonze's feature-filmmaking debut, *Being John Malkovich*, was released in 1999. The film earned three Academy Award nominations, including a Best Director nod for Jonze.

Harold and the Purple Crayon was adapted into a television show for HBO in 2002. In December 2016, it was announced that author Dallas Clayton would write the screenplay for a new, CGI adaptation of the book for Sony Pictures Animation.

As for Jonze and those *Wild Things*? It took fifteen years and a ton of hurdles for the rumpus to start—but his *Where the Wild Things Are* finally hit the big screen in the fall of 2009.

It's the kind of ending a purple crayon could draw.

4 Imagine this movie: *Ace Ventura: When Nature Calls* directed by Jonze. Picture that rhino birth scene Jonze-style. Alrighty then . . . (Luckily, he turned it down.)

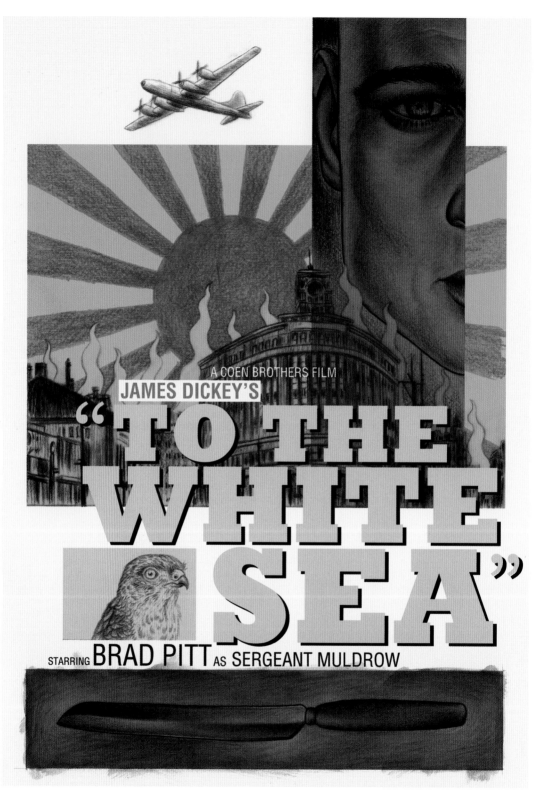

TO THE WHITE SEA

THE PLAYERS

Directors
The Coen
Brothers

Screenwriters
David and Janet
Peoples; the Coen
Brothers

Starring
Brad Pitt

Based on
To the White Sea
by James Dickey

FADE IN

As Joel and Ethan Coen wrapped up work on the Billy Bob Thornton–starring *The Man Who Wasn't There*, they were already well on their way to the white sea. A script for the adaptation of James Dickey's novel had hit the town back in 1996, from screenwriters David Webb Peoples and Janet Peoples. The pair were known for writing Terry Gilliam's 1995 time-travel thriller *12 Monkeys* (as a solo writer, David was known for writing Ridley Scott's *Blade Runner* and Clint Eastwood's *Unforgiven*). After years of trying to get the film made, producer Richard Roth (*Blue Velvet*, *Manhunter*) had finally found the team to bring another Dickey tale to the big screen.

FLASHBACK

The film adaptation of Dickey's first novel, *Deliverance*, hit theaters in 1972. Dickey himself adapted the screenplay for the film.[1] Directed by John Boorman, the film starred Burt Reynolds, Jon Voight, Ronny Cox, and Ned Beatty as a group of friends on a canoeing trip at the Cahulawassee River in northern Georgia. While on the adventure, the group of men have a horrific encounter with the backwoods locals of the area; in order to survive the ordeal, they're forced to take survival into their own hands. The film earned three Academy Award nominations, for Best Picture, Best Director, and Best Film Editing.

Twenty-three years later, Dickey's third novel, *To the White Sea*, was published. Drawing upon his own experience as a pilot in World War II, the author spun a tale of an American gunner, Muldrow, who is shot down over Tokyo in 1942. Muldrow sets out on foot to make it back home to Alaska alive, leaving a trail of dead bodies behind him. A violent tale of survival and desperation, the novel is a wartime companion to *Deliverance*.

Ready for war, the Coens began to shape their story and recruit their troop.

1 Dickey also appears in the film as Sheriff Bullard.

ACTION!

After signing on to direct the film, the Coens tackled a rewrite of David and Janet Peoples's existing screenplay. Their script immediately shows us how tough and hard-nosed Muldrow is; in an early scene, he's challenged by a mouthy recruit who calls him "the big nip-knocker," "little man," and "little prick" in the span of six lines of dialogue. Muldrow proceeds to put the man (Arlen) in his place by beating him in a chin-up challenge.

From here, we meet a redheaded recruit, aptly named "Red," and get to know more about Muldrow, particularly how prepared he is. He tells Red he won't rely on matches because they run out. Flint and steel are what keep him ready and what keep him alive. He proves his point by striking them together, sparking a flare.

THERE'S PLENTY OF FIRE IN THE ROCKS.
ALL YOU WANT.
-MULDROW, *TO THE WHITE SEA*

It might be one of the only moments in the entire script to show Muldrow as more than just a survivor and a killing machine. He can also be a mentor when need be, but make no mistake: he is 100 percent a survivor and a killing machine. Once he's gunned down into the burning landscape of Tokyo, Muldrow's violent journey home begins. Yes, it's brutal, and there's killing of humans and animals throughout the script, but the screenplay is rife with potentially breathtaking imagery—imagery that would once again be seen through the eye of legendary cinematographer Roger Deakins for the film. Deakins had just shot *O Brother, Where Art Thou?* and *The Man Who Wasn't There* for the brothers. He was also just coming off of Ron Howard's award magnet *A Beautiful Mind*.

With the screenplay and Deakins in tow, the filmmakers needed to lock in their Muldrow, and they needed someone who could carry a violent war movie with very little dialogue—someone audiences trusted to take them on a journey. They offered the role to one of the biggest movie stars in the world, Brad Pitt. This marked the first time the filmmakers worked with Pitt. *To the White Sea* would be his *Ocean's Eleven* follow-up, ensuring the actor would leave one ocean for another.

To the White Sea had an estimated budget of $80 million. Preproduction continued on the film, with an eye on filming in 2001—and then a bomb was dropped on the project.

CUT!

As the budget and production grew, so did concerns over the film's budget. Regardless of the cast and crew, $80 million is a big chunk for a nearly wordless film that follows one man on a warpath. Sure, that one man is Brad Pitt, but this would be his first film for audiences after his lovable Rusty Ryan in *Ocean's Eleven*. Would moviegoers shell out their hard-earned money to see Pitt savagely kill, skin, saw off the head, and cook a white swan?[2]

That's a big ask.

The Coens continued to flirt with the film for years, but they've never had luck it getting it made. In 2007, Ethan Coen told *Time* magazine that Brad Pitt was too old for the role at that point.

The Coens went on to make the George Clooney and Catherine Zeta-Jones crime comedy *Intolerable Cruelty* instead (Roger Deakins served as director of photography on the film). As for that much-anticipated Coen/Pitt collaboration? It finally happened in 2008, when Pitt played the sunshiny but doomed gym worker Chad Feldheimer in *Burn After Reading*.

In 2015, it was reported that Warner Bros. now owned the rights to the novel and were moving forward with a new adaptation. No further developments, however, have been released since.

2 Don't worry: the swan gets a good shot in on Muldrow's cheek.

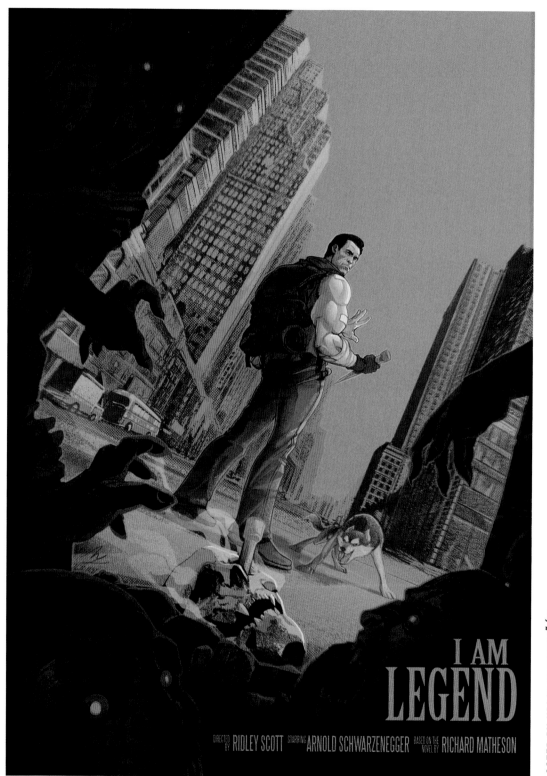

I AM
LEGEND

DIRECTED BY RIDLEY SCOTT STARRING ARNOLD SCHWARZENEGGER BASED ON THE NOVEL BY RICHARD MATHESON

I AM LEGEND

THE PLAYERS

Director
Ridley Scott

Screenwriters
Mark Protosevich
and John Logan

Starring
Arnold
Schwarzenegger

Based on
I Am Legend by
Richard Matheson

FADE IN

June 1997: Warner Bros. was gearing up for the release of their newest *Batman* movie, *Batman & Robin* (the latest adventure in Gotham that featured Uma Thurman as Poison Ivy and Arnold Schwarzenegger as Mr. Freeze). While the world was once again in Bat-mode, Warner Bros. was plotting a legendary remake, with a legendary director behind the scenes.

Unfortunately, all legends come to an end.

FLASHBACK

Leading up to *Batman & Robin*, the studio had high hopes for a much different Schwarzenegger movie: they were gearing up for a new version of Richard Matheson's vampire novel *I Am Legend*, and *The Cell*'s screenwriter, Mark Protosevich, had delivered a script that had all of Hollywood wanting to sink in their fangs.

Schwarzenegger signed on to star as Robert Neville, the last human survivor of a plague that has otherwise turned all of humanity into a nation of bloodsuckers. The film required a director who not only could tell a human story, but also one who had experience with horror. Not long after Arnold came on board, Ridley Scott signed on to direct the *I Am Legend* update.

The prospect of the *Alien* director tackling a film that would see one of the world's biggest action stars square off against vampire hordes was an exciting one—but was it a realistic one? It had been decades since Scott had worked in the horror genre. On top of that, it had been six years since critics had really connected with his work. His latest film, *G.I. Jane*, was two months away from release, and lackluster initial buzz wasn't exactly screaming, "Give this guy a blockbuster vampire movie!"

Jane tells the story of Jordan O'Neill (Demi Moore), following her journey as she trains to be the first female to make it in the elite Navy Seals selection program—the Combined Reconnaissance Team. With everyone expecting her to fail, O'Neill sets out to prove everyone wrong. Success

versus failure would remain a strong theme connecting *G.I. Jane* and *I Am Legend*.

Published in 1954, *I Am Legend* is one of the most influential horror novels of all time. Pushing growth and change in the genre, the book is often cited as having had an overwhelming impact not only on vampire and zombie lore, but also on postapocalyptic tales in general. Prior to Scott tackling the project, *I Am Legend* had been adapted twice: first by 1964's *The Last Man on Earth*, starring Vincent Price, and again by 1971's *The Omega Man*, starring Charlton Heston.

After the lackluster response to Scott's previous two films, *1492: Conquest of Paradise* and *White Squall* (and the soon-to-be lackluster response to *G.I. Jane*), Scott was out to prove he was, in fact, legend. He just ended up proving it in a way he never expected.

ACTION!

Regardless of how much the studio liked Protosevich's screenplay for *I Am Legend*, Scott himself was not too keen on it. Scott brought in screenwriter John Logan to do a rewrite. Logan turned the first half of the screenplay into an almost "silent arthouse" film, with minimal dialogue or speech from Schwarzenegger's Neville as he roams around a deserted Los Angeles. Logan and Scott also returned the Hemocytes, the creatures from the book, into bloodthirsty, feral creatures. At one point, Neville captures a female Hemocyte and brings it back to his lab as humanity's last hope for a cure.

Across the lot at Warner Bros., production had been shut down on Tim Burton's *Superman Lives*, so Scott brought in *Superman Lives* concept artist Sylvain Despretz to create the apocalyptic landscape of Los Angeles for *I Am Legend*. If you were to look at Despretz's *Legend* art without knowing what it was for, you'd most likely think it was for an unproduced Terminator film: there's Schwarzenegger, there's an LA wasteland, and there's unmanned military vehicles.

Clearly a *Terminator* film, that is, until you see Despretz's art for the Hemocytes—his approach there was inspired by burn and starvation victims, as well as by illness-riddled bodies (Scott intended to use CGI to give the horrifying creatures a more skeletal appearance).

While Despretz and a team of artists worked away on concept art and storyboards, Scott was also working with Studio ADI on creature effects and

tests. Known for their work on *Tremors, Alien 3, Jumanji, Mars Attacks!,* and *Alien: Resurrection,* special effects artists Tom Woodruff Jr. and Alec Gillis tested a number of different creature designs. In 2013, they released video of all of the creations. "Legendary" is one word for the designs. "Terrifying" is another.

But, in the end—much like the Hemocytes themselves—Scott's *I Am Legend* remained in the dark.

CUT!

As the budget grew, so did concerns over the tone and approach to the film. To genre fans, sure—an R-rated vampire flick from Scott, starring Schwarzenegger, sounds like a sure thing. But a $100 million (and rising) vampire movie from the director whose last movie was *G.I. Jane,* starring the man who just played a major part in cooling off the *Batman* franchise, wasn't.

Warner Bros. had just shut down production amid an ever-expanding budget and several controversies surrounding *Superman Lives.* If the Man of Steel hadn't been safe from the ax, you can be damn sure a Hemocyte wouldn't be, either.

In March 1998, *I Am Legend* became "I Am Shut Down."

All was not lost for Scott and screenwriter Logan, however: After production came to a stop, the pair packed their bags for ancient Rome, where Russell Crowe and a $100 million budget were waiting for them. The five-time Academy Award–winning *Gladiator* hit theaters just two years later.

As for *I Am Legend* and Robert Neville?

Will Smith and director Francis Lawrence finally brought a third official adaptation to theaters ten years later. The film opened to a massive $77 million at the domestic box office and finished with a total of $585 million worldwide. This version of *I Am Legend* took place in New York. In its very own fun *Underexposed!* moment, when Smith's Neville is driving through Times Square, there's a billboard for Wolfgang Peterson's doomed *Batman v Superman.*[1]

In 2014, Warner Bros. announced they were rebooting *I Am Legend* yet again, but no further updates have been shared.

1 Peterson was originally slated to inherit a *Batman v Superman* script written by *Se7en* screenwriter Andrew Kevin Walker. The script was too dark for the studio, so they had Akiva Goldsman rewrite it for the *Troy* director.

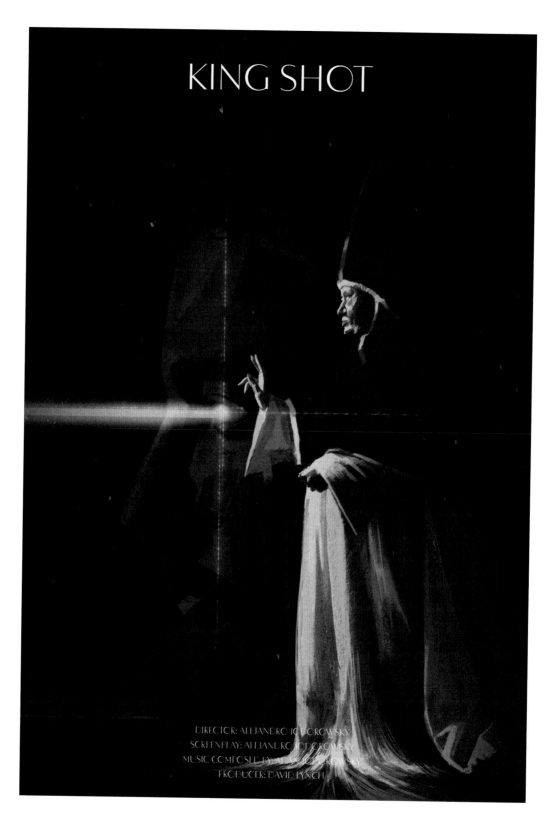

KING SHOT

DIRECTOR: ALEJANDRO JODOROWSKY
SCREENPLAY: ALEJANDRO JODOROWSKY
MUSIC COMPOSED BY: ALEJANDRO JODOROWSKY
PRODUCER: DAVID LYNCH

ALEJANDRO JODOROWSKY'S
KING SHOT

THE PLAYERS

Director
Alejandro
Jodorowsky

Screenwriter
Alejandro
Jodorowsky

Producer
David Lynch

Starring
Nick Nolte,
Marilyn Manson

FADE IN

Alejandro Jodorowsky is an icon of filmmaking. The Chilean director is heralded by critics and fans the world over for his vivid and surrealistic films. It's that same surrealism that has been known to hinder and delay his productions as well—but Jodorowsky remains a figure not afraid to live in the success (and failure) of projects.

There's his attempted sequel to *El Topo*, known as *The Sons of El Topo/ Abel Cain*. The sequel would have seen El Topo's sons, Cain and Abel, attempt to bury their mother in the paradise within the middle of a nuclear wasteland while fighting technology and destiny. The sons of El Topo were to be played by Johnny Depp and Marilyn Manson, but Jodorowsky couldn't attract funding for the project. There's also his planned fourteen-hour adaptation of Frank Herbert's *Dune* (more on that below).

And then there's *King Shot*.

But before we get to *that* desert epic, let's look back on our first Jodorowsky desert experience.

FLASHBACK

In 1970, Jodorowsky introduced the world to *El Topo*, a film the director also starred in. Jodorowsky's acid-soaked Western follows the titular mysterious gunslinger El Topo as he wanders the desert with his son. On the journey, he and his son encounter a ransacked village, where all the villagers have been left for dead. He finds the bandits who attacked the village and kills all but one: the woman Mara. It's here where our philosophical journey through the desert begins, as Mara tasks El Topo with killing four gun-masters. He's successful but is shot himself by a mysterious woman in black. Left for dead, Topo is saved by cave-dwelling dwarves. When he awakes, he discovers the dwarves and mutants now consider him to be a godlike figure. From here, there's murdering cultists, an El Topo revenge campaign, and finally, his death.

After *El Topo*, Jodorowsky scaled *The Holy Mountain* in 1973. In the same way that *El Topo* touched on religion, *The Holy Mountain* follows another godlike character as he—along with eight others—are led to enlightenment. The group attempts to overthrow the mountain and achieve immortality.

"GOODBYE HOLY MOUNTAIN, REAL LIFE AWAITS."

El Topo and *The Holy Mountain* have both become cult classics, serving as inspiration to countless films and filmmakers. In a weird twist of fate, however, Jodorowsky's unmade films have proven to be just as influential.

Jodorowsky's vision exists almost on an entirely different plane of existence—one where colors and geometric shapes smack you in the face. There are auteurs, and then there's Jodorowsky, the only filmmaker who would ever dream up casting Marilyn Manson as a three-hundred-year-old pope.

ACTION!

Jodorowsky announced in 2009 that *King Shot* would be his next feature film—his first since 1990's *The Rainbow Thief*. Described as a "metaphysical spaghetti western of gangsters," *King Shot* was set to star Nick Nolte and Manson, and to be produced by David Lynch.

Three things to note about *King Shot*:

1. As previously mentioned, Manson was cast as a three-hundred-year-old pope who runs a casino in the middle of the desert. That casino? It's shaped like the head of Jesus.

2. There would have been a man the size of King Kong.

3. Concept art depicts giant skeleton bones in the desert, as well as two flamingos pulling a giant gun called "King Shot."

JodorWOWsky. (Sorry.)

CUT!

As with *Dune* and *The Sons of El Topo*, Jodorowsky was yet again unable to secure funding for *King Shot*. It's a cinematic crime that the world doesn't have more Jodorowsky films to get swept away in, as he's only made and released seven feature films since 1968. Mostly, it's a cinematic crime that

we never got to see two flamingos pulling a giant gun.

In 2018 and 2019, comic book adaptations of *The Sons of El Topo/Abel Cain*, written by Jodorowsky with art by José Ladrönn, were released by Archaia. Jodorowsky has also announced plans to adapt *King Shot* into comic book form.

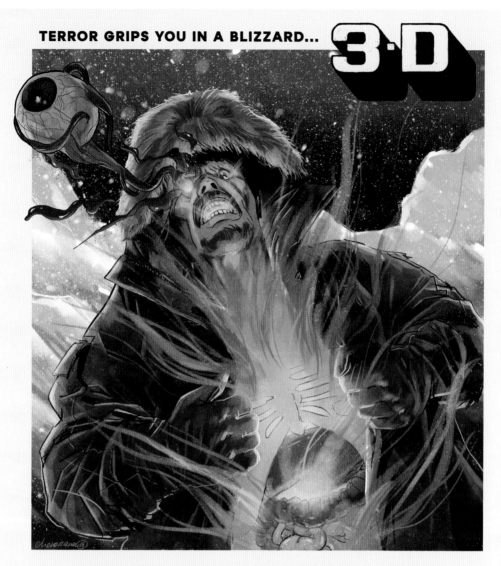

TERROR GRIPS YOU IN A BLIZZARD... **3-D**

FROM THE DIRECTOR OF DOG SOLDIERS AND THE DESCENT

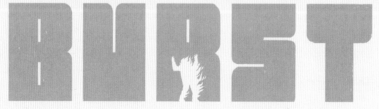

PRODUCED BY SAM RAIMI

WRITTEN BY GARY DAUBERMAN DIRECTED BY NEIL MARSHALL

LIONSGATE AND GHOST HOUSE PICTURES RELEASE

NEIL MARSHALL'S
BURST 3-D

THE PLAYERS

Director
Neil Marshall

Screenwriters
Gary Dauberman
and Terrance
Mulloy

Producers
Sam Raimi and
Rob Tapert

FADE IN

Spontaneous combustion is a horrifying way to go, and would absolutely be a horrible thing to see. So, of course, *Evil Dead* creator Sam Raimi, *Evil Dead* franchise producer Rob Tapert, and genre filmmaker Neil Marshall were planning on making an entire horror movie based around it.

Oh—and they also wanted it to be in 3-D. Because *of course*.

FLASHBACK

Marshall burst onto the scene in 2002 with his directorial debut, *Dog Soldiers*. The film follows a routine military exercise in the Highlands of Scotland, an area brimming with local horrific folklore. The team soon learns the truth about the area from a zoologist they cross paths with: werewolves, once chalked up to old campfire stories, do exist, and a full moon is about to rise. *Dog Soldiers* is a throwback—practical-effects-driven horror at its finest.[1]

The success of, and enthusiastic reaction to, *Dog Soldiers* led to a number of horror offers for Marshall. He agreed to tackle *The Descent*, a horror film about a group of people who go spelunking and come across cave-dwelling creatures, for his follow-up film. Originally, *The Descent* was going to be a mixed cast of men and women, but the filmmaking team chose to defy the conventions of the horror genre and focus exclusively on a female-driven creature-feature.

The Descent was a huge success for Marshall. The film earned a total worldwide gross of $57 million during its 2005 theatrical release, and has since landed on a number of all-time-best horror lists throughout the years (*The Descent*'s impact on contemporary horror, in particular, has been hard to ignore). Like most successful horror films, a sequel was immediately put into development. Although he stayed on as an executive producer, Marshall

1 Image FX handled the practical effects on the film. Their last produced credit was 2008's *The Black Balloon*.

chose not to return as writer or director on *The Descent: Part 2*.[2] Instead, he focused on a futuristic doomsday scenario.

Doomsday—inspired by classic movies like *Mad Max*, *Escape from New York*, and *A Boy and His Dog*, as well as more recent films like *28 Days Later*—was Marshall's third feature. The film follows a military team who must travel into a virus-riddled Scotland and find a cure. As you might expect, the team is met with hostility—as was the film when it was released. *Doomsday* barely made its budget back on release.

A return to form was needed for Marshall. Lucky for him, horror master Raimi and screenwriter Gary Dauberman had the perfect project.

ACTION!

Venturing into the unknown was an early staple of Marshall's films: the soldiers heading into the mysterious Highlands of Scotland; a group of friends spelunking into uncharted caverns; the military venturing into an apocalyptic Scotland. Throw a bunch of strangers, who have to find a way to survive, out in a blizzard and you have the making of a classic Marshall film. (Just don't forget the exploding guts and gore.)

Burst 3-D had a simple setup: a group of stranded travelers meet during a blizzard and are stalked by a malevolent force that makes people spontaneously combust. Our characters are literally picked off one by one as they try to figure out what is causing these people to explode (in 3-D!). They end up at a military base and discover the culprits: aliens.

Burst 3-D could have been an instant genre classic. Imagine sitting in a theater surrounded by other horror fans. You throw on your 3-D glasses and adjust them over the brim of your nose. The lights go down and you see a snowy landscape. The cold scene sends a shiver down your spine before the names Sam Raimi, Neil Marshall, and Rob Tapert even appear. Within a few moments, you see bodies explode in gory goodness all over the screen. You cheer and high-five the complete stranger next to you. You . . . notice that person is your middle school science teacher, Mr. Williams, who told you spontaneous combustion wasn't a real thing, so "quit freaking out about

2 *The Descent: Part 2* was written by James McCarthy, J. Blakeson, and James Watkins. It was directed by Jon Harris, the editor on the first film. Shauna MacDonald returned for the sequel and reprised her role as Sarah. Natalie Mendoza also returned as Juno.

it." You point at the screen in a "Looks pretty real to me" sort of way.[3] He informs you it's not even a real movie, so why are you imagining watching a fake movie with him?

Mr. Williams has a point.

CUT!

Burst 3-D seemed to combust all on its own. The project appeared to still be in development well into 2012. Marshall signed on to direct *The Last Voyage of the Demeter* later that year (another Marshall project that never happened). Unfortunately, all word on *Burst 3-D* has exploded into silence, except for one post from Reddit user EDoftheDEAD in 2015: "Whatever happened to Sam Raimi and Neil Marshall's Burst 3-D?" The question remains unanswered.

Marshall went on to make the early second-century war film *Centurion*, starring Michael Fassbender, Olga Kurylenko, and Dominic West. From there, he found a home on a number of high-profile television sets, including *Game of Thrones*, *Hannibal*, and *Westworld*. He's been attached to a number of interesting films throughout the years that have been stuck in development hell, including an American remake of the Norwegian hit *Trollhunter*.[4] He also had a segment in the 2015 anthology *Tales of Halloween*. Marshall's name returned to the multiplex in 2019 with his *Hellboy* reboot.

Burst 3-D went from a potential new genre favorite to a script collecting dust on the shelf at Lionsgate, bursting all of our collective horror hopes. Screenwriter Dauberman, however, has since been responsible for writing horror hits *Annabelle: Creation, It, It Chapter 2, The Nun*, and *Annabelle Comes Home* (which he also directed). Maybe there's still hope for this splatterfest to see the light of day.

3 Author Larry E. Arnold wrote a book called *Ablaze!* in 1995. In the book, he states there have been around two hundred reports of spontaneous human combustion worldwide "over a period of three hundred years."

4 *Trollhunter* was directed by André Øvredal. In October 2019, Øvredal signed on to direct *The Last Voyage of Demeter*, the same film Marshall was supposed to direct when he left *Burst 3-D*.

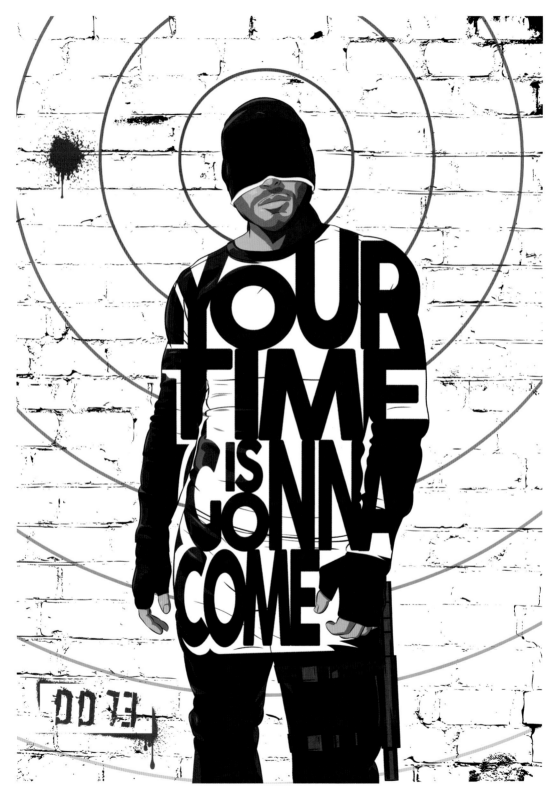

YOUR TIME IS GONNA COME

JOE CARNAHAN'S

DAREDEVIL TRILOGY (DAREDEVIL 1973, DAREDEVIL 1979, DAREDEVIL 1985)

THE PLAYERS

Director
Joe Carnahan

FADE IN

The Devil of Hell's Kitchen found himself behind cinematic bars after his big-screen debut in 2003's *Daredevil*. It wasn't that the film was bad, per se—it just missed the mark. Comic book movies weren't what they are today, and certainly not what they are *expected* to be today. There was no MCU, no DCEU—hell, Christopher Nolan and Jon Favreau wouldn't even release their first genre-changing films for another five years. But in the there-and-now of 2003? Ol' Hornhead had street-level expectations.

While director Mark Steven Johnson's big-screen adaptation of *Daredevil* had some honorable marks—including a fantastic performance by Michael Clarke Duncan as the Kingpin—it didn't take a blind person with heightened senses to see the movie wasn't the big-screen debut *Daredevil* fans had been dreaming about since Matt Murdock captured their imagination. Fans were promised an edgier, grittier comic book film that would be more in line with Marvel Comics' Bronze and Modern age incarnations of the character and his surroundings, but what they got was a Valentine's Day massacre.[1] Ten years later, it was announced that Joe Carnahan would tackle an R-rated *Daredevil* film set in the seventies. Would fans finally get the kind of adaptation the Man Without Fear deserved?

Well...

1 *Daredevil* was released in theaters on February 14, 2003.

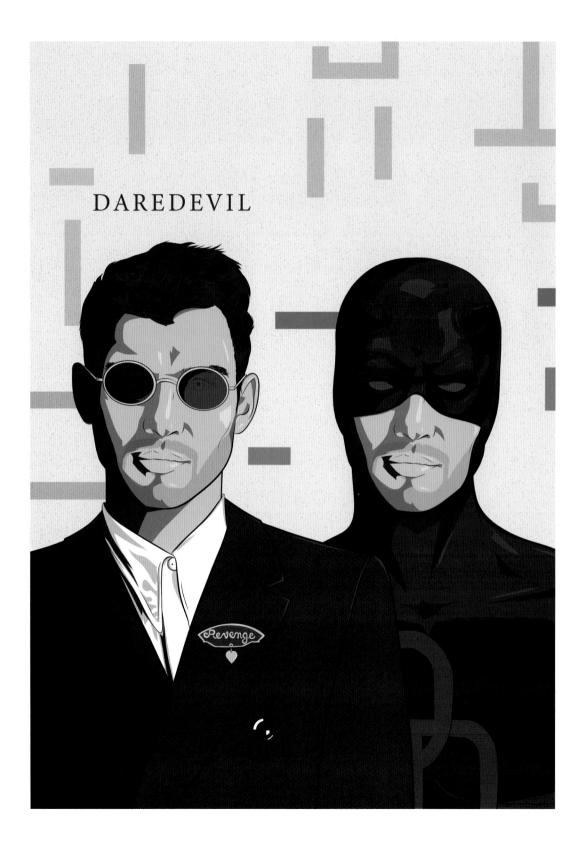

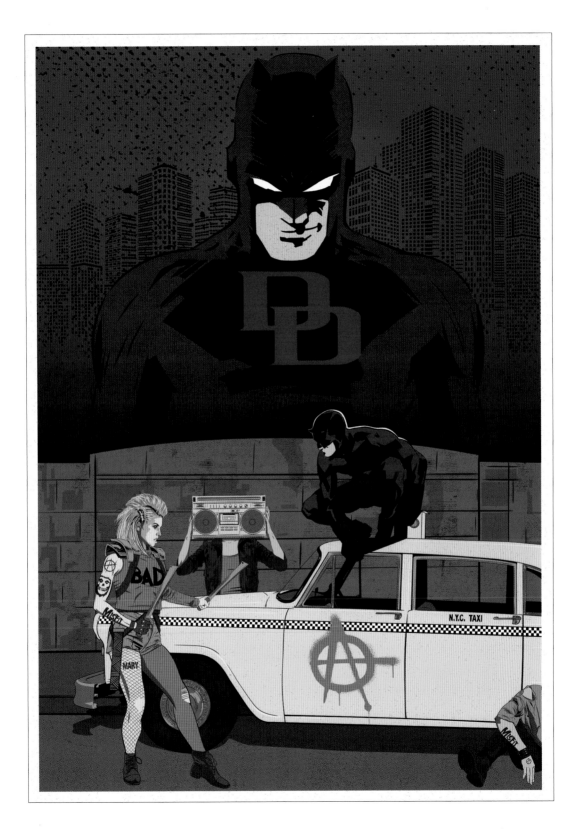

FLASHBACK

Daredevil made his Marvel Comics debut in 1964's *Daredevil*, no. 1. Created by Stan Lee, Bill Everett, and Jack Kirby, Matt Murdock is blinded when radioactive goo covers him after saving a pedestrian from a reckless truck. The substance heightens all of his senses—well, all of them except sight. After his boxer father, Jack Murdock, is killed, Matt grows up as an angry orphan, blinded not just by chemicals but also by rage. He learns how to fight using his heightened senses and becomes Daredevil, a vigilante watching over Hell's Kitchen.

Johnson's film was viewed as a modest success at the time. Its $45 million opening was the second-biggest February release ever, up to that point, and it came close to a worldwide gross of $200 million. It even spawned an *Elektra* spin-off.[2] There was even talk of a *Daredevil 2* at one point. Daredevil himself, Ben Affleck, said he'd only return if they adapted the darker, more mature stories. Soon after that, he said he'd never play a superhero again.

Soon after that, Affleck signed on to play Batman.

20th Century Fox continued to develop a new, Affleck-less *Daredevil* story to tell, but the closest they got to production was with *30 Days of Night* director David Slade and *Fringe* writer Brad Caleb Kane. That went up in smoke when Slade dropped out. The Man Without Fear became the Man Without Franchise, and things were about to get worse for ol' Hornhead. Fox had until October 10, 2012, to get a new film in production or else lose the character rights. 20th Century Fox needed a smoking ace in their pocket—and they almost got one.

Carnahan's filmmaking debut, *Blood, Guts, Bullets & Octane*, screened at the Sundance Film Festival in 1998. Carnahan wrote, directed, shot, produced, and acted in this car-dealership comedy about two salesmen in way over their heads. From there, he tackled the Jason Patric/Ray Liotta thriller *Narc*. In 2007, Carnahan's rambunctious third feature, *Smokin' Aces*, was released in theaters. *The A-Team* landed in 2010, setting in motion a back-to-back Liam Neeson adventure for Carnahan. In 2011, the critically and financially successful wolf thriller *The Grey* helped the filmmaker hit a bull's-eye on his next project.

2 If you look at your TV and say "Elektra" five times, it might *actually* come on.

ACTION!

In August 2012, Carnahan—armed with a sizzle reel and a pitch for a new take on Daredevil—walked into a meeting with executives at 20th Century Fox. Carnahan's pitch was heavily influenced by the legendary *Born Again* run from Frank Miller and David Mazzucchelli, but it also referenced Sidney Lumet's Oscar-nominated cop thriller *Serpico*. Carnahan wanted to take the Devil of Hell's Kitchen back to the seventies for the first film in his proposed trilogy.

The three films would take place in (and most likely be subtitled with the years) 1973, 1979, and 1985. Much like Johnson promised, this *Daredevil* was gritty and violent—and it would definitely be rated R. Carnahan also had a plan on how to make each film have its very own identity. Each entry's thematic arc would be influenced by the music of the era: 1973 would be "classic rock," 1979 would be "punk rock," and 1985 would be "new wave."

Carnahan had a proper grasp on the character and setting of *Daredevil*—he just had the wrong villain. Kingpin wasn't the one to take down the Man Without Fear, nor was Bullseye, Typhoid Mary, the Purple Man, the Owl, Stilt-Man, or Gladiator. His greatest nemesis turned out to be none other than Father Time.

CUT!

20th Century Fox knew time was running out, but they loved Carnahan's pitch. They asked for an extension on the production deadline, but that extension was declined by Marvel Studios. With less than two months to go until their October 10 deadline and no time to properly prep the film, Fox was forced to accept their fate: *Daredevil* was returning home to Marvel Studios. On April 15, 2015, *Daredevil*, the series, premiered on Netflix. The show lasted three seasons before being canceled in 2018. Eight years after returning home, Daredevil's future was once again up in the air.

After leaving Hell's Kitchen, Carnahan took a wild ride with Patrick Wilson, Ed Helms, and Brooklyn Decker in 2014's *Stretch*. His incredible sizzle reel for *Daredevil* is widely available online for your viewing pleasure (*and pain . . .*).

STEVE MARTIN MARTIN SHORT

David Lynch's
ONE SALIVA
BUBBLE

DAVID LYNCH'S
ONE SALIVA BUBBLE

THE PLAYERS

Director
David Lynch

Screenwriter
Mark Frost and
David Lynch

Starring
Martin Short,
Steve Martin

FADE IN

In the late 1980s, David Lynch nearly made a comedy about saliva. Not so surprising. The shocking aspect? *One Saliva Bubble*'s lineup had comedy legends Steve Martin and Martin Short. So what happened?

The details will make you salivate for this unmade comedy.

FLASHBACK

After the success of *The Elephant Man*, Lynch was offered the director's chair on a wide variety of projects, including *Return of the Jedi*. He turned down the actual *Star Wars* franchise for what some over the years have billed as "*Star Wars* for adults": *Dune*. Although he had never read the book, or even knew the story of *Dune*, Lynch accepted the offer to direct the big-screen adaptation for producers Dino and Raffaella De Laurentiis.

After a strenuous postproduction process, Lynch disavowed *Dune* altogether. Some versions of the film give directing credit to Alan Smithee, the classic pseudonym attribution given on films that directors disown. Although he had a miserable experience making *Dune*, Lynch did enjoy working with the De Laurentiises. He stayed in the De Laurentiis business—with one caveat: on his next film he would have complete creative control and final cut.

The result was the astounding *Blue Velvet*.

Shot for only $6 million, *Blue Velvet* saw *Dune* star Kyle MacLachlan partner again with Lynch to play the lead role of Jeffrey Beaumont. After returning to his hometown of Lumberton, North Carolina, Jeffrey finds himself in the middle of a small-town mystery involving a severed ear, a beautiful nightclub singer, and a mob of criminals who have kidnapped her child.

Blue Velvet also stars Isabella Rossellini as the mysterious singer Dorothy Vallens and Dennis Hopper (*Easy Rider*) as the sadistic Frank Booth—a role

turned down by Harry Dean Stanton because of its violent content. Nineteen-year-old Laura Dern played the innocent Sandy Williams.[1]

Blue Velvet was released on September 19, 1986, after premiering at the Montreal World Film Festival in August. The film opened at ninety-eight theaters across the country and grossed $789,409. *Blue Velvet* went on to gross a total of $8,551,228 over its theatrical run, with Lynch receiving an Academy Award nomination for Best Director.[2]

Bluer than velvet was the night for Lynch and the De Laurentiis partnership as they once again began work on a new film.

ACTION!

Lynch and *Twin Peaks* co-creator Mark Frost spent 1987 working on the screenplay for a bizarre comedy called *One Saliva Bubble*. In the film, a small saliva bubble escapes from the mouth of a guard at a secret government facility, resulting in a chain reaction that unglues an entire town.

After goofing around near an open control panel, the guard's one tiny saliva bubble enters the exposed wiring, signaling a countdown for an unknown weapon. The town of Newtonville is then hit with a laser twenty-four hours later, striking nearly every citizen in town.

At the Newtonville airport, the four leads—contract killer Horton Thursby, town laughingstock Newt Newton, Swiss scientist Hugo Zinzermacher, and family man Wally Newton—are dramatically changed by this bouncing military beam, as the laser somehow switches their minds. Hugo Zinzermacher becomes the laughingstock, Newt Newton lands the brains of the scientist, Wally gets the mind of a killer, and psychopath Horton gets a family.

This scenario leads to mayhem all across the town of Newtonville. The military eventually discover what has happened and have to figure out a way to reverse the accident before permanent damage is done—not to mention government secrets revealed.

Production was moving forward at the speed of a bouncing laser beam. Locations had been scouted for the town of Newtonville and casting was well underway. Martin Short and Steve Martin came on board to star in the film. Martin was coming off a considerably strong year after the release of

1 Helen Hunt and Molly Ringwald were both considered for Sandy.
2 Oliver Stone won the statue that year for *Platoon*.

Roxanne and *Planes, Trains and Automobiles*. Short had followed up *Three Amigos* with two films that failed to connect at the box office in 1987: the Steven Spielberg–produced, Joe Dante–directed science-fiction comedy *Innerspace* and the romantic comedy *Cross My Heart*, co-starring Annette O'Toole.

One Saliva Bubble would give the friends the chance to get back to the comedic hijinks of *Three Amigos*. It would also give Lynch the chance to flex a different kind of directing muscle—and maybe even have a little fun.

CUT!

The possibilities were endless for *One Saliva Bubble*; cashflow, however, was not.

Production came to a halt when the De Laurentiis Entertainment Group went bankrupt. In August 1987, after a string of box office let-downs, the company was $16 million in debt. Dino retained a controlling interest, but Raffaella left the company altogether. The De Laurentiis Entertainment Group saw a number of their projects released by different studios until 1992.[3]

After *One Saliva Bubble* crumbled, Lynch and Frost shifted their collective focus toward writing the pilot for a TV show about an FBI agent investigating the murder of a young woman in the small town of Twin Peaks. The series premiered on ABC on April 8, 1990, and gained a cult following. After the series was canceled in 1991, Lynch

3 Some of these "lost to other companies" titles include Stan Winston's *Pumpkinhead* and Stephen Herek's *Bill & Ted's Excellent Adventure*.

OVEREXPOSED!
DAVID LYNCH

Lynch has always been known to push the boundaries of cinema with his surreal approach to filmmaking, art, and life. Sometimes that approach isn't the easiest to digest, much less find funding for. Here's a brief look at two other Lynch films too curious for reality.

***RONNIE ROCKET*:** The most-known unmade Lynch film, *Ronnie Rocket* followed a detective's quest to enter the second dimension. Throughout this journey, he's followed by electric "Donut Men." There's also the titular teenage dwarf Ronnie Rocket, who becomes a rock star. These are all *very* normal things. Lynch had trouble finding financing for the film, so he moved on to make *The Elephant Man*.

***DREAM OF THE BOVINE*:** In 1994, Lynch set out to make a screenplay he cowrote with *Twin Peaks* writer Robert Engels called *Dream of the Bovine*. Inspired by the Marx Brothers, the film followed three men who used to be cows but are now human. The thing is, they all still act like cows. Harry Dean Stanton was eyed for one of the cow-men.

followed it up with the feature-length prequel, *Twin Peaks: Fire Walk with Me*. In 2017, the show was revived again on Showtime with *Twin Peaks: The Return*—a return that saw MacLachlan's Dougie experience *One Saliva Bubble*–like personality swaps.

VINCENZO NATALI'S

NEUROMANCER

THE PLAYERS

Director
Vincenzo Natali

Screenwriter
Vincenzo Natali

Based on
Neuromancer
by William Gibson

FADE IN

The cybernatural *Neuromancer* has proven to be the white whale for a number of filmmakers throughout the years. A precursor to *The Matrix* and other science-fiction stories dealing with forces out of the control of humans is prime real estate for an eye-catching cinematic experience. It's the type of film that attracts a visionary filmmaker looking to adapt challenging material.[1]

But *what* exactly is *Neuromancer*?

FLASHBACK

Published in 1984, the novel follows Case, a computer hacker, or "console cowboy," who steals from the wrong people. Kicked out of the network and forced to live his life as a regular human, he's offered a chance at redemption by the mysterious Armitage. Soon after, Case finds himself facing off against a powerful AI. The book was the first novel to simultaneously win the Philip K. Dick Award, the Hugo Award, and the Nebula Award; it's an action-packed feast of technological and visual possibilities, which explains why a filmmaker like Vincenzo Natali pursued it.

Arriving on the scene in 1997 with his directorial debut, *Cube*, Natali showed a penchant for a visionary filmmaking unlike any of his other contemporaries. The science-fiction-horror film follows six strangers as they wake up inside a giant cube filled with thousands of potential rooms. The six soon discover they each bring a different skill to the table that can keep them alive when traps littering the cube threaten their collective demise. It's very much a precursor to James Wan's *Saw*, minus the tricycle-riding dummy. *Cube* was a huge hit for Natali, launching two sequels: 2002's *Cube 2: Hypercube* and 2004's *Cube Zero*. A third sequel, *Cube 3-D*, was rumored,

1 Example: Denis Villeneuve seeking out a new adaptation of *Dune*.

but never found its way out of the development maze.[2] (Natali was not involved in either of the sequels.)

After the success of *Cube*, Natali directed the science-fiction thriller *Cypher* in 2002. The film follows a bored worker who takes a new job as an industrial spy at the company Digicorp. He travels the country recording speeches at conventions until he meets a woman who turns his entire life upside down, and he soon finds himself in a downward spiral of conspiracies and brainwashing. The film garnered comparisons to Philip K. Dick and *The Matrix*, leading Natali further down the path toward *Neuromancer*. A year later, Natali made *Nothing*, an experimental flip-side version of *Cube*, about two men stuck in a blank void.

During a seven-year break from features, Natali made a documentary about the making of Terry Gilliam's *Tideland*, but by 2009 he was ready to return to science-fiction horror with *Splice*. He did so with the producing powerhouse team of Joel Silver, Don Murphy, and Guillermo del Toro.

Starring Adrien Brody, Sarah Polley, and Delphine Chanéac as the human/animal hybrid Dren, the film follows two reckless genetic engineers who splice together the DNA of different animals to create a new one. After their work is shut down, they continue the process in secret by splicing human DNA with the genetic blend they created, in order to break new ground in science. They instead break new ground in horror.[3]

While not a massive box office success, *Splice* did more than enough for Natali to prove he could bring the visual and thrilling goods to challenging material. It was time for the director to head into the matrix.

ACTION!

In June 2010, Natali was officially announced as the new director of *Neuromancer*, replacing *Torque*'s Joseph Kahn. In the press release for the announcement, Peter Hoffman, head of Seven Arts Pictures (which was funding the project), specifically pointed out the director's use of effects on *Splice* proved that Natali could translate the story successfully to the big screen.

Natali himself strayed away from comparing his take on the film to *The Matrix*, instead bringing his influence closer to the grounded approach of

2 In 2015, Lionsgate announced a remake of *Cube* from director Saman Kesh called *Cubed*; however, development stalled in 2016.

3 And Brody breaks new ground in cinematic sex scenes.

NEUROMANCER

POSTER BY ALEKSEY RICO

Blade Runner. He would approach the human relationship to technology in *Neuromancer* the same way he approached the human relationship to science and DNA in *Splice*. (So, yeah, there was definitely going to be some interface intercourse.)

Preproduction was scheduled to begin in 2011. The film even had A-list stars like Mark Wahlberg and Liam Neeson circling the starring role. It seemed that after nearly thirty years of waiting, Gibson would finally see his novel on the big screen.

Then out of nowhere, the server was disconnected.

CUT!

After five years of development on the film, Natali left *Neuromancer* in 2015. No reason was ever given, but it was most likely a classic case of "creative differences." The announcement was a disappointing turn for a project that had so much promise at the beginning. Instead, the filmmaker directed 2013's time loop horror film *Haunter,* as well as episodes of the *Hannibal* TV show in 2014.

In 2017, *Deadpool* director Tim Miller was announced as the next director to take on the infamous *Neuromancer* project. Production on the film is scheduled to begin after Miller wraps up his 2019 science-fiction offering, *Terminator: Dark Fate*.

OVEREXPOSED!
NEUROMANCER

Neuromancer has had on-again/off-again relationships throughout its publication history. Here's a brief rundown of three other almost-*Neuromancers*.

CABANA BOYZ ENTERTAINMENT: A production company consisting of the wife of a plastic surgeon and two cabana boys optioned the novel for $100,000 in 1986. In an effort to raise money for the film, they made an infomercial featuring Gibson, psychedelic guru Timothy Leary, and *Buckaroo Banzai* screenwriter Earl Mac Rauch hyping *Neuromancer*. As you can already guess, the video didn't work for Cabana Boyz Entertainment.

CHRIS CUNNINGHAM: Famed music video director Chris Cunningham was set to make his feature directorial debut in 2000 with *Neuromancer*. The director, best known for his science-fiction-themed work with artists Björk, Aphex Twin, and Portishead, collaborated with Gibson on the screenplay. Aphex Twin was even on board to score the cyberpunk thriller. In the end, Cunningham became too weary of the studio system and walked away from the project.

JOSEPH KAHN: The second music video director to attempt a big-screen adaptation of *Neuromancer*. In 2007, Kahn took control of the system and began plotting his take on the property. Milla Jovovich signed on to star in the film, while *Star Wars* prequel star Hayden Christensen was rumored to join her in the role of Case. Same story, different director: Kahn ended up walking away from the project and has since made every music video ever for Taylor Swift—and two critically acclaimed films, *Detention* (2011) and *Bodied* (2017).

BONUS OVEREXPOSED!
VINCENZO NATALI

Natali has been involved with a number of exciting projects throughout the years. Here's a brief look at four almost-films that would have had genre fans drooling for more.

SWAMP THING: In 2009, Natali signed on to write and direct a 3-D *Swamp Thing* reboot for producer Joel Silver. After spending years on the film, Natali faded back into the swamp. He tweeted the opening pages from the screenplay in 2015, revealing a four-page introduction to the history and power of *Swamp Thing*.

PREDATOR: Natali crafted a pitch for the *Predator* franchise that contained storyboards and concept art from the director and from artists Amro Attia and Dan Milligan. One exciting piece of art from Milligan featured a human slicing the neck of a Predator with a sword. (Yeah, we definitely need more Predator sword fights at the multiplexes.) 20th Century Fox passed on Natali's pitch and instead made Nimród Antal's *Predators* in 2010.

IT: Not much is known about Natali's pitch for Stephen King's *IT*. The filmmaker tweeted out Pennywise concept art in 2015 from himself and from artist Amro Attia. Natali's Pennywise had more of the classic clown feel in the art, but Attia's, on the other hand, was pure nightmare fuel. As we all know, a different version of *IT* made it to theaters in 2017: Andy Muschietti's record-breaking take.[1]

HIGH RISE: Natali was briefly attached to the adaptation of J. G. Ballard's novel *High Rise*. *Hardware* filmmaker Richard Stanley was brought on to write the screenplay for the project, which eventually fell apart. Ben Wheatley (*Kill List*) then adapted *High Rise* in 2015 with Tom Hiddleston.

1 A film that has its very own "What if?" scenario, as Muschietti replaced Cary Fukunaga after the critically acclaimed filmmaker left the film due to—you guessed it—"creative differences."

EVEN THE SMALLEST PERSON CAN CHANGE THE COURSE OF THE FUTURE

STANLEY KUBRICK'S

THE LORD OF THE RINGS

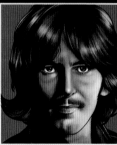
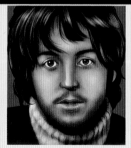
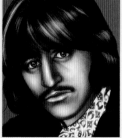

A STANLEY KUBRICK PRODUCTION "THE LORD OF THE RINGS"

Staring:
JOHN LENNON • GEORGE HARRISON • PAUL MCCARTNEY • RINGO STARR

Executive producers:
STANLEY KUBRICK & THE BEATLES

Written and directed by:
STANLEY KUBRICK

Based on the novel by:
J. R. R. TOLKIEN

PG-13 PARENTS STRONGLY CAUTIONED
Some material may be inappropriate for children under 13

POSTER BY LIZA SHUMSKAYA

THE LORD OF THE RINGS STARRING THE BEATLES

THE PLAYERS

Director
Stanley Kubrick

Starring
The Beatles (John Lennon, Paul McCartney, Ringo Starr, and George Harrison)

FADE IN

Long before Peter Jackson's Frodo and company began their walk to Mordor in 2001, a different fellowship almost took the live-action journey in the late sixties/early seventies.

After topping the music charts, the Beatles were setting their sights on cinema. Landing a three-picture deal in 1963 with United Artists, the Fab Four teamed up with director Richard Lester for their 1964 film debut, *A Hard Day's Night*. A year later, the foursome returned in Lester's cult comedy *Help!* With two of the films completed, the focus shifted to the third. You might assume this film would have been called either *The White Movie* or *Abbey Road*—but John Lennon's eye was on something new. United Artists had just purchased the rights to J. R. R. Tolkien's hugely popular fantasy series *The Lord of the Rings*.

For Lennon, happiness was a warm ring.

FLASHBACK

A sequel to Tolkien's 1937 epic, *The Hobbit*, *Rings* follows the journey of the hobbit Frodo and his companions on a quest to destroy the one ring of power, which threatens to rule them all. As they travel across Middle-earth, the fellowship encounters Ringwraiths, Elves, Orcs, a Balrog, Ents (talking trees), a giant spider called Shelob, and finally, the Dark Lord Sauron. It's the fantasy epic of all fantasy epics, and the kind of material that could give "amateur" actors like the Beatles—who had only previously played themselves or ciphers for themselves—an opportunity to stretch and grow their talents.

In *Help!* and *A Hard Day's Night*, the band basically starred in the films as themselves. 1967's *Magical Mystery Tour* allowed the band to play fictionalized caricatures of themselves, but it hardly counts as a feature film

(its run time is only fifty-two minutes). Contrary to popular belief, the foursome doesn't star (or voice) the cartoon-musical versions of the band in 1968's *Yellow Submarine*. And while Richard Lester had directed their first two films, Lennon wanted a different filmmaker to guide them through Middle-earth's paths of glory.

Stanley Kubrick's science-fiction epic *2001: A Space Odyssey* was released in spring 1968. After making the wartime satire *Dr. Strangelove or: How I Learned to Stop Worrying and Love the Bomb*, Kubrick found himself enamored with the thought of extraterrestrial life and sought out author Arthur C. Clarke to collaborate with on a science-fiction film. The result of that collaboration, *2001*, follows mankind's dual discoveries of mysterious black monoliths—the first at the dawn of man's history and the second on the moon in 1999. Eighteen months after the moon-monolith is "activated," the United States launches an expedition to discover what, or who, is responsible. A life-or-death struggle ensues between the expedition's astronauts and their onboard computer HAL 9000, pitting mankind against technology in the quest for truth.

2001 is a masterful accomplishment that is not only regarded as one of the greatest movies of all time, but also one that profoundly changed and influenced all science-fiction cinema thereafter. *2001* nabbed four Academy Award nominations (Best Director, Best Original Screenplay, Best Production Design, and Best Visual Effects), winning the statue for Best Visual Effects. It was also nominated for five BAFTA nominations, winning four of them: Best Cinematography, Best Soundtrack, Best Production Design, and the Best Road Show Award.

ACTION!

With Kubrick in mind, the band focused on the roles they wanted to play in the film. Lennon was set on bringing the ring-obsessed Gollum to life; Paul McCartney would play Frodo; Ringo Starr would play Samwise; and George Harrison would portray Gandalf the Grey. It's definitely hard, today, to picture the Fab Four in the roles made famous by Andy Serkis, Elijah Wood, Sean Astin, and Ian McKellen—especially when you take into consideration the motion-capture/CGI performance of Gollum (Lennon was a talented performer, but it's tough to picture him topping Serkis).

With a solid plan for the film, the Beatles just needed the Kubrick plans to come together, but not even the One Ring could camouflage the doubt on this project.

CUT!

Kubrick briefly considered pursuing *The Lord of the Rings* with the Beatles, but ultimately decided against the film.

He was already developing his *2001* follow-up, and the world of Tolkien wasn't enough to pull his focus away from his adaptation of Anthony Burgess's *A Clockwork Orange*.[1] The filmmaker also considered the material "un-filmable," which, coming from the man who had just changed the science-fiction genre forever, is really saying something.

Without the award-winning filmmaker in tow, the Tolkien estate turned down the Fab Four's request to make the film.

Afterward, filmmaker John Boorman attempted his own walk through Middle-earth. Glaring changes to the source material and a skyrocketing budget led United Artists to scrap the film entirely. Boorman next directed *Deliverance*, and later *Exorcist II: The Heretic*—another film Stanley Kubrick was offered. In 1978, United Artists released a *Lord of the Rings* film from *Fritz the Cat* animator Ralph Bakshi.

The fellowship finally saw live action in 2001, when Peter Jackson released the first of his award-winning trilogy adaptation, *The Fellowship of the Ring*. *The Two Towers* followed in 2002, and the series ended with *The Return of the King* in 2003.

The trilogy combined for a total of thirty Academy Award nominations, winning seventeen of them. Jackson later returned to Middle-earth with a second trilogy based on Tolkien's *The Hobbit*.[2] *The Hobbit* series netted a total of seven Academy Award nominations, winning only one: the Sci-Tech Award.

In 2017, Amazon Studios acquired the television rights to *The Lord of the Rings*. Their series is expected to run for five seasons and be the most

1 A project the Beatles had their own history with, as they were set to score a failed earlier adaptation of *A Clockwork Orange* starring the Rolling Stones. Dive in more on pages 117-121.

2 *The Hobbit: An Unexpected Journey* opened in 2012, followed by 2013's *The Desolation of Smaug* and 2014's *The Battle of the Five Armies*.

expensive series ever made, with a target release date on the streaming service in 2020.

While their Middle-earth plans never panned out, the Beatles weren't exactly slouching when it came to success stories. The foursome, however, was successful in making cinephiles everywhere attempt to picture exactly what a seventies-era Kubrickian *Lord of the Rings* starring the Beatles would have looked like.

One thing I can tell you: It would have been an absolute trip.

OVEREXPOSED!
STANLEY KUBRICK

While *The Lord of the Rings* is one of the most hypothetical of Kubrick's unmade films, the legendary director had a number of projects that actually came close to happening. We're going to talk briefly about three of them.

NAPOLEON: One of the most infamous unmade movies of all time, Kubrick first set out to tell the story of Napoleon Bonaparte after *2001: A Space Odyssey*. The filmmaker had a massive organizational system for the project of more than 15,000 index cards, and the screenplay came in at 155 pages. The film was to star David Hemmings and Audrey Hepburn, and to contain war sequences that would require more than 50,000 extras. Kubrick was never able to get the film moving and it remained on the shelf.

ARYAN PAPERS: In 1991, Kubrick focused his attention on developing an adaptation of Louis Begley's autobiographical novel *Wartime Lies* under the title *Aryan Papers*. The story told the tale of a boy and his aunt who are in hiding from the Nazis during the Holocaust. Kubrick, however, walked away from the project after Steven Spielberg made *Schindler's List*.

THE EXORCIST: Kubrick had always wanted to make the world's scariest movie. The filmmaker was approached to direct the adaptation of William Peter Blatty's *The Exorcist*, but ultimately turned down the film. After Friedkin's film became a hit, Kubrick was approached for the sequel, *Exorcist II: The Heretic*. He declined the offer once again. In 1980, Kubrick finally released a horror movie into the world with his adaptation of Stephen King's *The Shining*.

SUDDENLY SHE COULD SEE
INTO THE FUTURE...
AND SAW HER OWN MURDER

PRODUCED BY LUCIO FULCI

STARRING
BRIDGET FONDA

THE PSYCHIC

THE FOURTH FILM FROM QUENTIN TARANTINO

POSTER BY MIKI EDGE

THE PSYCHIC

THE PLAYERS

Director
Quentin Tarantino

Starring
Bridget Fonda

FADE IN

Quentin Tarantino is a filmmaker who isn't shy about paying homage to the filmmakers and films that he loves. In early 2000, there was talk of him doing more than just paying homage; he openly discussed remaking one of them.

That film? One of the director's favorites: Lucio Fulci's *The Psychic*.

FLASHBACK

Released in 1977, *The Psychic* (aka *Seven Notes in Black*) was a product of bad timing. The giallo genre[1] was fading, and the general public had little interest in seeing another one, much less an entry with very little blood and gore. Fulci was coming off the 1976 sexually charged comedy *La Pretora* (aka *The Magistrate*) and making his return to a genre he hadn't released a film in since 1972's *Don't Torture a Duckling*.

Starring Jennifer O'Neill (*L'Innocente, Scanners*), *The Psychic* follows the clairvoyant Virginia, who has a murderous vision involving a wall in her husband's house in Italy. Upon visiting the home, she opens up the wall and discovers the skeleton of a woman inside. The skeleton is revealed to be that of her husband's former lover. Virginia sets out, with the help of her psychiatrist, to clear her husband's name and discover the truth of what happened to the woman. As her vision begins to play out piece by piece, it becomes horrifically clear to Virginia that her vision wasn't the murder of her husband's ex-girlfriend, but her own.

The film is a twisted maze for the viewer to sit through, as the guessing game of Virginia's vision lasts until the final frame of the film. It's a psychological thriller that bends time, and the audience's perceptions, throughout its run time. It's the type of film that could play gangbusters with contemporary crowds, who are now trained to expect Shyamalan-type third-act twists—which could explain why Quentin Tarantino flirted with remaking the film.

1 Originally the name given to Italian crime novels; *giallo* is Italian for "yellow." These novels would have yellow covers, letting readers know what they were in for. Soon, the giallo genre expanded into filmmaking with entries from horror maestros Fulci, Mario Bava, and Dario Argento. In 2019, horror master James Wan (*Saw, The Conjuring*) went into production on his very own original giallo film entitled *Malignant*.

ACTION!

1997 saw the release of Tarantino's third film, *Jackie Brown*, an adaptation of Elmore Leonard's novel *Rum Punch*, and the first film for the director based on existing material. *Jackie Brown* featured an all-star cast of Pam Grier (as Jackie Brown), Samuel L. Jackson, Bridget Fonda, Robert De Niro, Robert Forster, Michael Keaton,[2] and Chris Tucker. In the film, Brown is a flight attendant who smuggles money for arms dealer Ordell Robbie (Jackson). When she gets caught by two ATF agents, she's given the chance at freedom if she helps them bring in Robbie. She accepts, but Robbie finds out about the deal, setting in motion a bloody, violent game of betrayal.

Jackie Brown had a budget of $12 million—and grossed a worldwide total of $74 million. Forster landed a Best Actor nomination from the Academy, and Jackson and Grier landed Golden Globe nominations. Although she wasn't nominated for any awards for the film, Fonda landed a different prize: Tarantino was planning on building his remake of *The Psychic* around her.

Tarantino had once attempted to purchase the rights to the film for his distribution company, Rolling Thunder Pictures, but that fell through. Not long after, in 2000, he discussed simply remaking the film in the "murky future."

It wouldn't take a psychic to see that the future of the proposed remake just got murkier as time went on.

CUT!

So what happened to the remake? Simply put, Tarantino set out to *Kill Bill* instead of Fonda. He spent his early 2000s writing and prepping his two-part revenge tale starring Uma Thurman. The filmmaker (and Fonda) haven't mentioned the project since the initial announcement. Tarantino fans (and cinephiles in general) excited by the prospect of the director tackling a horror film had to wait until 2007, when his killer-car movie *Death Proof* hit screens as half of the double feature *Grindhouse*.

While definitely hypothetical, Tarantino had enough interest and passion for the idea to talk about it in interviews. That's enough interest for us to picture what it could have looked like if he did tackle Fulci.

2 Keaton briefly played the same character in Steven Soderbergh's own Leonard adaptation, *Out of Sight*.

OVEREXPOSED!
QUENTIN TARANTINO

Alongside *The Psychic*, there are a number of other projects that almost hit Tarantino's filmography. We briefly discuss four of them here.

KILLER CROW: The original idea that spawned *Inglourious Basterds*, *Killer Crow* follows a troop of African American soldiers screwed over by the American military, and they go on a warpath across military bases. In later iterations of the project, *Killer Crow* was to be the third entry in Tarantino's "Basterds" trilogy, which would have also included *Django Unchained*. Brad Pitt's Aldo Raine and Eli Roth's Donny Donowitz were both rumored to be involved with *Crow* at one point in its development. The *Killer Crow* troop are still out there in the land of development.

LUKE CAGE: After the success of *Reservoir Dogs*, Tarantino approached the producers who owned the rights to the Marvel character Luke Cage. The director wanted to take the Hero for Hire back to the seventies and cast Laurence Fishburne as Cage. A violent, period-piece Marvel adaptation from Tarantino? Sweet Christmas! In the end, all parties went their separate ways. Tarantino would go on to make a little film called *Pulp Fiction*, and Cage later ended up with his own series on Netflix.

KILL BILL VOL. 3: The third volume in the *Kill Bill* story follows Nikki, the daughter of Vivica A. Fox's Vernita Green, on her quest for revenge ten years later. Volume three was never confirmed, just mentioned and teased by the director as something he'd like to eventually make. Tarantino, however, has confirmed there is no script for the film, and as he winds down on his "ten films and out" plan, it seems unlikely that *Kill Bill Vol. 3* will be Tarantino's grand finale. The director did claim in July 2019 that the film wasn't dead yet though, so who's to say.

STAR TREK: During prep for his ninth film, *Once Upon a Time in Hollywood*, the director set news to stun with the announcement that he would be tackling an R-rated *Star Trek* film as his next project. *Star Trek* reboot director J. J. Abrams signed on to produce the film. As of July 2019, the film was still being planned and had a screenplay from Mark L. Smith.

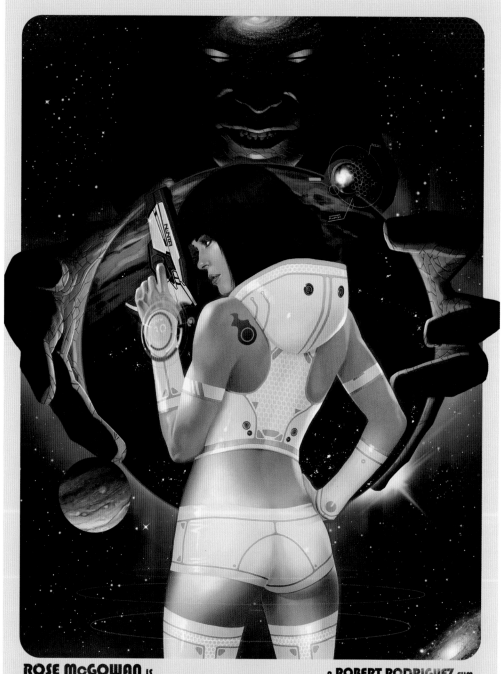

ROSE McGOWAN IS A ROBERT RODRIGUEZ FILM

BARBARELLA

ROBERT RODRIGUEZ'S
BARBARELLA

THE PLAYERS

Director
Robert Rodriguez

Screenwriter
Neal Purvis and
Robert Wade

Starring
Rose McGowan

FADE IN

In 2007, Robert Rodriguez signed on to direct an out-of-this world follow-up to his *Grindhouse* feature *Planet Terror*. Producers Dino and Martha De Laurentiis pursued the filmmaker for an all-new, big-budget remake of the de Laurentiis–produced 1968 science-fiction classic *Barbarella*. With screenwriters Neal Purvis and Robert Wade on board for the screenplay, the film had all the makings to be a galactic hit.

FLASHBACK

Starring Jane Fonda, *Barbarella* is set in the year 40,000 A.D. and follows astronaut Barbarella as she sets out to find missing scientist Durand Durand. What she finds instead is dolls with razor-sharp teeth, a killer sex organ called the Excessive Machine, hookah-smoking women, and a lesbian queen with a Chamber of Dreams. Oh, and there's sex.[1] Directed by Roger Vadim, the film was originally written by Terry Southern; Vadim and Fonda were married at the time, which parallels the relationship Rodriguez had with his own choice for Barbarella. The film has influenced a number of science-fiction movies, and pop culture in general, throughout the years.

The cult classic also has a strong visual sense, which made it the perfect material for a filmmaker like Rodriguez to tackle. The *El Mariachi* filmmaker was two years removed from his groundbreaking adaptation of Frank Miller's graphic novel *Sin City*. Rodriguez has always brought a DIY approach to his filmmaking, and *Sin City* was no exception, as he made the entire film at his Austin-based Troublemaker Studios. Similar to his approach to his *Spy Kids* franchise, he used green screen/CGI for the majority of the film. This approach works amazingly for a project like *Sin City* because you can bring Miller's panels to life with more visual and stylistic fidelity. It would also

1 Barbarella attempts to reward the man who rescues her at the beginning with "Earth intercourse." In the year 40,000, that's accomplished via both parties taking a pill. Someone could make a ton of money with "Netflix and Pill" shirts on Zazzle.

work well if, say, you were making a film about an astronaut who encounters a number of different locations and characters in space.

Coming on board the film in May 2007, Rodriguez was just wrapping up promotion duties for the double-feature film event *Grindhouse*. He was ready to jump into *Barbarella* prep at light speed.

ACTION!

Opening on April 6, 2007, *Grindhouse* was a love letter to the grindhouse movies of yesteryear. The film consists of two full-length feature films, *Planet Terror* from Rodriguez and *Death Proof* from Quentin Tarantino. Bridging each half are five fake trailers: Jason Eisener's *Hobo with a Shotgun*, Edgar Wright's *Don't*, Rob Zombie's *Werewolf Women of the SS*, Eli Roth's *Thanksgiving*, and Rodriguez's own *Machete*.[2]

Rodriguez's half of the bill, *Planet Terror*, is a gross-out zombie movie following a group of survivors, and the US army, at war with the dead. It stars Rose McGowan, Josh Brolin, Michael Biehn, Freddy Rodriguez, Marley Shelton, and Bruce Willis. Tarantino also pops up and then . . . pops out. *Planet Terror* is a fun drive-in splatter-fest, but the most memorable part of the film is McGowan's performance. She plays a dancer named Cherry who brutally loses her leg to zombies. First, her severed leg gets a wooden upgrade, then it gets an M4 carbine attached to it—and that's when the fun happens. I would also imagine it's one of the moments that convinced Rodriguez that McGowan would be perfect as Barbarella. The actress officially signed on to the role in fall 2007.

On the writing front, Purvis and Wade were coming off of 2006's James Bond reinvention/reboot *Casino Royale*. The film landed the pair a BAFTA nomination for Best Adapted Screenplay and set them off on every Bond adventure since.[3] Screen tests and artwork were done for *Barbarella*. Rodriguez described the approach as an "R-rated, sexy *Heavy Metal* version of a *Star Wars* film." Plans were well underway.

2 Since the release of *Grindhouse*, *Hobo with a Shotgun* and *Machete* have been made into feature films. *Machete* even got a sequel in 2013. Every Thanksgiving, fans beg for a feature-length version of Roth's *Thanksgiving*. Fake trailer, real trailer—all get cut.

3 They wrote *Skyfall* with John Logan and have had an on-again/off-again relationship with Cary Joji Fukunaga's *Bond 25*.

With Rodriguez confirmed, *Barbarella* cast, a screenplay from BAFTA nominees in hand, and a legendary producing team behind the project, Universal Pictures officially put the film into production. Then suddenly—like Cherry in *Planet Terror*—the big-budget remake lost its footing.

CUT!

While no one was counting on *Grindhouse* to be a massive box office success, there were people counting on the film to make *something*. The double feature had a budget of $53 million and was estimated to bring in half of that its opening weekend. The film, instead, made only $11 million when it released, setting in motion a devastating flop for the filmmakers. The Weinstein Company later split the film into two separate releases, but the damage had been done. *Grindhouse* left theaters with a total of only $67 million.

Universal had been watching the *Barbarella* budget grow, alongside growing fears that McGowan's name might not be able to carry the film. Once the price tag hit $80 million, Universal pulled out of the film altogether. Rodriguez wasn't willing to give up on the film and pursued other financing options. He found financiers in Germany willing to give him $70 million to make *Barbarella*, but he would have to shoot the film overseas. For a filmmaker who has his own studio and has made a number of big movies there specifically so he doesn't have to be away from his family, this was a big ask. Rodriguez turned down the offer, and in 2009, his version of *Barbarella* was officially dead.

In 2012, Amazon Studios and Gaumont International Television announced they were making a pilot for a potential *Barbarella* series. Purvis and Wade were announced as the writers on the pilot. *Drive* filmmaker Nicolas Winding Refn was announced as the director, but all signs of life on that series ended in 2016. In another *Underexposed!* moment, we're now all left to imagine what Refn's take on *Barbarella* would have looked like.

Instead of his R-rated, sexy take on *Barbarella*, Rodriguez followed up *Planet Terror* with the—checks notes—family-friendly magical rock film *Shorts*. Something tells me that one doesn't feature an Excessive Machine.

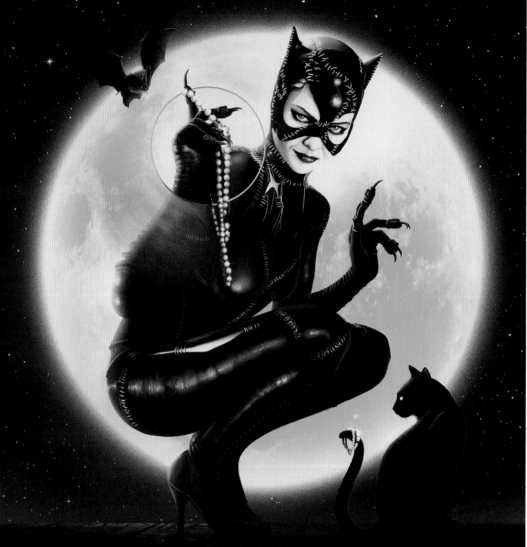

MICHELLE PFEIFFER

A TIM BURTON FILM

CATWOMAN

WARNER BROS. PRESENTS

TIM BURTON'S
CATWOMAN

THE PLAYERS

Director
Tim Burton

Screenwriter
Daniel Waters

Starring
Michelle Pfeiffer

FADE IN

Long before her leather-clad introduction in Tim Burton's *Batman Returns*, Catwoman was making a habit of taunting "the Bat" in DC Comics. Debuting in spring 1940's *Batman*, no. 1, as "the Cat," Selina Kyle was partially inspired by screen actress Jean Harlow. Created by Bill Finger and Bob Kane, the cat burglar began a love/hate relationship with Batman (and Bruce Wayne) that continues to this day.[1] A strong character in her own right, Catwoman has proven that she can carry her own series, at least in comic form, since 1989. Four years after her solo comic book debut, she almost got to carry her own solo film as well.

FLASHBACK

Catwoman made her screen debut in 1966, with Julie Newmar portraying the character in seasons one and two of the *Batman* TV series starring Adam West. Eartha Kitt took over the role in season three. Further complicating matters (and the series' continuity), 1966's *Batman: The Movie* saw Lee Meriwether star as the feline villain. Twenty-six years later, Catwoman returned to the streets of Gotham, and to the big screen, for the highly anticipated sequel to Burton's *Batman*.

A massive hit when it was released in 1989, *Batman* grossed $40 million in its opening weekend. It then passed the $100 million mark in record time: less than twelve days.

Warner Bros. fast-tracked the sequel, with hopes of having the Caped Crusader and Burton back on set in 1990. Those plans, however, didn't work out, as Burton refused to rush into a sequel he didn't find "new and exciting." Development on the sequel continued as *Batman* writer Sam Hamm delivered draft after draft. Taking his time with the *Batman* sequel, as well

1 See Tom King's 2018 run on the *Batman* comics line, leading up to their "wedding," for just how complicated that relationship is.

as refusing to take *Beetlejuice* to Hawaii,[2] Burton still ended up shooting a movie in 1990; it just wasn't for Warner Bros. Burton instead made *Edward Scissorhands* for 20th Century Fox.

Filming took place in Lutz, Florida. Winona Ryder was attached to the project from the get-go after the pair collaborated on *Beetlejuice*. Since journeying into the afterlife together, the director had become a fan of one of Ryder's movies from 1988—more specifically, he was a fan of the writing.

Ryder plays Veronica in Michael Lehmann's high school–set *Heathers*. Written by first-time screenwriter Daniel Waters, the film follows Veronica as she tries to survive (and kill?) her shallow, nasty friends: Heather 1, Heather 2, and Heather 3. Released in 1988, Waters had originally wanted Stanley Kubrick to direct the film and made a number of attempts to get the script in his hands. It instead fell into the hands of Lehmann.

Sure, the cult film is set in high school, but it dissects the wider trope of societal acceptance in pitch-dark fashion. This is something Burton connected with and something he wanted to bring to Gotham; originally hired to write *Beetlejuice 2*, Waters was asked by Burton to rewrite the screenplay for *Batman Returns* instead. Exceptionally confident in Burton due to the box office success of *Batman*, Warner Bros. granted him an unusual amount of creative control on the film. It proved to be a decision they questioned when footage, and angry calls, started coming in.

Keaton returned to the role of Batman/Bruce Wayne. After Dustin Hoffman declined an offer to play the Penguin, a number of other actors were considered for the role, including John Candy, Bob Hoskins, and Joe Pesci—but the umbrella ultimately fell into the flippered hands of Danny DeVito. Michelle Pfeiffer, who originally had been offered the role of Vicki Vale in *Batman*, was in early consideration for the role of Catwoman/Selina Kyle, but Pfeiffer lost out to Annette Bening. Pfeiffer's nine lives with the Bat-movies weren't up just yet, however, as Bening became pregnant and had to drop out of the film.[3] Pfeiffer would ultimately beat out Nicole Kidman, Madonna, and others for the role of Catwoman.

2 Warner Bros. wanted, for specious reasons, a *Beetlejuice* sequel where he, the Maitlands, and the Deetz family go to Hawaii.

3 Bening eventually turned up in a comic book movie in 2019. She played the roles of Dr. Wendy Lawson/Supreme Intelligence in Marvel Studios' *Captain Marvel*.

Batman Returns was released on June 19, 1992. Much like *Batman*, the sequel was a massive box office success. It had the highest opening weekend of 1992 with a $45 million, but it wasn't all sunshine and dollar signs at Warner Bros. once the film was released. Burton's creative freedom on the film had caused a bit of a headache for the studio. Parents all over the country were angry about the monstrous version of the Penguin and the oversexed "BDSM" version of Catwoman.

Burton, who had been planning on returning for a third film, was politely asked by the studio *not* to return to Gotham. Instead, they set their focus on developing a more lighthearted, colorful take on the Caped Crusader with *Batman Forever*. Even though Burton was done with Batman, there was a character he and the studio felt had more of a story to tell.

Pfeiffer's Catwoman was about to land on her feet with her own movie.

ACTION!

The Catwoman spin-off was announced in June 1993, a year after *Batman Returns* opened. Waters was returning to write the script, and Pfeiffer was returning as Selina/Catwoman. Burton was weighing his options before committing to the film: Should he direct the Bat spin-off or a new adaptation of Edgar Allan Poe's *The Fall of the House of Usher*?[4]

Waters's plan with the spin-off was to take Selina out of Gotham as she recovered from the trauma of *Batman Returns*. But as the saying goes, you can take the Cat out of Gotham, but you can't take the Gotham out of the Cat.

In *Catwoman*, Selina wakes up riddled with bullet holes and amnesia. She has no memory of the events of *Batman Returns*, so naturally, she makes her way to a Palm Springs–esque resort town called Oasisburg. The resort just so happens to be operated by a group of superheroes who aren't exactly supergood people. It's here where she takes up the mantle of Catwoman again, looking to knock the male heroes down a peg (or nine).

Waters delivered his *Catwoman* script on June 6, 1995—the same day Joel Schumacher's *Batman Forever* opened.

4 He wouldn't direct either.

CUT!

Batman Forever broke box office records when it opened: after its $52 million weekend, the film went on to gross a total of $336 million worldwide. That was enough to outgross *Batman Returns* entirely. Families flocked to the fun, colorful new side of Gotham. The Catwoman spin-off, like Jim Carrey's spandex, was covered in question marks. It didn't take long for everyone involved to move on from the project. Instead of the *House of Usher*, Burton went on to make *Mars Attacks!*

Pfeiffer stayed involved as long as she could, but her interest in the project was also declawed. Ashley Judd eventually signed on to replace her in the film, but development continued to stall until 2004, when Halle Berry starred in a new approach to the spin-off—an approach that not only bombed at the box office, but also earned Berry a Razzie for her performance.

OVEREXPOSED!
SUPERMAN LIVES

Catwoman wasn't the only comic book movie Burton attempted to get off the ground after his time in Gotham. His *Superman Lives* is one of the most well-known never-made films on the face of the internet. The film has been wildly discussed by Kevin Smith and even has a documentary: *The Death of "Superman Lives": What Happened?*

Superman Lives draws upon the hugely popular *The Death of Superman* comic book storyline for inspiration. Doomsday was scripted as one of the villains in the film, but mostly appeared as a pawn of the main villain, Brainiac. Brainiac's plan? Block out the sun while Doomsday turns Metropolis into his own private smash club. Obviously, the sun is what gives Superman his strength, so in Brainiac's Doomsday scenario, Superman is powerless to defend the city. Superman dies in the battle, but is later resurrected by a Kryptonian force known as "K." Back to life, and back to reality, a new artificially enhanced Superman defeats Brainiac and saves the world.

Nicolas Cage was set to play the Son of Krypton for the Batman director. Wardrobe fittings and concept art are widely available online, giving a glimpse of just what they were cooking up for the new *Superman* movie. There were even rumors that Burton was able to convince Michael Keaton to cameo as Batman in the film. On the villain side, Kevin Spacey was attached to play Lex Luthor, and even though he had already played DC villain Max Shreck for Burton in *Batman Returns*, Christopher Walken was rumored to play Brainiac. Concept art available online shows the *Sleepy Hollow* actor with an oversize green head on a robotic spider body. Creative differences, budgetary concerns, and a string of box office bombs for Warner Bros. ultimately killed *Superman Lives*.

A massive cloud of "What if—but more importantly, why?" hangs over Burton's *Superman* production to this day.

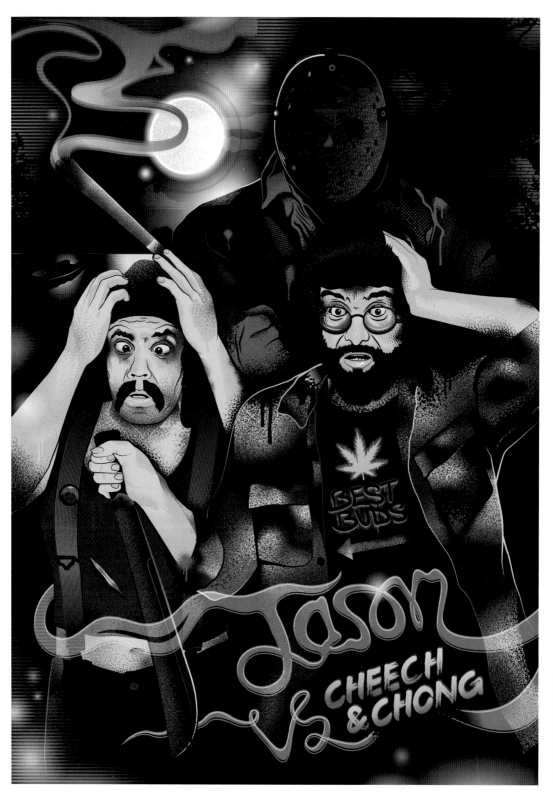

JASON VS. CHEECH AND CHONG

THE PLAYERS

Director
Tom McLoughlin

Starring
Tommy Chong
and Cheech Marin

FADE IN

Jason vs. Cheech and Chong was, believe it or not, an actual, real, potential thing that existed for, like, a tenth of a second in the late eighties. It's hard *not* to wonder what this film could have been like or looked like. So let's dive into one of the most "hypothetical" entries in *Underexposed!*, shall we, man?

FLASHBACK

After working in the comedy scene for around ten years, Tommy Chong and Richard "Cheech" Marin starting reworking some of their material into a feature film. *Up in Smoke* sees Cheech as a guitarist and Chong as a drummer who have a chance encounter and end up in a series of odd situations. One of those odd situations just happens to be accidentally smuggling an entire van constructed of "fiberweed" (hardened THC resin taken from marijuana) across the border.

Up in Smoke was a huge success for the duo. *Cheech and Chong's Next Movie* came out in 1980. Their second film was more of the same drug-fueled shenanigans that filled *Up in Smoke*. Come to think of it, the same could be said for *Nice Dreams*, *Things Are Tough All Over* (although Chong gave up drugs for a bit in that one), and *Still Smokin'*. The pair had an audience and knew what that audience wanted. They also knew exactly what kind of situations they could get themselves into because of their stoner shtick.

As did filmmaker Tom McLoughlin.

McLoughlin started out as a screenwriter and actor, appearing in Woody Allen's *Sleeper* and John Frankenheimer's *Prophecy*. After years of stalled projects, frustration grew, and McLoughlin set his sights on making an Edgar Allan Poe–type gothic horror film.

The result was *One Dark Night*, a supernatural horror film about three teenage women who enter a mausoleum for their high school initiation. It just so happens that a dead occultist with telekinesis rises from the dead

that same night. The girls are forced to survive the night (and high school after that!). The film was a success for McLoughlin when it released in 1983.

Lucky for him, the producers of *Friday the 13th* were looking for a new beginning after the disastrous fan reaction to *A New Beginning*'s ending. (Spoiler alert: Jason Voorhees wasn't killing all the kids at the halfway house throughout the film; it was an ambulance driver named Roy Burns, whose son died early in the film. The sight of his dead son made him snap and pretend to be Jason in order to get revenge. Oh, and if imposter Jason wasn't enough to ruffle feathers, the final scene had hero Tommy Jarvis in the hockey mask.) What was supposed to be a new beginning for the *Friday the 13th* franchise quickly became frantic phone calls to the Voorhees house.

Jason was needed back in Crystal Lake.

ACTION!

Friday the 13th producer Frank Mancuso Jr. brought McLoughlin on to write and direct the sixth film in the franchise, with free creative rein, under one condition: he had to bring Jason back. McLoughlin drew inspiration from the classic Universal Monster films to bring the slasher back from the dead. More specifically, he used the Dr. Frankenstein method of using electricity to resurrect him. They also took a page from the *Halloween 4* playbook by letting fans know Jason was back in the subtitle of the film: *Jason Lives*.

Jason Lives slashed its way to theaters on August 1, 1986. The film brought in $6.7 million its opening weekend and ended its theatrical run with a worldwide total of $19.4 million. Happy with the results and fan reaction, Mancuso approached McLoughlin about returning for the next *Friday the 13th* film.

Unsure of where they could go after anchoring Jason to the bottom of Crystal Lake, McLoughlin started dreaming up possible ideas, unaware that Mancuso's head was already in a dream world.

Early on, Mancuso pitched McLoughlin on the idea of doing a Jason versus Freddy movie. Citing rights issues, as well as his personal preference for seeing monsters stay in their own universes, McLoughlin shuddered at the idea. Mancuso eventually backed off the idea as well, telling the director "it wouldn't work anyway."[1] While he wasn't a fan of the Freddy idea, there

1 Freddy Krueger and Jason Voorhees eventually met on the big screen in 2003. It's a mixed bag of reactions on whether or not "it worked."

was something to this "crossover" idea that McLoughlin liked. Especially if he could combine characters Paramount already owned.

Armed with his comedy-writing background, and with his knack for doing something different with Jason, McLoughlin pitched Mancuso *Jason vs. Cheech and Chong*. He would have the stoners play counselors at Camp Crystal Lake who discover the legend of Jason Voorhees is real. It's a pretty far out idea, man.

CUT!

A little too far out for producer Frank Mancuso. He immediately rejected the idea. If fans reacted poorly to Ambulance Roy, they surely wouldn't appreciate Cheech and Chong smoking out their favorite slasher. Or would they?

Friday the 13th was remade in 2009, and a group of teens discover that Crystal Lake has a ton of homegrown marijuana. They all die, brutally, I may add, shortly after the discovery, at the hands of one-man cartel Jason Voorhees. Maybe the biggest problem in McLoughlin's pitch was the "versus" aspect.

Sounds like the three of them would have been best buds.

OVEREXPOSED!
FRIDAY THE 13TH

It's been more than ten years since the last *Friday the 13th* film was released. In that time, we've seen new installments from the *Leprechaun, Tremors, Hellraiser, Candyman, Puppet Master, Child's Play,* and *Halloween* franchises. Jason just can't seem to find his way back to a machete, but it's not for a lack of trying. Let's pitch a tent and talk about a few *Friday the 13th* movies discussed since 2009.

FRIDAY THE 13TH: CAMP BLOOD: THE DEATH OF JASON VOORHEES:
Yes, that was the entire title. Mark Swift and Damian Shannon have a deep history with Jason Voorhees. The screenwriting duo wrote *Freddy vs. Jason* and 2009's *Friday the 13th* reboot. They also wrote an unproduced sequel to that very reboot. Despite being well-received by fans and earning respectable box office returns, the studio never moved forward on it. Where did Swift and Shannon take Jason? The sequel picked right up from where the first film ended, but it followed new characters instead of Clay and Whitney. Swift and Shannon also set the film in winter. Instead of fans delighting to cold kills and snow angels, however, movement on the killer sequel froze.

SECOND FRIDAY THE 13TH REBOOT:
Speaking of snowy Crystal Lake, rumors hit the web that the second *Friday the 13th* reboot would be built around the found-footage concept. There were talks of it being set in the wintertime as well. Paramount even hired director David Bruckner, who is well known for his work in the genre via an entry in the found-footage anthology *V/H/S*. An eighties-set *Friday the 13th* film was then developed that played around with this found-footage trope, but the concept was quickly dropped when writer Nick Antosca was brought in to write a new draft.

Antosca and Bruckner's vision kept the story set in the eighties, with shades of the nostalgia that carried *Stranger Things* to popular acclaim. It also had a ruthless, killing-machine version of Jason. Much like the Shannon and Swift plan, Bruckner and Antosca laid sequel plans for a winter massacre. Unfortunately, it wasn't meant to be. Instead, the future of the *Friday the 13th* franchise is as murky as Crystal Lake. I know—total mood killer. But here, I'll leave you with my favorite part of Antosca's script. After the title page, there's an entire page describing each character in the film. We're introduced to nine camp counselors, the camp nurse, the groundskeeper, and one local guy. Wait, scratch that; two local guys. The page ends with this:

JASON VOORHEES

NICE GUY. YOU'LL MEET HIM SOON.

Let's hope we all get to meet him once again on the big screen.

HENRI-GEORGES CLOUZOT'S

INFERNO

THE PLAYERS

Director
Henri-Georges
Clouzot

Screenwriter
Henri-Georges
Clouzot

Starring
Serge Reggiani,
Romy Schneider

FADE IN

Henri-Georges Clouzot and Albert Hitchcock have always been connected through comparisons, rivalry, and more in their filmography. Take *Diabolique*, for example: Clouzot optioned the screenplay before Hitchcock could get his hands on it, resulting in Hitchcock pursuing and making *Psycho*.

Both directors have unrealized films in *Underexposed!*, and both of these films would have been colorful, groundbreaking takes on the thriller and slasher genres.

And both would have been iconic in their own ways. For Clouzot, *Inferno* was to be a life-changing film that would break him out of the comparisons with Hitchcock, once and for all.

Instead, it would forever shackle him to them.

FLASHBACK

Originally getting his start in screenwriting, Clouzot had a unique entrance into filmmaking. Diagnosed with tuberculosis at the age of twenty-eight, he had an unusual amount of time to dedicate to the fundamentals and techniques of storytelling as well as writing. His directorial debut came in 1942 with *The Murderer Lives at Number 21*. This serial-killer thriller landed Clouzot the opportunity to make the true story *Le Corbeau*, a story of poison-pen letters sent to a French doctor accused of practicing abortion. Due to the unflattering presentation of France in the film, *Le Corbeau* led to Clouzot being fired by production company Continental Films. His relationship with Continental also got him banned from making films in France until 1947. A devastating one-two *le punch* for Clouzot.

After a number of award-winning and critically acclaimed films such as the Golden Lion–winning *Manon* from 1949, Clouzot released *The Wages of Fear* in 1953. *Fear* follows a group of men tasked with transporting nitroglycerine to a distant oil field across rough South American terrain. The hugely popular and award-winning film opened the doors for Clouzot to make *Diabolique* (and burn Hitchcock in the process...).

187

Diabolique follows the murder of a private-school headmaster by his wife and mistress. They intend it to be the perfect crime, manipulating the scene of his murder so that his death is mistaken for an accidental drowning. After drowning him in the tub, the women dispose of his body in the school pool only to find his body has disappeared when the pool is drained. As the mystery grows about his death and the whereabouts of his body, our killers begin to unravel. The film was a massive success for the filmmaker, and *Diabolique* can be said to have truly matched the intensity and twists of a Hitchcock film.

Now Clouzot just needed an international audience, and Columbia Pictures was intent on giving him one.

ACTION!

After the success of *The Wages of Fear* and *Diabolique*, not to mention the award-winning documentary *The Mystery of Picasso*, Clouzot had a number of options to choose from for his next movie. Columbia Pictures offered to give him whatever he needed.

With Columbia by his side and with freedom from creative and budgetary constraints, Clouzot set out to make the marriage thriller *Inferno*. *Inferno* focuses on the married Marcel and Odette—and more specifically, the jealousy Marcel has toward Odette. Marcel owns a hotel and finds himself constantly aware of the other guests, as well the attention that Odette gives them. Marcel's jealousy ultimately ends up being too much for him to handle, and it drives him out of his mind.

Clouzot set out to bring a number of mesmerizing techniques to *Inferno* that were ahead of their time. Among them, the director wanted to manipulate colors on-screen when it came to portraying Marcel's jealousy-fueled fantasies. In order to do so, he would put the actors in different-colored paint (in order for them to still appear skin-colored regardless of the background). Additionally, Clouzot had a number of crew members experimenting with lenses and filming through water, as well as distorting images in-camera.

Jealousy fuels madness.

Madness fuels filmmaking.

Filmmaking fuels . . . issues.

un film de **Henri-Georges Clouzot** avec **Romy Schneider Serge Reggiani Dany Carrel Catherine Allégret**

photo **Andréas Winding** scénario **Henri-Georges Clouzot Jean Ferry José-André Lacour** montage **Marie-Sophie Dubus**

une production de **Columbia Pictures** effets optiques **Andréas Winding** et **Armand Thirard**

L'ENFER

[INFERNO]

CUT!

Clouzot and his cast and crew abandoned filming on *Inferno* just three weeks after it began. Heatstroke and illness ran rampant on set, as did last-minute cast replacements. Clouzot himself suffered a heart attack from the stress of the film, definitively proving that filmmaking is not for the weak of heart.

Clouzot returned four years later with the dramatic thriller *Woman in Chains*. The award-winning filmmaker passed away in 1977, leaving a number of projects unfinished, including *Inferno*.

After discovering hours of footage shot for *Inferno*, Clouzot's late wife, Ines, and film restorer Serge Bromberg made the documentary *Henri-Georges Clouzot's Inferno*. The documentary features a number of interviews and exclusive footage, and was released in 2011 (Arrow Films released the Blu-ray in 2018).

A cult filmmaker who dealt with failing health and political fallout most of his life, Clouzot's career is perfectly analogous with the theme of this book: you can have unlimited creative control and unlimited budgets, but sometimes the filmmaking gods refuse to bend the knee to creatives. Everything is out of your hands—and the majority of films are finished with sheer luck.

Filmmaking fuels madness.

Madness fuels desperation.

Desperation fuels creativity.

HARMONY KORINE'S
FIGHT HARM

THE PLAYERS

Director
Harmony Korine

Starring
Harmony Korine

FADE IN

Harmony Korine has a certain effect on people.

For example, when I approached artist Dru Phillips about tackling Korine's unfinished Buster Keaton–esque comedy, *Fight Harm*, I simply said, "You seem to be a fan of Harmony Korine." (I assumed this because I saw Dru's alternative poster for Korine's *Trash Humpers*, and let's be honest: you have to be somewhat of a fan if you do poster art for a movie about old men thrusting their crotches into garbage piles.)

Dru's response? "I don't know if anyone can really call themselves a fan of Harmony Korine."

It's a fair statement.

Korine is a provocateur, an agent of chaos walking a fine line between filmmaker and disruptor. It's no surprise he tried his best to combine both of them in his abandoned project *Fight Harm*.

FLASHBACK

Korine met photographer Larry Clark while skateboarding with friends in New York City's Washington Square Park in the mid-nineties. Clark had a knack for exposing the underbelly of America's drug problem and built a photography career out of it with projects like *Tulsa* (1971) and *Teenage Lust* (1983). In 1993, Clark directed the music video for Chris Isaak's "Solitary Man," immediately setting in motion his desire to move into filmmaking.

Clark set out to make what he called "the great American Teenage movie" and asked the nineteen-year-old Korine to write the screenplay. Clark asked for two things in the script: skater kids and the AIDS experience seen through the eyes of teens. Three weeks later, Korine finished the script.

A day in the life of New York City teens, *Kids* is a docu-style look at underage drinking, smoking, and sex. Released on July 25, 1995, the movie introduced the world to Rosario Dawson, Chloë Sevigny, and the rambunctious, volatile new talent of Korine.[1]

1 Give his early, erratic interviews with David Letterman a watch or a rewatch . . .

Now a cult classic, *Kids* is not only a pre–social network look at kids running around without eagle-eyed parental supervision, but also a very real look at the horrors of decision-making at that age. While the character of Casper may have requested silence at the end of the film, *Kids* was wildly discussed across the country for how it tackled the AIDS crisis and underage sex. Some critics even went so far as to compare the final scene to child pornography.

The film made Korine a household name and opened the doors for him to tackle his directorial debut, *Gummo*. Unleashed on the unsuspecting world in 1997, *Gummo* follows a group of Xenia, Ohio, citizens as they pass the time in their tornado-devastated town. The cast of characters includes the mute, rabbit ear–wearing teenage boy simply known as Bunny Boy; the feral-cat-killing duo of Tummler and Solomon; the drag-dressing, cat-poisoning teen Jarrod Wiggley, who cares for his grandmother on life support; and two rowdy, foul-mouthed boys dressed as cowboys who fake-kill our Bunny Boy.

The *Gummo* narrative is a loose one mixed in with vignettes of other disturbing Xenia townsfolk. Shooting with nonactors and in real locations, Korine pushed the buttons of anyone he could, including those of his own crew. While shooting in an unkempt home where up to fifteen people lived, not to mention thousands of cockroaches,[2] crew members refused to shoot the scene unless they were provided hazmat suits. Korine and his director of photography, Jean-Yves Escoffier, scoffed at the idea, and both shot the scene wearing speedos and flip-flops.

Provocateur. Mischief-maker. Rabble-rouser.

In 1999, Korine embarked on his most controversial project yet. The filmmaker set out to make a violent, self-destructive comedy about fighting that was inspired by Buster Keaton. He just didn't tell anyone about it.

ACTION!

Keaton, an actor, screenwriter, director, and comedian, had a prolific career in the 1920s. A vaudeville baby, Buster grew up performing onstage with his father, Joseph Keaton. The act consisted of Buster being thrown around the sets constantly. The show was focused on extreme physical comedy, but Keaton never left the stage with bruises or broken bones.

2 The cockroaches themselves got plenty of screen time.

If only that aspect of the performance was what inspired Korine on *Fight Harm*.

The project had simple rules. Korine had to verbally assault a random passerby—but this random person had to be bigger than him. They also had to throw the first punch. Korine's goal with *Fight Harm* was to push humor to its breaking point.

Instead, he was the one that broke.

CUT!

After suffering multiple broken bones and injuries during filming, Korine shut the project down. Apparently, Buster Keaton never had a bouncer shatter his ankle with a furious stomp. But then again, Keaton also probably never antagonized a bouncer and smashed him in the head with a brick.

"Inspiration" is a funny word.

Korine has gone on record as saying the film contains nine "fights" total and is just over seventeen minutes long. He shared a clip of the film at the 2018 Key West Film Festival, and that remains the only footage seen to this day. In the end, Korine stated he wanted to make "the type of comedy" that Keaton or the Three Stooges would have been jealous of. Instead, he ended up battered, bruised, and in jail for fighting. Korine was arrested three different times while making the movie.

Although *Fight Harm* was shelved, 1999 saw the release of Korine's second feature film, *Julien Donkey-Boy*. The Dogme 95–style film focuses on a schizophrenic man and his dysfunctional family. Ewen Bremner (*Trainspotting*), Sevigny, and Werner Herzog star in the film. Impersonator dramedy *Mister Lonely* and the previously mentioned *Trash Humpers* followed.

Having spent much of his filmmaking and writing career toeing the line of inappropriate and accessibility, Korine, with the help of distributor A24, returned to the masses once again with 2012's *Spring Breakers*. A violent, Florida-set ode to the annual Bacchanalian ritual of spring break, the film was cast by Korine with pop star princesses who do drugs, rob diners, and have threesomes with James Franco.[3]

Korine returned in 2019 with the Mathew McConaughey–led *The Beach Bum*. The film follows Moondog (McConaughey), a rebellious writer who lives life by his own rules and makes plenty of mistakes along the way.

Sounds familiar, doesn't it?

3 A regular Florida weekend, right?

TEENAGE MUTANT NINJA TURTLES: THE NEXT MUTATION

THE PLAYERS

Screenwriters
Kevin Eastman
and Peter Laird

FADE IN

Before they were rebooted into CGI characters in 2014, the Teenage Mutant Ninja Turtles nearly saw the big screen again in a fourth live-action film. The studio and creators were oozing with ideas on where they wanted to take the beloved characters, and rightfully so: the third film was a massive disappointment. The franchise needed to head in a completely different direction and, well . . . they certainly tried.

FLASHBACK

Kicking off the franchise in 1990, *Teenage Mutant Ninja Turtles* was the wildly anticipated big-screen debut of the heroes in a half shell. Brought to life with the help of Jim Henson's Creature Shop and directed by Steve Barron (*Electric Dreams*, *Coneheads*), the film follows the Turtles and their Master Splinter as they fight the Foot Clan and Shredder. They get help along the way from hockey maniac Casey Jones (Elias Koteas) and TV reporter April O'Neil (Judith Hoag). *TMNT* opened number one at the box office on March 30, 1990, with a $25 million haul. Moviegoers ended up shelling out more than $200 million before the film left theaters.

New Line Cinema had a new franchise on their hands.

The Turtles returned to the big screen less than a year later with the greatest motion picture of all time: *Teenage Mutant Ninja Turtles II: The Secret of the Ooze*. Directed by Michael Pressman, the sequel took place one year after the events of the first film. The Turtles and Splinter now live in April's New York apartment as they look for a new sewer lair.[1] (The

1 April O'Neil was played by Paige Turco in the sequel, as well as the third film.

lair they end up finding made every kid in the early nineties want to find an abandoned subway station.)[2] The secret of said ooze is a chemical spill from Techno Global Research Industries. This ooze just happens to mutate anything that crosses its path. Say, like, four turtles and a rat.[3]

Or maybe the secret is there's still ooze left over after all these years, which is terrible news if Shredder survived being crushed by a garbage truck at the end of the first film. You know where this is going, right?

He one hundred percent survived that.

Shredder and the Foot Clan steal the surviving canisters from TGRI and use them on two unsuspecting victims: a baby snapping turtle and a baby wolf. Adorable, right? Wrong.

Okay, well, sort of wrong.

The ooze turns them into full-grown monsters named Tokka and Rahzar. The mutated beasts then terrorize and destroy anything they can get their hands on, which ends up being our Turtles. Once the Turtles come up with an antidote for these new creatures, they trick them with cure-coated candy. The big finale interrupts a Vanilla Ice concert, and Tokka and Rahzar return to their adorable baby-selves.

Once again foiled by the green foursome, Shredder uses the ooze on himself. This, logically, turns him into Super Shredder.[4] The Turtles take on the massively shredded villain, who in turn destroys the entire pier trying to, well . . . shred them, which causes the pier to collapse on all five fighters. Shredder is presumably killed, and the Turtles survive and celebrate with a cool-as-ice victory dance.

Secret of the Ooze opened number one at the box office on March 22, 1991, grossing $20 million. It wound up grossing $78.6 million, significantly less than the first film. (I had assumed, up to this point in my life, that like most of the other "greatest movies ever made," this movie had grossed $100 trillion at the box office. Clearly, it did not.)

The inevitable third Ninja Turtles live-action movie was released March 19, 1993. Simply titled *Teenage Mutant Ninja Turtles III*, this sequel sends the turtles back in time to 1603 feudal Japan in order to save April.

2 Not to mention, do all of the karate. Or maybe that was *3 Ninjas*.
Regardless . . . karate!
3 [Whispering to wife while watching *Secret of the Ooze* when the Turtles and Splinter first appear on the screen] "That's the secret of the ooze."
4 Super Shredder was played by wrestling legend Kevin Nash.

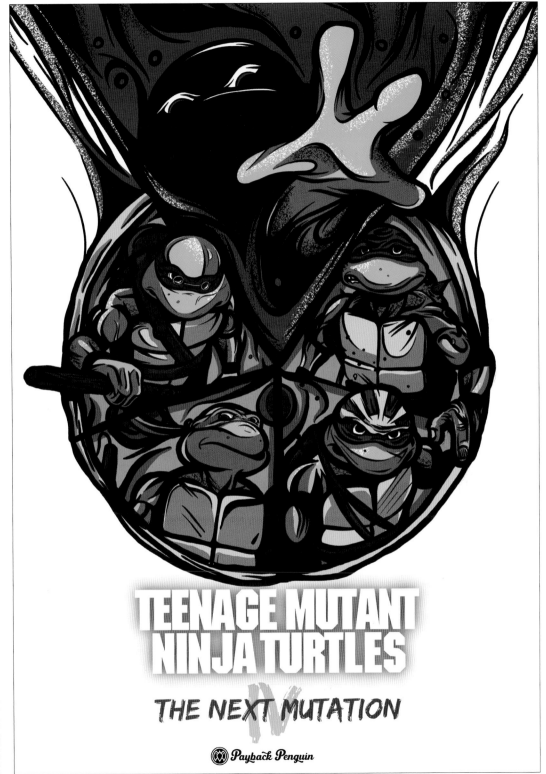

TEENAGE MUTANT NINJA TURTLES

THE NEXT MUTATION

Payback Penguin

Wait—how the heck did April end up in Japan?

She bought an ancient Japanese scepter at a flea market that just happens to allow people, and reptiles, to experience the seemingly random vicissitudes of the space-time continuum.[5] Part three would be the first live-action *TMNT* film made without the Jim Henson Creature Shop. Instead, the animatronics were handled by Eric Allard's All Effects Company. All Effects created *Short Circuit*'s Johnny 5, the Energizer Bunny, and handled effects on films like *Demolition Man*, *Alien: Resurrection*, and *The Matrix Reloaded*. The third film would carry the largest production budget of the franchise.

It would also see the lowest box office returns, despite opening number one with $12 million. The film edged out Bridget Fonda's *Point of No Return*, Robert Patrick's *Fire in the Sky*, Chris Rock's *CB4*, and Bill Murray's *Groundhog Day*.

After the critical and commercial failure of part three, producers were desperate for a change. It was time to give the franchise, and Turtles, a makeover.

ACTION!

Development on the fourth film began in 1994. *Turtles* creators Kevin Eastman and Peter Laird wrote the outline and did a number of character sketches for the film, which they were calling *The Next Mutation*.

Now, I'm no expert, but it seems like if you nearly killed the franchise with time travel, you should *time travel* back to what worked for the franchise originally: Ninja Turtles doing karate, eating pizza, and fighting bad guys. Much like cheese pizza itself, it's a simple recipe.

Ninja Turtles: The Next Mutation would continue to move the Turtles away from the franchise's origins. In the fourth film, Eastman and Laird planned on introducing a second round of bizarre mutations for the Turtles and Master Splinter. They would all be impacted differently.

Donatello ends up with new telekinetic and telepathic powers. Because of these new gifts, however, he starts to lose his eyesight. That's right, ladies and gentlemen, Donatello is going blind.

5 Side note: Has Pinhead ever considered dropping off that little LeMarchand Box from *Hellraiser* with a flea-market vendor? The savings would be legendary!

Leonardo is now able to change his skin into a chrome-like, indestructible surface for protection—basically he is the Ninja Turtle version of Colossus from the X-Men. Party dude Michelangelo mutates into just that: a party dude. Literally. He can morph into human form, allowing him to interact and eat pizza with humans freely. Raphael is also able to morph, but into something they are calling "Raptor Raph"—a dinosaur/turtle hybrid in a red bandanna. Classic Raph! Master Splinter is able to change into a super-muscular rat mutant . . . because *of course.*

The sequel also sees the return of Super Shredder, the Foot Clan, Casey Jones, April O'Neil, and an Evil April. The strangest part of *The Next Mutation*? There is a fifth turtle introduced, named Kirby.

CUT!

I think it's pretty obvious why this movie never happened. Let's run it back just in case it isn't: Blind Donatello. Chrome Leonardo. Human Michelangelo. Raptor Raph. Rat Monster Splinter. New turtle Kirby. Evil April.

I mean, these movies were geared toward children, but these new mutations were clearly not geared for even a relatively sane human of any age. Even though there were teasers released in comic books and an entire toy line planned, the film was scrapped altogether.

The franchise remained in the sewers until 2007's *TMNT*. The all-CGI-animated film features a voice cast of Chris Evans, Patrick Stewart, Kevin Smith, Sarah Michelle Gellar, and Laurence Fishburne. In 2014, Paramount and Nickelodeon gave the franchise a live-action reboot with the help of Platinum Dunes. The Turtles were motion-capture/CGI with the help of Industrial Light & Magic. Jennifer Fox, Will Arnett, William Fichtner, and Whoopi Goldberg starred as the human characters.

This reboot opened at the box office with $65.6 million and went on to make a worldwide total of $493.3 million. A sequel, *Teenage Mutant Ninja Turtles: Out of the Shadows*, was released on June 3, 2016, once again starring Fox and Arnett. *Arrow* star Stephen Amell joined the cast as Casey Jones and Tyler Perry played the role of Dr. Baxter Stockman. The sequel also featured the big-screen debuts of Bebop, Rocksteady, and Krang (voiced by Brad Garrett).

In summer 2018, it was announced that Platinum Dunes would reboot the franchise yet again. There have been no further developments since. Cowabunga!

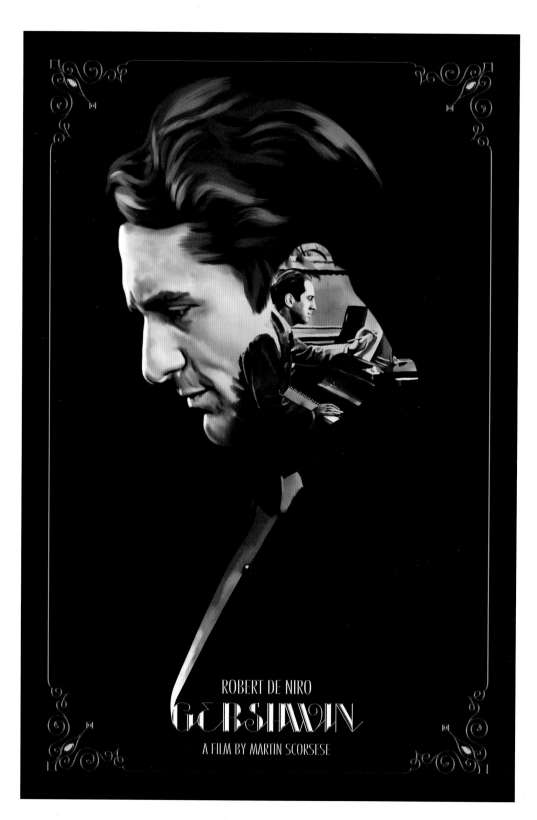

ROBERT DE NIRO

GERSHWIN

A FILM BY MARTIN SCORSESE

MARTIN SCORSESE'S
GERSHWIN

THE PLAYERS

Director
Martin Scorsese

Screenwriters
Paul Schrader and
John Guare

Starring
Robert De Niro

FADE IN

Legendary director Martin Scorsese has tackled an array of subjects through-out his fifty-year filmography. From mob movies to epic dramadies about disturbed antiheroes to smaller-scale dramas about bedraggled ambulance drivers, one subject Scorsese tends to hang his hat on is real-life people.

The filmmaker has dramatized the lives of Jake LaMotta, Henry Hill, the Dalai Lama, Jordan Belfort, and Howard Hughes.[1] Scorsese spent nearly two decades attempting to bring another life to the big screen: composer George Gershwin.

Let's strike up the band and dive into the development of Scorsese's *Gershwin*.

FLASHBACK

After depicting the unsettling downward spiral of psychopath Travis Bickle in *Taxi Driver*, Scorsese spent the next few years on a musically driven path. His *Taxi Driver* follow-up, 1977's *New York, New York*, starred Liza Minnelli and Robert De Niro, in De Niro and Scorsese's third collaboration to that point. *New York, New York* follows the struggling-yet-egotistical musician Jimmy and singer Francine, who meet on August 15, 1945—commonly known as V-J Day (or Victory over Japan Day). The couple navigate love, careers, and dreams in the changing landscape of postwar New York.

Leaving the city that never sleeps behind, at least for a time, Scorsese released two documentaries in 1978. After sixteen years on the road, the Band plays their last concert in *The Last Waltz*. The concert took place on November 25, 1976, and audience members were treated to a full turkey dinner after the show. The concert featured a number of guests, including Neil Young, Joni Mitchell, Muddy Waters, Ringo Starr, Bob Dylan, and Neil Diamond.

1 *The Aviator*, Scorsese's 2004 film about Howard Hughes, derailed another promising film on the life of Hughes. Christopher Nolan nearly made a film about the last years of the mogul's life starring Jim Carrey. Uninterested in competing with Scorsese, he shelved the film after *The Aviator*.

Diamond also shares a connection with Scorsese's second documentary of that year, *American Boy: A Profile of Steven Prince*. Steven Prince played gun salesman "Andy" in Scorsese's *Taxi Driver*, and the documentary follows Prince as he tells stories about his life as the road manager for Diamond and being an ex–drug addict.

In 1980, Scorsese returned to the narrative ring, and to New York City, with the boxing drama *Raging Bull*. Starring De Niro, Joe Pesci, and Cathy Moriarty, *Raging Bull* tells the story of prizefighter Jake La Motta—a punishing, talented boxer inside the ring, but a reckless, violent man outside of it. The film was adapted from La Motta's memoir, *Raging Bull: My Story*, by Mardik Martin and *Taxi Driver*'s Paul Schrader. While the film had a low box office tally, it raged into awards season. It was nominated for eight Academy Awards, winning a Best Actor statue for De Niro and a Best Editing statue for Thelma Schoonmaker. De Niro also won the Golden Globe for Best Actor and received a BAFTA nomination as well. (Schoonmaker won a BAFTA for Best Editing, and Pesci won for Most Promising Newcomer.)

After a bevy of awards for *Taxi Driver* and *Raging Bull*, Scorsese and Schrader attempted to strike another memorable note with a third collaboration: they set out to bring the story of Gershwin to the big screen.

The project left both feeling kind of blue.

ACTION!

Gershwin is one of the most beloved American composers and pianists, and his influence has spanned well past his lifetime. Known for the compositions "An American in Paris," "Concerto in F," and "Rhapsody in Blue," as well as the musicals *Funny Face* and *Girl Crazy*, he left a lasting mark on the world. The composer also wrote the music for the Fred Astaire/Ginger Rogers RKO musical *Shall We Dance*. While his music was widely known across the world, his personal life was more of a mystery to the masses—a mystery Scorsese and Schrader set out to unravel.

Schrader's screenplay for *Gershwin* was a masterful dive into the composer's life, divided into nine different chapters. Each chapter represented a significant thematic part of his story. While Gershwin in general is fantastic material for a film, it's the approach to the script/film that would have made it seem even more extraordinary. The plan was to have eight to fifteen minutes of each chapter be in black-and-white, followed by a four- to five-minute musical conclusion for each chapter in color. Each coda

would also feature a guest or cameos from Gershwin's life. The screenplay is 132 pages of a miraculous existence told through music and musical numbers that ends with the quiet death of Gershwin.

CUT!

After the success of *Taxi Driver*, Schrader started directing films as well. This led to complications with writing credit, and credit in general. Development on Schrader and Scorsese's version of *Gershwin* ended after disagreements on a remake of Vincente Minnelli's *The Bad and the Beautiful*, which also would have starred De Niro.

Years later, Scorsese brought on *Six Degrees of Separation* screenwriter John Guare to write a new take on a Gershwin biopic. That version nearly starred Richard Dreyfuss and De Niro. When Scorsese brought the project to Warner Bros., they asked for Scorsese's proposed biopic on Dean Martin, *Dino* (see Overexposed!), instead. Gershwin once again passed away quietly, this time at the hands of the studio.

After declaring they would never work together again after their falling out, Scorsese and Schrader mended their rift and teamed up again for 1988's *The Last Temptation of Christ* and 1999's *Bringing Out the Dead*.

As for *Gershwin*, the film that seemed destined for awards and acclaim remains on the shelf to this day. Time and disagreements seemed to have robbed film lovers of another classic Scorsese, Schrader, and De Niro team-up.

That's not music to our ears . . .

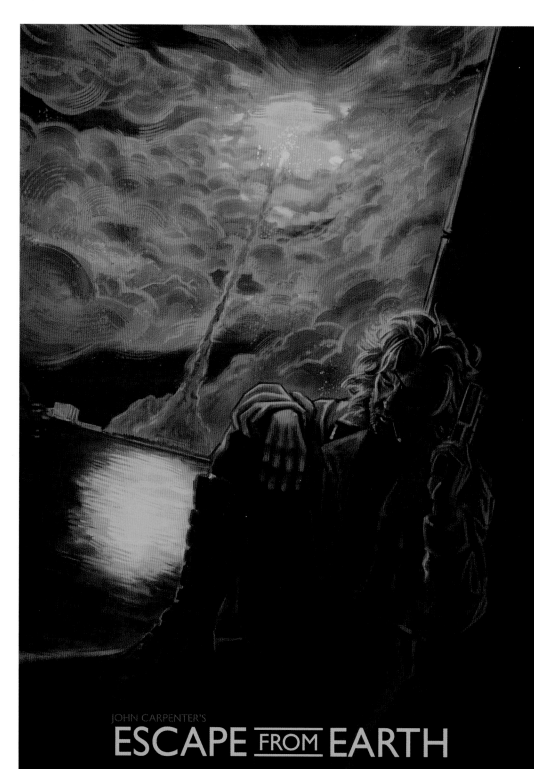
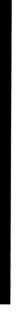

JOHN CARPENTER'S
ESCAPE FROM EARTH

JOHN CARPENTER'S
ESCAPE FROM EARTH

THE PLAYERS

Director
John Carpenter

Screenwriters
John Carpenter

Starring
Kurt Russell

FADE IN

Originally planned as John Carpenter's follow-up to 1974's *Dark Star*, *Escape from New York* had to wait in line behind an *Assault on Precinct 13*; the sister-killing Michael Myers in 1978's *Halloween*; and the ghost-pirate-carrying fog in 1980's *The Fog*.

While audiences met Snake Plissken in New York in 1981, and reacquainted with him in LA in 1996, they were nearly reunited again with the eye-patch-wearing antihero years later in a third *Escape* movie: *Escape from Earth*.

FLASHBACK

Set in the bold future of 1997, *Escape from New York* reframes Manhattan as New York Maximum Security Penitentiary. During a flyover to a summit, *Air Force One* is brought down by the convicts of the island-wide penitentiary, resulting in the president being held hostage. The prison dean offers Snake Plissken, a former Special Forces soldier, the chance at parole if he can rescue the president and recover a secret audiotape in less than twenty-three hours. Snake is injected with micro-explosives that will explode in twenty-two hours.

No pressure, right?

An action-packed adventure follows as Snake locates the president and the audiotape. He might even have a little fun doing it all. Snake delivers the president and the audiotape to the dean, resulting in the micro-explosives being neutralized. Snake is then offered anything he wants by the president, but he ignores the question and walks away. The dean discovers that the tape Snake turned in is actually a song called "Bandstand Boogie," meaning Snake kept the real one, which is filled with nuclear secrets. *New York* opened July 10, 1981, grossing a total of $25 million.

It took Snake Plissken fifteen years to get back to the big screen. In *Escape from L.A.*, the year is 2013. After an earthquake breaks Los Angeles away from the rest of the country, it's turned, like Manhattan before it, into a

prison-like island. A giant wall is built around LA, and citizens who refuse to follow the law are deported to "La La Island." When the president's daughter abandons *Air Force One*, and takes control of the "Sword of Damocles" along with her,[1] she joins forces with LA revolutionary Cuervo Jones. Jones knows what the Damocles can do to the technology of the world—and he also just happens to know the code that can knock out power all over the world. Plissken, already on his way to the island for his own crimes, is offered a chance at freedom if he can get control of the Damocles back from Cuervo. Snake eventually does so after playing a little basketball, defeating Jones, and escaping with the president's daughter and his life. Oh yeah, Snake also gets the code to shut down the world. It shouldn't come as any surprise that Snake does indeed use the code, sending the world back into the dark ages: "Welcome to the human race."

Armed with a $50 million budget, *Escape from L.A.* opened August 9, 1996. The sequel landed at number three for the weekend, falling behind Francis Ford Coppola's *Jack* and Joel Schumacher's *A Time to Kill. L.A.* dropped 52 percent in its second weekend of release. The third weekend saw a nearly identical drop for the film. After four weeks, *L.A.* escaped from theaters with $25.4 million, a nearly identical gross to *Escape from New York*. Snake's audience proved to be consistent but his budgets proved to be his fatal flaw.

ACTION!

With New York and Los Angeles checked off his travel boxes, not to mention the entire world wanting his head on a stick, Plissken only had one place to escape from next: Earth.

In the lead-up to *Escape from L.A.*, a third entry was talked up by both Carpenter and Russell. It would have been fascinating to see what Carpenter and Russell would have cooked up to get Snake off of Earth, considering he had just rendered all technology useless in the second film's finale. There were even rumors in the early 2000s that Paramount was actively pursuing a third *Escape* movie. Those, unfortunately, proved to be false.

1 Damocles is a group of satellites that can knock out electronic devices all over the world when it's activated. One of those patented "This can't fall into the wrong hands" type of things. It does, however, fall into the wrong hands.

Snake Plissken had finally found the one thing he couldn't escape from: disappointing box office results.

CUT!

Due to the lackluster box office of *Escape from L.A.*, as well as lackluster critical reception, the future of Snake Plissken was put on ice. Years later, another *Escape* project was developed. This one would see Plissken already off of Earth and attempting to escape Mars. Plissken is transported to a remote mining town, only to discover the miners have been possessed by "Mars ghosts."

I know what you're thinking: "Hey, wait a minute—John Carpenter made a movie about ghosts on Mars."

He sure did, but only after replacing Snake Plissken with a character named Desolation Williams. And replacing Kurt Russell with Ice Cube. And, you know, calling the movie *Ghosts of Mars* instead of *Escape from Mars*.

It's essentially the same movie. Only, one that got made and just happens to have Jason Statham in it.

While Carpenter himself has escaped the Snake franchise, talks of reviving Snake in an *Escape from New York* remake have been happening for years. Gerard Butler was announced as the new Snake in 2007. A year later, Josh Brolin was rumored to have snaked the role from Butler. Ten years after the Butler story hit, Robert Rodriguez (*Sin City*, *Planet Terror*) was announced as the director of the *New York* remake. In early 2019, however, Leigh Whannell (*Insidious*, *The Invisible Man* [2020]) was announced as the screenwriter, and possible new director, for the remake. As of that announcement, Carpenter was executive producing Whannell's remake.

OVEREXPOSED!
JOHN CARPENTER

While he's billed as the Horror Master, Carpenter had a prolific career outside of the genre as well. For as many films as he's made, and the legacy he holds as one of our greatest filmmakers, there were countless other exciting films he almost brought to life.[1] One of which, *Shadow Company*, is already in the pages of this book (see pages 43-46). We briefly discuss four more "almost-Carpenters" below.

HALLOWEEN 4: Carpenter and Debra Hill were approached to bring Michael Myers back to the big screen after the disappointing reaction to *Halloween III: Season of the Witch*. Dennis Etchison was brought on to write the screenplay, and Carpenter wanted Joe Dante to direct the film. Hill and Carpenter, however, sold their interest in the franchise, and Etchison's screenplay was not included. Carpenter had no interest in returning to Haddonfield, so franchise producer Moustapha Akkad moved on to what became Dwight H. Little's *Halloween 4: The Return of Michael Myers*.

HALLOWEEN H20: 20 YEARS LATER: In 1998, Carpenter once again nearly returned to the franchise that started it all for him. With Jamie Lee Curtis returning, Carpenter agreed to direct the film for a $10 million fee. Akkad

refused to pay the massive salary, resulting in Carpenter walking away from the film. *Friday the 13th: Part 2* director Steve Miner directed the film instead.

Carpenter finally returned to Haddonfield twenty years later, with Curtis, for David Gordon Green's *Halloween* (2018). Carpenter served as executive producer and returned to score the film alongside his son Cody Carpenter and Daniel A. Davies.

PINCUSHION: In 1989, after *Shadow Company* fell apart, Carpenter set out to make an apocalyptic road trip film starring Cher. *Pincushion* would have seen the musician play a courier who within three days must deliver to Salt Lake City the cure for the plague destroying the country. Easier said than done when the drive is filled with radiation and disease-ridden mutants, as well as a sinister group known as The Cross trying to stop her. The Cross isn't some religious group of freaks—it's literally a tyrannical version of the Red Cross. Issues in preproduction, as well as a writers' strike, put a pin in this cushion. If we could turn back time . . .

CREATURE FROM THE BLACK LAGOON: After memoir'ing an invisible man in 1992, Carpenter set out to give his take on another legendary Universal Monster with a remake of Jack Arnold's *Creature from the Black Lagoon*. *Christine* screenwriter Bill Phillips was

brought on board to write the script, and Carpenter brought on practical-effects wizard Rick Baker to bring the Gill-Man to life. Universal unfortunately never gave the green light for this remake.[2] Eagle-eyed fans, however, caught a glimpse of Baker's Gill-Man sculpt in 2019, when Carpenter was doing an interview. The Gill-Man was sitting on a shelf behind the filmmaker, giving "what if"-ers a peek into Carpenter and Baker's monstrous plans.

1 Also, some curious ones: Did you know John Carpenter almost directed a movie about Santa Claus? Not a killer Santa or anything. Just a movie about the mysteries and myths of Santa. Like, how his reindeer fly. That movie eventually became *Santa Claus: The Movie*, starring Dudley Moore.
2 Universal also famously declined a *Creature from the Black Lagoon* remake from Guillermo del Toro. He went on to make his own *Creature*-esque story with the Academy Award-winning *The Shape of Water* in 2017.

LARRY CLARK'S
MONA LISA

THE PLAYERS

Director
Larry Clark

Screenwriters
Larry Clark and
David Reeves

Starring
Mickey Rourke,
Eva Green

FADE IN

In 1986, Neil Jordan unleashed his violent crime drama about an ex-convict who gets caught up in the life of a call girl. Written by Jordan and David Leland, *Mona Lisa* starred Bob Hoskins, Michael Caine, and Cathy Tyson. Hoskins played George, an ex-con who gets a job driving Tyson's Simone from client to client. The relationship grows between George and Simone, eventually leading to trouble with Caine's kingpin, Mortwell. The thriller ends in a violent confrontation, leaving Simone a killer and George free of the criminal past that has haunted him his entire life.

The critically acclaimed film soon found itself at the center of awards-season talk. Hoskins earned Academy Award, BAFTA, and Golden Globe nominations for Best Actor (he won both the BAFTA and the Golden Globe). Cathy Tyson also scored a BAFTA nomination, losing out to Maggie Smith for her role in James Ivory's *A Room with a View*. *Mona Lisa* was a critical and award darling, and was made relatively recently—just twenty-five years ago, at the time—but none of that stopped Larry Clark from doing his damnedest to remake the film in 2009.

FLASHBACK

Clark was used to drawing attention. His debut feature film, *Kids*, was a gritty, realistic look at teenagers on the streets of New York dealing with life, drugs, and the AIDS epidemic (see pages 191–192). The controversial NC-17 film put Clark and writer Harmony Korine on the filmmaking map, and both soon proved they weren't ones to follow a simple path.

The success and attention of *Kids* helped Clark land the crime drama *Another Day in Paradise* in 1998. Starring James Woods and Melanie Griffith, the film follows a robbery gone bad and the two couples who attempt to right the wrong with an even bigger score.

After *Another Day in Paradise*, Clark headed back into the teenage wasteland for 2001's *Bully*. Another graphic, violent film from the director, *Bully* was based on the real-life 1993 murder of Bobby Kent. After suffering years

of abuse at the hands of their friend Bobby, a group of teens conspire and, eventually, brutally kill Bobby in the swamps of Florida. The film starred Brad Renfro, Bijou Phillips, Michael Pitt, Daniel Franzese, Rachel Miner, and Nick Stahl (as the doomed Bobby Kent).

After his 2002 made-for-TV film *Teenage Caveman*, Clark reteamed with Korine for the sexually graphic *Ken Park*, also in 2002. Korine wrote the film based off of Clark's journals. Once again set around the lives of dysfunctional teens, *Park* is a far more explicit and intense journey. A visual onslaught of suicide, uncomfortable sexual encounters, and brutal killings, the film was saddled with issues and controversy from the beginning. Clark himself was arrested for assaulting the film's UK distributor. After the film played the Telluride Film Festival, it couldn't be released in the United States due to copyright issues, and the film was (and still is) banned in Australia because of the subject matter.

In 2005, Clark toned things down with his fourth film about teenagers. *Wassup Rockers* focused on a group of South Central LA teens who skateboard, wear tight pants, and listen to punk rock music (instead of diving into the hip-hop and gang culture of their neighborhood). Trouble still finds the group of friends as their attitudes, race, and behavior clash with their neighbors.

Later that year, Clark revealed he'd be tackling a remake of Neil Jordan's *Mona Lisa*. It took four more years for things to get rolling.

ACTION!

After 2008's *The Wrestler* landed him a Best Actor Oscar nomination, Mickey Rourke was looking for his next work of art. He found his *Mona Lisa* in 2009, signing on to star as George in Clark's updated take on the eighties thriller. Former Bond girl Eva Green wasn't far behind Rourke, taking on the role of Simone and setting up a thrilling one-two punch for the film.

Clark's plan was to take the film out of London and set it in New York City. Principal photography was scheduled to start in August 2009.

But it never did.

CUT!

There's no explanation from Clark as to why the remake of *Mona Lisa* fell apart. In November 2012, three years after filming was scheduled to begin,

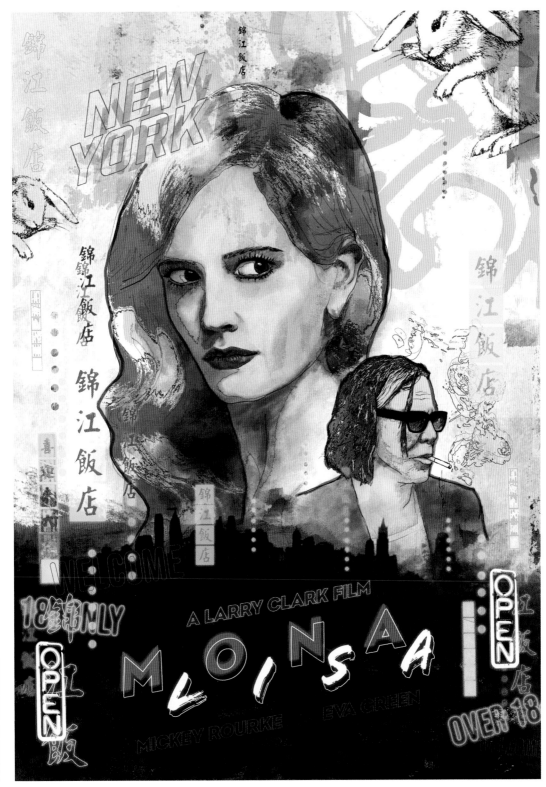

POSTER BY SAM COYLE

he was asked about the status of the film in an interview and responded with three simple words: "It's not happening."

While it's surprising that a filmmaker like Clark would tackle a remake of a classic film in the first place, it's exciting to imagine just what his grungy, New York City version of *Mona Lisa* might have looked like.

In 2012, Clark directed the first film in the *Marfa Girl* trilogy. *Marfa Girl* follows a directionless teenager as he weaves in and out of relationships. While by no means directionless, Clark continues to weave in and out of our lives, leaving cinematic shocks and awes when he does.

KEVIN SMITH'S

FLETCH WON

THE PLAYERS

Director
Kevin Smith

Screenwriter
Kevin Smith

Starring
Jason Lee

Based on
Fletch Won
by Gregory
Mcdonald

FADE IN

In 1985, Chevy Chase played the role of reporter Irwin M. "Fletch" Fletcher in director Michael Ritchie's *Fletch*, a loose adaptation of author Gregory Mcdonald's *Fletch* novels. In the film, Fletch receives an offer to kill a sick millionaire but soon discovers all might not be what it seems. *Fletch* opened number two at the box office on May 31, 1985, behind *Rambo: First Blood Part II*. The film ended its box office run with a total of $59 million and added another $24 million with its home video release.

Ritchie and company returned four years later with a sequel: *Fletch Lives*. An inheritance brings the reporter to Louisiana, and he finds himself embroiled in more criminal shenanigans. Despite opening number one at the box office, *Fletch Lives* wrapped up its theatrical run with a total of $39 million worldwide, an exact $20 million drop from the first film. Lackluster reviews and poor box office receipts stopped the franchise in its tracks until a former clerk from New Jersey got his hands on the property in 2000.

FLASHBACK

After a whirlwind tour promoting *Dogma*, Kevin Smith was ready to move past the controversies, the protests, the death threats, and the giant poop monsters.[1]

Smith's largest budget before *Dogma* had been the $6 million *Mallrats*. That second entry in the View Askew universe (hereafter referred to as the "ViewAskewniverse") saw two slacker best friends spend the day in the local mall after their girlfriends break up with them. There they encounter mystery schooners Michael Rooker, Stan Lee, and Ben Affleck.[2] Alongside Rooker and Affleck, *Mallrats* also stars Jeremy London, Jason Mewes,

1 *Dogma* was Smith's fourth film and carried a budget of $10 million. You'd have to assume at least $5 million of that is what it cost to give Affleck the genitalia of a Ken doll.

2 This time with Full Affleck Crotch for all of those, uh, uncomfortable places.

Shannen Doherty, Joey Lauren Adams, and Jason Lee (in his acting debut). Keep that last bit of casting information in your memory bank.

Mallrats opened number thirteen at the box office the weekend of October 20, 1995. The film grossed a total of $2.1 million, with $1.2 million of that from its opening weekend alone. After taking a critical and commercial thumping at the mall, Smith returned to a smaller-budget production with *Chasing Amy*. Reuniting with Adams, Affleck, and Lee, *Chasing Amy* was also a return to Smith's smaller, character-driven *Clerks* roots.

In *Chasing Amy*, comic book artists Banky (Lee) and Holden (Affleck) meet comic book artist Alyssa (Adams). Holden falls head over heels for her, but his world is thrown upside down when he discovers she's a lesbian. Banky and Holden's friendship and creative partnership hits a major snag as Holden and Alyssa navigate their complicated relationship. Made for $250,000, *Chasing Amy* went on to make more than $12 million. The film was nominated for numerous awards, including three Independent Spirit Awards, winning Best Screenplay and Best Supporting Actor for Lee.

The success of the film also scored Smith a meeting with Stacey Snider, an executive at Universal. When asked if there was a project Smith had his eyes on, he pitched Snider on a Universal property: *Son of Fletch* starring Chevy Chase, Lee, and Adams. But after Smith met with Chase, and the two didn't exactly see eye to eye, development stalled on the film.

Flying high, critically and commercially, and somewhat in demand, Smith instead turned his attention to the previously mentioned $10 million religious comedy *Dogma*, starring Affleck and Lee, as well as Matt Damon, Chris Rock, Linda Florentino, Alan Rickman, Salma Hayek, George Carlin, Alanis Morissette, and Janeane Garofalo.

The fourth film in the ViewAskewniverse follows an abortion clinic worker who has to prevent two renegade angels from reentering heaven, which would prove God wrong and unmake the entirety of existence.

The film attracted controversy from all angles, including a "blasphemy" label from the Catholic Church. *Dogma* was protested outside of theaters all across the country, and Smith even received death threats because of the film. Reminder: this movie features crotchless versions of both Damon and Affleck, as well as a giant poop monster, so it's a bit confusing as to why *anyone* took it that terribly seriously.

Despite the commotion, *Dogma* opened on 1,269 screens on November 12, 1999. It opened number three behind *Pokémon: The First Movie* and *The Bone Collector*. It did, however, beat *The Messenger: The Story of Joan of Arc* by $2 million, so *Dogma* etched out another small win over Catholicism that weekend.

Whose house?

Run's house.

ACTION!

In mid-2000, after his falling-out with Chase, Smith was informed that Universal had let the rights to the *Fletch* franchise lapse. He then approached Miramax to see if they had any interest in acquiring the rights. Within twenty-four hours, the *Fletch* franchise landed in the hands of Bob and Harvey Weinstein. Smith scrapped plans for *Son of Fletch* and instead focused on a complete reboot of the franchise, starting with Mcdonald's eighth book in the series, *Fletch Won*.

Published in 1985, *Fletch Won* is a prequel book taking place before the first seven novels. The book follows our titular hero as he stumbles his way through an early reporting career and into a criminal conspiracy involving a crooked lawyer and his law firm.

With Fletch living once again, Miramax and Smith turned their attention to casting. The Weinsteins pushed for Affleck, while Smith wanted Lee to take on the role. David List, Mcdonald's manager, wanted Ryan Reynolds as the reporter, but Reynolds passed on the role. Three years after securing the *Fletch* rights, the Weinsteins were prepared to offer Affleck $10 million to take the role. Passing on his first choice, Lee, Smith agreed to cast Affleck as Irwin Fletcher.

Production officially began on Smith's *Fletch Won*.

CUT!

Soon after, Affleck ghosted the production to star in Mark Waters's *Ghosts of Girlfriends Past*.[3] Smith once again went on the campaign trail for Lee, but Weinstein refused to budge. Silent Bob was officially silenced on the matter.

3 Affleck wouldn't do this movie, either. *Ghosts of Girlfriends Past* eventually came out in 2009 starring Matthew McConaughey.

The casting train continued to move slowly down the rails. Zach Braff was heavily considered after the success of *Garden State*, and Dave Chappelle was even briefly discussed at one point. Struggles over casting, and frustration with the Mcdonald camp, led to Smith walking away from the project altogether in 2005. Ironically, *My Name Is Earl*, starring Lee, premiered to huge numbers later that year.

Smith returned to the ViewAskewniverse, and to Miramax, with 2001's *Jay and Silent Bob Strike Back*. The film follows the adventures of, well, Jay and Silent Bob as they try to shut down the big-budget version of a metafictional Bluntman and Chronic movie.

Affleck, Damon, and Lee all made appearances. As for *Fletch Won*, the movie remains in development hell. Soon after Smith left, *Scrubs* creator Bill Lawrence came on board the film to direct Braff as Fletch. Both eventually walked away from the project. Steve Pink (*Accepted*) then signed on to make the movie in 2007. This version of *Fletch* would have starred Joshua Jackson—but the circle of unmade Fletch continued. Jason Sudeikis next signed on to star in a *Fletch* reboot in 2014, but there have been no signs of life on that version since.

It's worth noting that Smith recently returned to the ViewAskewniverse in 2019, after a thirteen-year break, to write and direct the *Jay and Silent Bob Reboot*. Yes, your math is correct. The movie Smith made after his *Fletch* reboot crumbled got a reboot *before* the *Fletch* franchise did.

Snoochie Boochies.

EARTH'S DARK DEAD CORNERS AND DEPTHS BE LET ALONE

TOM CRUISE

from visionary director
GUILLERMO DEL TORO

AT THE
MOUNTAINS OF
MADNESS

based on the book by H.P. LOVECRAFT

AT THE MOUNTAINS OF MADNESS

THE PLAYERS

Director
Guillermo del Toro

Screenwriters
Guillermo del Toro and Matthew Robbins

Producer
James Cameron

Starring
Tom Cruise

Based on
At the Mountains of Madness by H. P. Lovecraft

FADE IN

Picture this: You're Guillermo del Toro. Ahem, I'm sorry: You are the Oscar-nominated Guillermo del Toro. You're one of the most beloved film-makers in the world. You know how to juggle fantasy and horror with humor and spectacle. You're currently waiting to hear if you get the green light on the movie you've been developing for more than six years. A wait that, at this point, honestly seems a little absurd.

Sure, it's a $150 million-budget film that will be rated R … but you cow-rote the screenplay with Matthew Robbins. He worked on *Close Encounters of the Third Kind* and wrote **batteries not included*.[1] Hell, he even wrote your gothic horror romance movie, *Crimson Peak*. You have James Cameron pro-ducing the movie for you and lending his expertise with the 3-D technology. *Terminator 2: Judgement Day* did all right with its R rating, and *Avatar* did all right with its 3-D. You also have Tom Cruise as the star.

Maverick could get that $150 million back just by flashing his perfect smile. This is a foolproof package. Nobody in their right mind would say no to— What's that?

They *actually* said no?

Yes, they actually said no. Universal Pictures turned down a $150 million H. P. Lovecraft adaptation from Tom Cruise, James Cameron, and Guillermo del Toro. How does that even happen?

Let's dive in.

1 Robbins also worked on Spielberg's *The Sugarland Express* and *Jaws*, as well as del Toro's *Mimic*.

FLASHBACK

After playing the major-studio game with 2004's *Hellboy*, del Toro returned to his small-scale, Spanish-focused films with *Pan's Labyrinth*. Set in 1944 post–civil war Spain, the horror-fantasy follows young Ofelia (Ivana Baquero), who joins her pregnant mother to live with the totalitarian Captain Vidal (Sergi López). Escaping the horrors of her real world, Ofelia follows a fairy into a maze, where the faun Pan waits for her with three tests. If she succeeds, she will gain immortality and rejoin her father, king of the underground. *Pan's Labyrinth* fantastically interweaves Ofelia's fantasy tasks and the real-life resistance against Vidal and his troops, resulting in a masterpiece of cinema.

Released in 2006, *Pan's Labyrinth* received six Academy Award nominations, winning three of them: Best Cinematography, Best Art Direction, and Best Makeup. It followed that up with eight BAFTA nominations, winning three: Best Film Not in the English Language, Best Costume Design, and Best Hair and Makeup. It was also nominated for Best Foreign Film at the Golden Globes.

Equally as important as being an award darling, *Pan's Labyrinth* gave del Toro the clout to get *Hellboy II* made at Universal. After Revolution Studio's deal with distributor Columbia Pictures fell through, Universal Pictures acquired the rights to the *Hellboy* franchise. They also acquired another property del Toro had been developing—an adaptation of H. P. Lovecraft's *At the Mountains of Madness*.

Written by Lovecraft in 1931, *Madness* is the account of one Dr. William Dyer of the Miskatonic University, who tells the story of an expedition that came across ancient alien ruins. Inside these ruins lies the secret to mankind and evil itself. There are Elder Things, blind six-foot-tall penguins, and an ancient, evil black mass called Shoggoth.

Giant monsters, general fantasy spookiness, and mysterious structures— these are all common ingredients in a del Toro film. They are definitely heavy ingredients in *Hellboy II: The Golden Army*. All signs were pointing to del Toro tackling *Madness* after the *Hellboy* sequel until he suddenly (and unexpectedly?) jumped on a different fantasy adaptation.

With a little more than two months to go before the release of the *Hellboy* sequel, del Toro signed on to write and direct *The Hobbit* for New Line Cinema and MGM. A sequel series to Peter Jackson's award-winning *Lord*

of the Rings trilogy, del Toro would direct two *Hobbit* films back-to-back. The director relocated to New Zealand for writing and preproduction.

Nearly two years later, on May 31, 2010, del Toro took his own unexpected journey and walked away from *The Hobbit*. A month and a half later, *At the Mountains of Madness* was announced as his next film.

He was leaving Middle-earth for the South Pole.

ACTION!

Del Toro's *At the Mountains of Madness* was originally announced in 2004, but the film never came together, partly due to budgetary concerns on the side of DreamWorks. But 2010 obviously wasn't 2004: Universal knew what they had in del Toro—a fan-favorite auteur who would deliver a stunning product for genre fans all over the world.

With news of *Madness* breaking in late July, del Toro and company started preparing for their chilly expedition. Preproduction and prep followed the announcement, with an eye fixed toward filming in summer 2011.

Del Toro was not only adapting a challenging, massive Lovecraftian tale for the big screen, but he was going to shoot the film in 3-D. This would be the filmmaker's first time directing in the third dimension, so he sought out James Cameron's guidance. Cameron not only offered his assistance on the technological aspect, but also his assistance on the film in general, coming on as producer.

The legendary Industrial Light & Magic (ILM) also came on board for effects work. Founded by George Lucas in 1975, ILM is responsible for effects work in all of your favorite movies: the *Star Wars* franchise, *Poltergeist*, *E.T. the Extra-Terrestrial*, *The Goonies*, the *Indiana Jones* franchise, *Howard the Duck*, *Who Framed Roger Rabbit*, *Terminator 2: Judgment Day*, *Jurassic Park*, and more. Way more. Now they would bring to life blind penguins and Lovecraftian monsters.

After a long back-and-forth with the actor and studio, Tom Cruise joined the film as the lead. Del Toro had always pushed for Cruise, but Universal was pushing for their own leading man: James McAvoy. Back then, the Scottish actor wasn't quite the name talent he is today, but the studio was willing to place their bets. He had a promising little film due out in June 2011 called *X-Men: First Class*. In fall 2010, however, it was Gnomeo versus Cruise in the casting department.

Cruise wins that battle every time.

Preproduction rolled along as del Toro and Robbins tweaked and rewrote the screenplay to bring it down in size. As casting and budgetary concerns from the studio mounted, del Toro and company could've taken a page from the actual *Madness* story: When Dr. William Dyer and his team enter the ancient ruins, they discover hieroglyphics that reveal the horror around them. The writing was literally on the wall for Dyer, just like it was for del Toro.

But by the time you see it, it's already too late.

CUT!

Del Toro's *At the Mountains of Madness* was declared dead in March 2011, less than a year after it was green-lit. Even with a package as promising as del Toro, Cameron, and Cruise, Universal couldn't justify the $150 million price tag the R-rated film needed. And, well, you can't really blame them. Instead, blame *Prometheus*.

Ridley Scott's *Prometheus* started filming in March 2011. *Prometheus* was an R-rated, big-budget science-fiction horror film that saw humans discovering ancient horrors about the origin of humankind. While the film's release in June 2012 wasn't technically a financial failure, it far from met its hefty expectations.[2]

But it wasn't so far from the storyline of *Madness*. You'd have to be as blind as a six-foot Lovecratian penguin to move forward on *At the Mountains of Madness*... at the time. Del Toro went on to make a different giant monster movie: 2013's *Pacific Rim*.

With even more clout behind him in 2020, perhaps del Toro might wonder if a studio could now be willing to write a blank check for him to make the Lovecraftian horror film he's dreamed of for decades. Here's looking at you, Amazon and Netflix . . .

2 *Prometheus* is partly the reason why two of the films in this book–*At the Mountains of Madness* and Neill Blomkamp's *Alien 5*–were never made.

OVEREXPOSED!
GUILLERMO DEL TORO

Much like other beloved filmmakers, del Toro has a list of films that were discussed or in production but unfortunately never happened. In November 2018, he tweeted a long list of these projects, along with brief explanations. One of those, *Nightmare Alley*, will begin production in 2020, featuring Bradley Cooper, Cate Blanchett, Willem Dafoe, Michael Shannon, and more.

We briefly tackle three other del Toros below.

HELLBOY III: Before he set his directing sights on *At the Mountains of Madness*, del Toro initially planned on making *Hellboy III* immediately after his double dose of *Hobbit* movies. When he dropped out of Middle-earth, however, the decision had a ripple effect on his other projects. Timing was a huge factor in the delay of the third chapter; budget concerns were the other.

The *Hellboy* franchise was a consistent moneymaker, so long as budgets remained modest. The third chapter, as del Toro envisioned it, needed a sizable increase in budget, which made it a risky investment for studios. Very few details are known on the third installment, aside from Hellboy, Liz, their twins, and the B.P.R.D. coming to grips with Red's true nature. Unfortunately, the 2019 *Hellboy* reboot put del Toro's franchise to bed for good. Note: For a deeper dive into del Toro's *Hellboy* franchise, see pages 57–60.

BEAUTY AND THE BEAST: In 2011, del Toro set out to tell a tale as old as time with a reimagining of the classic fairy tale *Beauty and the Beast*. In the only casting news for the film, *Harry Potter* star Emma Watson signed on as Belle. I imagine that Ron Perlman would have reprised his role from 1987's *Beauty and the Beast* and that Doug Jones would have played Lumière.

Del Toro dropped out of the film in 2014. Watson kept the role of Belle for Walt Disney in 2017's live-action remake, the same year del Toro's own beauty-and-the-beast-ish story, *The Shape of Water*, opened.

THE HAUNTED MANSION: Announced in 2010, del Toro set out to write and produce a remake of the Eddie Murphy film. Leaning in closer to the vibes and style of the original Disney attraction, del Toro wanted to place the mansion in a "heightened reality." The infamous "Hatbox Ghost" would be the main haunting, and Ryan Gosling was attached to star. Tragic.

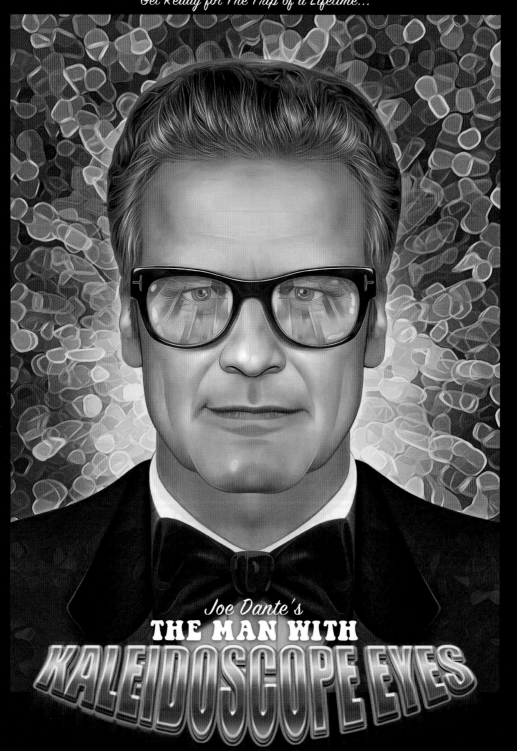

Get Ready for The Trip of a Lifetime...

Joe Dante's
THE MAN WITH
KALEIDOSCOPE EYES

THE MAN WITH KALEIDOSCOPE EYES

THE PLAYERS

Director
Joe Dante

Screenwriters
Joe Dante, Tim Lucas, and Charlie Largent

Producer
Roger Corman

Starring
Colin Firth

Author's Note: *As of July 2019, this movie was still in development and had rumblings of going into production in late 2019. Nothing has been confirmed.*

FADE IN

In 1967, Roger Corman released his forty-seventh feature film, *The Trip*. This LSD-infused experiential film, starring Peter Fonda, Dennis Hopper, Bruce Dern, and Susan Strasberg, was written by Jack Nicholson.[1] It was an absolute mind-bending experience, and production of the film saw Corman himself experiment with the drug. It's exactly the kind of "making of" tale that is ripe for the big-screen treatment.

Fortunately for all of us, Joe Dante agreed.

FLASHBACK

The Trip follows Paul Groves (Peter Fonda), a director at the edge of his rope. His wife has left him, resulting in his world being turned upside down. Lonely and without direction, he turns to his friend, LSD advocate John (Bruce Dern). Already seeing life through a warped perspective, Paul asks John to guide him on his first LSD trip.

> **"YOU GOTTA TURN OFF YOUR MIND, AND RELAX, AND THEN JUST FLOAT DOWNSTREAM. OKAY?"**
> **–JOHN, *THE TRIP***

1 LSD was spelled out as "Lovely Sort of Death" on the poster for *The Trip*. Obviously, this was a family film.

What follows is a visionary trip into horror and psychedelia, filled with the eye-piercing pulses of strobe lights, visions of sex, torture chambers, a dwarf, and witches. It's a wild trip that not only alters Paul's reality, but eventually shatters it altogether.

For Corman, the film was an exploration into seeking escape from life—and ultimately ending up worse off than before. Is Paul a changed man after his bad trip, or is he still stuck inside it, forced to live with the consequences and choices he's made in his past, as well the images haunting his nightclub-filled journey down the Sunset Strip?

The Trip isn't a romantic, dreamlike take on directing. It's a nightmare take on it; directors are stuck inside a nonstop bad trip filled with images they can't quite make out or control.

But it's all about the experience, right?

Experience with LSD wasn't exactly something Roger Corman had. The legendary filmmaker went the method route and experimented with the drug in order to make the film as realistic as possible. Luckily, he did not use the same approach on 1970's *Gas!* (aka *GAS-SSS* aka *It Became Necessary to Destroy the World in Order to Save It*).

Joe Dante got his start in filmmaking by editing trailers for Corman. After two early feature experiences with the hodgepodge collection *The Movie Orgy* and the codirected *Hollywood Boulevard*, Dante made his true feature debut with the Corman-produced *Piranha*.

Loosely inspired by *Jaws*, the 1978 film sees the accidental release of genetically altered piranha that find their way downstream to a resort and summer camp. An absolute bloodbath of horror and comedy, *Piranha* put Dante on the Hollywood map. Dante's follow-up to the killer fish was the killer werewolf film *The Howling*. Corman would have a cameo in that 1981 film. After joining Steven Spielberg, John Landis, and George Miller to direct a segment of *Twilight Zone: The Movie*, Dante headed to Kingston Falls to direct one of his biggest hits: the adorable 1984 cult classic *Gremlins*. Dante turned out a string of cult hits after *Gremlins*, including its sequel, *Gremlins 2: The New Batch*, *Explorers*, and *The 'Burbs*.

In 1993, Dante tackled the period comedy *Matinee*, a film inspired by B-movie impresario William Castle. The film follows a B-movie promoter, Lawrence Woolsey, using the Cuban Missile Crisis to market the premiere of his new nuclear-infused monster movie, *Mant!* The effects and tactics used

by Woolsey end up causing hysteria in the town. Woolsey himself finds joy in the chaos. An ode to B-movies and filmmaking, *Matinee* is a film for film lovers of all stripes—the kind of film that shows how far producers will go to promote their movies.

While *Matinee* was inspired by the great Castle's tactics, Dante also found inspiration in the tactics of his friend Corman—mostly in how far Corman was willing to go while making *The Trip*. Lawrence Woolsey was just a character in a movie making fake movies; Dante set his sights on the warped story of a real director making a real movie.

It ended up being Dante's most painful filmmaking trip...

ACTION!

Dante originally attempted to make *The Man with Kaleidoscope Eyes* in 2004. One thing didn't lead to the other, so he attempted the project again in 2008. And again in 2013.

The film has been his white whale for more than a decade. Dante, with Charlie Largent and Tim Lucas of *Video Watchdog*, wrote the screenplay, which kicks off after the release of Corman's *The Wild Angels*. The script is filled with references to Corman's career and even calls for Corman-related montages revealing the director's work and style. Ripe with period-accurate sixties lingo and references, *Kaleidoscope Eyes* travels the line between surreal nightmare and loving tribute, ending with a tennis match as trippy as the premise: cinematic Corman versus real-life Corman—in a sense, it asks if we're constantly in a game against ourselves, when it comes to where we choose to go in life. That could be to Kingston Falls, or it could be to Big Sur in order to try LSD for the first time.

You can't make a movie about Roger Corman without casting the role of Roger Corman. Rumors persisted for years that Dante had cast fellow director Quentin Tarantino as Corman, but that rumor was eventually dispelled by Dante himself. Colin Firth was briefly attached to the film in 2010, but his interest was short-lived.

Casting rumors and production issues were beginning to make this trip to the big screen look unlikely once again.

CUT!

Aside from the constant starts and stops, *Kaleidoscope Eyes'* development always had one crucial piece keeping it from set: funding. While Dante is a legendary filmmaker responsible for some of the greatest films ever made, his recent output hasn't stacked up, critically or financially. But ... it's Joe Dante we're talking about here. He's an icon. All it takes is one company to come forward to help him make this movie.

And they might have already.

In October 2016, Cinefamily and the production company SpectreVision did a live reading of *Kaleidoscope Eyes* at SpectreFest. Bill Hader was cast as Roger Corman, Jason Ritter played Peter Fonda, Ethan Embry played Jack Nicholson, and Claudia O'Doherty played Corman collaborator Frances Doel. In November 2016, Company X (members of SpectreVision) announced they would be putting *Kaleidoscope Eyes* into production in 2017. There's been no other developments since, so only time will tell with this one.

VAMPIRELLA

THE PLAYERS

Director
John Hough,
Gordon Hessler

Starring
Barbara Leigh,
Peter Cushing,
Sir John Gielgud

FADE IN

In the mid-seventies, Hammer Films was starting to feel the bite of shrinking revenue. Although they had been responsible, from the mid-1950s through the early 1970s, for a slew of the greatest horror movies ever made, the studio's then-recent output was failing at the box office, and they desperately needed to find something that could connect with a massive audience. They set their sights on the scantily clad superhuman vampire known as Vampirella.

She nearly saved the day for Hammer and studio producer Michael Carreras.

Nearly.

FLASHBACK

Vampirella made her comic debut in 1969 in Warren Publishing's *Vampirella*, no. 1.[1] Created by artist Trina Robbins and Forrest J. Ackerman (Ackerman, or "Forry" as he was so widely and affectionately known in the industry, was also the editor and writer for the horror magazine *Famous Monsters of Filmland*), *Vampirella* served as a companion to Warren's other horror properties: *Eerie* and *Creepy*. Vampirella not only "hosted" these comics, but she also starred in selected stories for each series.

But who exactly is Vampirella?

She hails from the blood-flowing planet of Drakulan, where a race known as the Vampiri live. These Vampiri drink blood, turn into bats, and have super strength. They sound a lot like Earth-bound vampires, but I assure you, these are Vampiri. From space.

And they hate it when someone mixes that up.

1 Renowned artist Frank Frazetta painted the cover art for issue no. 1. Frazetta's lasting legacy in the art, film, and comic worlds speaks for itself, but I'll point out a few highlights: he did cover work for *Eerie* and *Creepy* comics; he worked with Ralph Bakshi on *Fire and Ice*; and his *Death Dealer* painting is one of the most widely known fantasy paintings in the world.

After Drakulan suffers a blood-drought, most of the Vampiri die unfortunate deaths. When a spaceship crashes on Drakulan, however, Vampirella discovers humans—and, more important, humans with blood flowing through their veins. In a bid to save her race, she takes the ship back to Earth, where she discovers that vampires have been living there for ages, feeding on helpless humans. Vampirella chooses to fight the good fight on Earth.

It's a common bad-girl-makes-good-even-with-fangs sort of tale, which follows what some might view as a typical antihero narrative arc: she drinks blood and comes from the same planet that Dracula is from. When your fellow Drakulan is literally one of the worst vampires in history, it's pretty hard for your new Earth neighbors to bring over baked goods and welcome you to the neighborhood.

But Vampirella was welcomed by comic fans. Her comic ran until issue number 112 was released in 1983, capping a fourteen-year run for the cosmic bloodsucker. During this run, Vampirella caught the attention of Michael Carreras, the head of Hammer Films. At the time, Hammer was working on a massive, and costly, collaboration with Toho Studios called *Nessie*. Described as a cross between *Godzilla* and *Jaws*, *Nessie* was a big change in direction for the legendary horror company.

Established in 1934, Hammer Films was a London-based production company most widely known for macabre horror films. Hammer, however, originally started out as a multi-genre production house (the comedy *The Public Life of Henry the Ninth* was Hammer's first feature film in 1935).[2] Fourteen years later, the production offices and studios became known as Hammer House—a few years later, it garnered yet another new name: Hammer House of Horror.

The gothic atmosphere of Hammer's films was applied to an entire roster of classic monsters with the films *The Curse of Frankenstein* (1957), Christopher Lee's *Dracula* (1958), and Peter Cushing's *The Mummy* (1959). The studio spawned franchises out of each of these monster films, alongside a laundry list of other cult-classic horror films.[3] After *Frankenstein and the Monster from Hell* (1973), *The Legend of the 7 Golden Vampires* (1974), and

2 *Henry the Ninth* was the first film from Britain to be nominated for an Academy Award.

3 *The Curse of Frankenstein* had six sequels, *Dracula* had eight, and *The Mummy* was wrapped up with two.

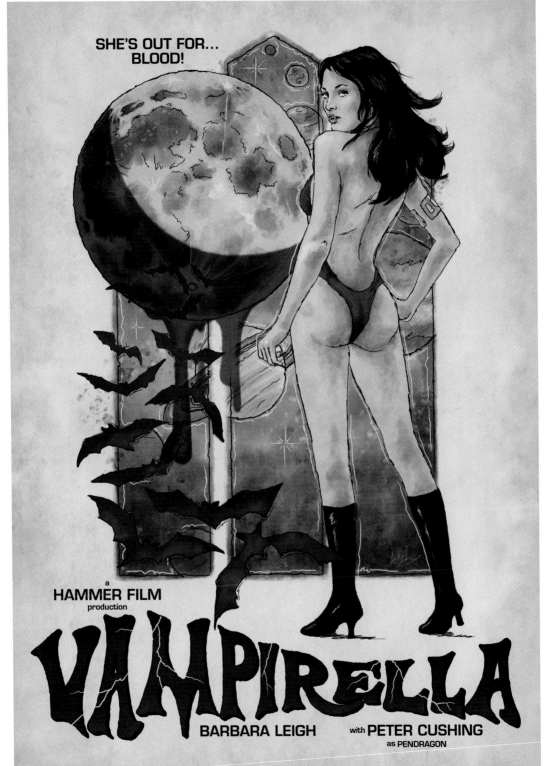

SHE'S OUT FOR...
BLOOD!

a
HAMMER FILM
production

VAMPIRELLA

BARBARA LEIGH with **PETER CUSHING**
as PENDRAGON

Captain Kronos—Vampire Hunter (1974), Hammer's franchises and resources were beginning to run as dry as the blood-rivers of Drakulan.

Hammer and Carreras were in desperate need of new blood.

ACTION!

Carreras asked the readers of *Eerie*, *Creepy*, and more who they wanted to see get a feature-film adaptation from Hammer Films. Vampirella won the poll by a landslide, and not long after, Hammer began promoting the film in those very same pages. Two striking promos hit the eyes of readers, both featuring the iconic character and her comic-font logo, as well as one bold tease: "A Major Motion Picture Now in Production from Hammer Films. Coming Your Way in 1976!!"

Two things jump out immediately from these promos: Hammer was looking to spend major money on the adaptation, and they were looking to do it quickly. If there's anything we've learned in the pages of this book, you can't do things quickly and you can't do them without money.

Hammer was *trying* to do both.

Director John Hough (*Twins of Evil*, *The Legend of Hell House*, *The Watcher in the Woods*) was brought on to direct the film, whose screenplay would be adapted by Hammer staple Jimmy Sangster. Sangster had scripted cinematic classics like *The Curse of Frankenstein*, *Dracula*, and *The Mummy*, and also wrote for the *Kolchak: The Night Stalker* and the *Wonder Woman* television series.

Sangster's story brought Vampirella to the streets of South West London, where she meets Pendragon the wizard. The two set up shop in Chelsea, performing as a magic-and-mind-reading duo. Horror, however, lurks not only on the streets of London, but also in the sky above. Vampirella hunts down vampires during the night, all while serving the Space Operatives for Defense and Security. Yep, alongside the vampires, we have aliens and wizards—not exactly staples of Hammer Horror. One staple of the Hammer House of Horror would be in the film: the Van Helsing bloodline. Even though she's a superpowered space-vampire, Vampirella is still, in the eyes of Earthlings, a vampire—which means there's a Helsing out to give her Hel. Much like other cinematic antiheroes, Vampirella must prove she's living among us with good intentions: to protect mankind.

The Hammer House of Horror soon became the Hammer House of Casting Rumors and Attachments. Bray Studios was essentially a second home for Peter Cushing, so it's no surprise that he was attached the film. The surprise came with the role: Cushing had played Van Helsing five times for Hammer, and *Vampirella* would have her face-off against a Helsing (or two) in her movie. It would have made perfect sense for Cushing to play the role one last time. But remember, friends, we're living in an *Underexposed!* world.

Nothing makes sense here.

Cushing, instead, was set to play the wizard Pendragon. Character actor Sir John Gielgud was to play the top brass of the Space Operatives for Defense and Security, to whom Vampirella reports. But who would report to the role of Vampirella?

After a brief search and a string of notable rejections—because of the nudity they were requiring—Hammer locked in Barbara Leigh to play the superpowered role. The former *Playboy* model–turned–actress signed a six-picture deal with Hammer to play Vampirella. (Of course, this was back in the days when studios signed actresses or actors to more films than seemed realistically necessary, in the hope that the studio could then cash in their franchise chips for several years. These days, more modest three-picture deals are common business for aspiring franchisers, with the exception of Marvel Studios, where they've returned to the long-term-contract days by offering actors like Chris Evans nine-picture deals.)

Hammer and Leigh immediately began promotion on *Vampirella*. This, after all, was the movie fans and readers voted into existence. Unfortunately, they were never given the chance to vote with their wallets.

CUT!

1976 came and went without a *Vampirella* film from Hammer. They had spent the last two years at festivals and conventions promoting the movie as Warren Publishing watched from the sidelines. Hammer had one of the most recognizable names in horror, and currently had one of the biggest names in horror comics. The merchandising potential for Hammer, Leigh, and the Vampirella brand was sky-high. Warren Publishing brought them all back down to earth (without the help of the Space Operatives for Defense and Security, I might add). Due to creative differences and lack of funding, Hammer dropped the project completely.

Soon after, Hammer itself dropped into bankruptcy for the second time.

Decades later, Hammer found new life once again when they returned with 2009's horror thriller *Wake Wood*. They have since released Matt Reeves's remake of *Let the Right One In*, called *Let Me In*; Daniel Radcliffe's *The Woman in Black*; a sequel titled *The Woman in Black 2: Angel of Death*; and most recently, 2019's *The Lodge*.

Comic book company Dynamite Entertainment acquired the rights to Vampirella in 2010. She has held down her own regular ongoing monthly series ever since, most recently with the Dynamite team-up series, *Vampirella/Red Sonja*.

As for the movie? *Vampirella* finally made it on set in 1996, when Jim Wynorski directed a straight-to-video adaptation. Decisions . . . were made. Nearly twenty-five years later, the character is as popular as ever, and Hammer is back in the horror business—so a return to the silver screen may not seem as far-fetched today as it once did.

DAVID CRONENBERG'S

TOTAL RECALL

THE PLAYERS

Director
David Cronenberg

Screenwriter
David Cronenberg

Starring
William Hurt

FADE IN

"YOU ARE WHAT YOU DO. A MAN IS DEFINED BY HIS ACTIONS, NOT HIS MEMORY."
–KUATO, *TOTAL RECALL*

In 1990, *RoboCop* director Paul Verhoeven took Arnold Schwarzenegger to Mars in the science-fiction thriller *Total Recall*. Also starring Michael Ironside and Verhoeven's future *Basic Instinct* star Sharon Stone, *Recall* follows Douglas Quaid's (Schwarzenegger) virtual vacation to the red planet. A vacation and life—both of which might all be in his head—that ends with a corporation and dictatorship bent on killing Quaid, and Quaid bent on giving "the people air" in order to save the planet's downtrodden underclass.

Mutants, virtual reality, and body-horror may have worked in Verhoeven's film, but there was almost a different version of *Total Recall* with a director known to specialize in all three—a version that would have been a science-fiction monstrosity of the best kind. That filmmaker? David Cronenberg.

FLASHBACK

After spending the seventies sending *Shivers* down the spines of critics and moviegoers, Canadian filmmaker Cronenberg exploded into the eighties with three new films released between 1981 and 1983. All three laid the groundwork for the kind of science fiction the Rekall company needed.

Released in 1981, *Scanners* follows the mind-blowing fight between the weapons and security systems company ConSec and the most powerful "scanner"—a person with telekinetic and telepathic powers—in the world, Darryl Revok (Michael Ironside). One of the most memorable scenes in the film is when Revok volunteers to have one of ConSec's own scanners, played by Louis Del Grande, test his powers on him. This proves to be a mistake

when Revok makes the man's head explode like a watermelon.[1] *Scanners* hit US theaters in January 1981, grossing $14.2 million. Ten years later, the film saw four sequels/spin-offs released without Cronenberg's involvement.[2]

Cronenberg returned to the mystery of the mind two years later with *Videodrome*. Starring James Woods and Debbie Harry, *Videodrome* follows sleazebag programmer Max Renn as he acquires a mysterious new show for his UHF television station CIVIC-TV (the channel specializes in X-rated and violent programming). After illegally obtaining the satellite signal of a sexually violent and murderous show called *Videodrome*, Renn sets out to find the producers and instead finds what very well could be the horrific future of media.

Videodrome opened February 4, 1983. The film performed poorly at the box office, opening at number eight with $1.1 million. By comparison, Sydney Pollack's *Tootsie* won the box office that weekend with $6.5 million in its eighth weekend of release. In its thirty-fifth week in theaters, Steven Spielberg's *E.T. the Extra-Terrestrial* made just over $1 million that weekend. *Videodrome* finished its box office run with a total of just $2,120,439.[3]

Cronenberg returned to theaters nine months after the debut of *Videodrome* with Stephen King's *The Dead Zone*. Produced by *Halloween*'s Debra Hill and starring Christopher Walken, *Zone* follows high school teacher Johnny Smith, who gains psychic abilities after a five-year coma. Smith proceeds to use his newfound gift to help Castle Rock police find a killer, and to thwart a nuclear holocaust by killing a compromised candidate for the United States Senate. On October 21, *The Dead Zone* opened number two at the box office with $4.5 million, falling to Irvin Kershner's Bond adventure *Never Say Never Again*. *The Dead Zone* grossed a total of $20.7 million when all was said and done.[4]

1 This scene has also become memorable as the perfect hangover GIF on social media.

2 Darren Lynn Bousman (*Saw II*, *III*, and *IV*, as well as 2020's *Saw* reboot) and David Goyer (*Blade: Trinity*) were set to remake *Scanners* in 2007, but the project seems to have "scanner-ed itself."

3 When it came to the moviegoing audience, *Videodrome* landed in the dead zone. Three decades later, however, the film is considered an ahead-of-its-time masterpiece.

4 In its fourth week of release, *The Dead Zone* made $2,015,323 at the box office. That number tops *Videodrome*'s total gross by $105,116. *Zone* was still in 1,100 theaters at that point; *Videodrome* only opened in 600, total.

On the *Recall* front, writer Ronald Shusett had acquired the rights to Philip K. Dick's 1966 short story "We Can Remember It for You Wholesale" in 1974. In the story, Douglas Quail (not Quaid) sets out to take what the company Rekall, Inc. is calling a "false memory vacation." These vacations *feel* like real vacations—something Quail is in desperate need of. Instead of a virtual experience, however, Quail is implanted with the memory of a secret agent's trip to Mars, which unravels his secret identity and raises multiple unanswered questions as to what will happen if he dies in this "simulation."

After acquiring rights to the Rekall story, Shusett brought Dan O'Bannon on board to help craft a screenplay. The pair worked on the script until it was apparent the project was too costly to film at that point. They instead turned their attention to a different science-fiction idea, involving Harry Dean Stanton, Sigourney Weaver, and facehuggers. The success of *Alien* gave Shusett a first-look deal at Disney, where he could then once again focus on what he was now calling *Total Recall*. Disney, however, passed on the project, opening the doors for producer Dino De Laurentiis to become attached to the film. The De Laurentiis Entertainment Group was coming off a busy 1983, with the releases of *Amityville 3-D*, *Halloween III: Season of the Witch*, and *The Dead Zone*. After struggling to find a director for *Total Recall*, De Laurentiis dipped his toes back into *The Dead Zone* to bring Cronenberg on board. If only the trio could have seen the future as clearly as Johnny Smith.

ACTION!

Cronenberg jumped right into reworking and rewriting the Shusett/O'Bannon script. The *Rabid* filmmaker set out to lend the script some of his trademark personality, as well as to make the script more, well, Dick-ian.

Cronenberg brought on production designer Pierluigi Basile, who set his team, including artists Ron and Judith Miller, to work on conceptual art. Decades later, in 2012, Ron revealed that stunning concept art to *Gizmodo*. Here's some of what was posted among the treasure trove of tease: a futuristic office for the villainous Governer Cohaagen, layered with stairs and floral stained-glass windows; a futuristic city, complete with propaganda art; and a rather Cronenbergian series of art showcasing mind-reading mutant Kuato's transformation.

After completing twelve drafts of the screenplay over twelve months, Cronenberg was finally ready to take the trip to Mars with Shusett and De Laurentiis—unaware that the trip was already doomed.

CUT!

Shusett and De Laurentiis had a specific vision for *Total Recall*: they wanted *Raiders of the Lost Ark Goes to Mars*. What they got was *David Cronenberg's Blade Runner Goes to Mars*. How does this miscommunication happen?

Well, by not communicating your vision to the director you hired.

Clearly the trio was imagining different futures on Mars. While Shusett and De Laurentiis wanted to adapt the Philip K. Dick story, they weren't interested in actually making it Philip K. Dick–ish.

They were also imagining different leads.

Cronenberg wanted to cast William Hurt, who was coming off of Michael Apted's *Gorky Park* and Lawrence Kasdan's *The Big Chill*. The producers had their eye on "the everyman" actor Richard Dreyfuss, who was coming off of back-to-back Steven Spielberg films (*Jaws* and *Close Encounters of the Third Kind*). Between casting disputes and his reluctance to deliver the kind of film that Shusett and De Laurentiis wanted, Cronenberg walked away from the film.

Years later, Paul Verhoeven brought his version of *Total Recall* to the big screen, starring Arnold Schwarzenegger. As for Cronenberg? He left Mars for a remake of the classic Kurt Neumann movie *The Fly*. Cronenberg's 1986 horror film forged new ground for the body-horror maestro.

Interesting note: During a Q&A with John Waters at the Provincetown Film Festival in 2014, Cronenberg revealed that he was, very briefly, attached to the 2012 remake of *Total Recall*. Len Wiseman ended up directing that film. So Cronenberg has walked away from the Rekall company twice. Judging by how both films were received, producers might want to have some fake memories implanted where Cronenberg *did* direct either (or both!).

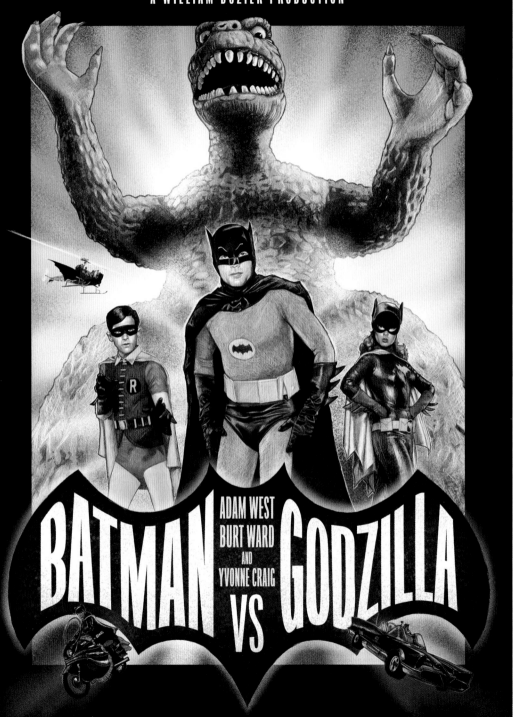

BATMAN VS. GODZILLA

THE PLAYERS

Producer
William Dozier

Screenwriter
Shin'ichi Sekizawa

Starring
Adam West,
Burt Ward,
Yvonne Craig

FADE IN

Godzilla has faced a wide variety of foes over the years, from the scary (King Ghidorah) to the silly (King Caesar), but at one point, things almost got downright batty for the King of Monsters. After Godzilla's wildly successful battle with King Kong, writer Shin'ichi Sekizawa was looking for a repeat crossover success, and he proposed another "versus" movie in 1965. But where do you go after Kong? Well, if you're Sekizawa, you flash the Bat-signal and hope for the best.

FLASHBACK

Sekizawa made his writing (and directing) debut with 1956's *Fearful Attack of the Flying Saucers*. The film was released by Shintoho Films,[1] and is wildly believed to be one of the first alien-invasion movies to come out of Japan.[2] Toho had released *Godzilla* just two years earlier in 1954. *Godzilla* was a monster-sized allegory for the horrors and fallout of nuclear weapons; Godzilla's destruction mirrored the devastation that "Little Boy" and "Fat Man" left in Hiroshima and Nagasaki nine years earlier. Inspired by monster movies like *The Beast from 20,000 Fathoms* and *King Kong*, *Godzilla* was unleashed in Japan nationwide, roaring his way to box office destruction. Toho wasted no time on prepping a sequel. *Godzilla Raids Again* hit theaters six months after the first film was released. The sequel introduced audiences to Anguirus, the speedy, digging kaiju who was the first monster to fight Godzilla.

Sekizawa made his way over to Toho to write a new kaiju film for his director friend Ishiro Honda. That film, *Varan the Unbelievable*, released

1 Shintoho Films was founded by workers who left the original Toho Co. during a strike in 1947.

2 Unfortunately, not much is known about *Fearful Attack of the Flying Saucers*. A rare 16mm print turned up at an auction in 2010, where the film was sold. Upon purchase, the buyer changed his mind and the film was listed again at the price of 3,000,000 Japanese yen ($27,984 in the United States). It didn't sell, and there have been no further developments since.

in 1958 and introduced a different giant reptile to the world. While not initially part of the *Godzilla* universe, Varan popped up in 1968's Godzilla film *Destroy All Monsters*. After *Varan*, Sekizawa went on to write a number of Toho properties including *Battle in Outer Space* (1959), *The Secret of the Telegian* (1960), *Mothra* (1961),[3] and *King Kong vs. Godzilla* (1962).

King Kong vs. Godzilla's journey to the big screen was as rocky and turbulent as a rowboat ride to Skull Island. The film started out in the offices of RKO as *King Kong Meets Frankenstein*. This wouldn't have been an Abbott-and-Costello-type meeting, either; Kong was going to meet a giant version of Frankenstein's monster. Since Universal Pictures owned the rights to Frankenstein's monster, the film was tweaked and renamed *King Kong vs. Prometheus*.[4] Development continued on the film, but when the budget proved to be too much for RKO, producer John Beck took the film overseas to gauge international interest. Toho, who had long been wanting to be in the King Kong game, purchased the script. They made two immediate changes to the project: Frankenstein's monster/Prometheus was replaced by Godzilla, and Shin'ichi Sekizawa was brought on to rewrite the script.

King Kong vs. Godzilla released in 1962, marking the first time both Kong and Godzilla appeared on-screen together—and in color. It also became the highest-grossing *Godzilla* film to date. Much like they did with the first *Godzilla*, Toho attempted to fast-track a sequel simply called *Continuation: King Kong vs. Godzilla*. Sekizawa wrote that ill-fated sequel, which was split into two films and revamped as *Mothra vs. Godzilla* (1964) and *Frankenstein vs. Baragon* (1965).

After Kong, Sekizawa spent his next few years writing *The Lost World of Sinbad* (1963); *Atragon* (1963);[5] the previously mentioned *Mothra vs. Godzilla*; the screen debut of the giant jellyfish-like invader *Dogora* (1964); and *Ghidorah, the Three-Headed Monster* (1964). While the majority of these films were well received, none of them was received quite like *King*

3 This was the first appearance of Mothra, who went on to have a fine career as a movie star. Most recently, she appeared in Michael Dougherty's *Godzilla: King of the Monsters*, and she became an internet meme when *Godzilla vs. Kong* (2020) was announced.

4 "The Modern Prometheus" was an alternate name for Frankenstein's monster in Mary Shelley's novel.

5 This warship thriller introduced the monster Manda, who later turned up in *Destroy All Monsters!*

Kong vs. Godzilla. Toho was looking for another massive hit, and they knew their best bet was another "versus" movie. Sekizawa knew that, too; he also knew, however, that there were only so many giant monster fights he could write. Instead of looking at what could come out of the Pacific, Sekizawa started thinking about what, and more importantly who, could come *across* the Pacific.

ACTION!

Although *Batman* the TV series didn't premiere until January 1966, the show had been in development since the early 1960s. It's hard to say if Sekizawa knew of the show or if Toho had plans for their own version of the Bat-family. What's not hard to imagine is a world where the same Batman who used his Shark Repellent Bat-spray to fend off a man-eating shark faces off against the King of Monsters.

But what brings the Dynamic Duo to Japan?

Commissioner Gordon and his daughter, Barbara, are on vacation in Japan when their boat is capsized by a mysterious tidal wave. We're introduced to a sinister meteorologist named Klaus Finster, who can control the weather from his secret lair inside Mount Fuji. Klaus informs the nation that he will destroy Japan with his weather machine if they don't give him $20 million in gold. So—we have a ransom, a secret lair inside a volcano, and a guy named Klaus. That is what you call "classic supervillain hijinks."

Unwilling to have his vacation ruined, and Japan destroyed, Gordon calls the Bat-phone and summons Batman and Robin to Japan. Upon arrival, Batman's Bat-sense tingles, and he reveals what Finster really has control over: Godzilla. He does this by conveniently showing footage from *King Kong vs. Godzilla*—you know, the monster hit that Sekizawa wrote and was trying to replicate with this current matchup.

Such a setup of Batman knowing about Godzilla is alarming: Are we to believe the Caped Crusader kept this information to himself, or did he tell the world and the Justice League? It's hard to imagine a world where Superman knows of Godzilla and *doesn't* just punch him in the nose. Or better yet, can't Aquaman just ask Godzilla to take it down a notch?

Regardless, after getting trapped in a gas chamber disguised as a taxi, Batgirl (Gordon's daughter, Barbara) saves the day, and the trio encounter Godzilla in the Batcopter. They decide to bait Godzilla with a mating call,

tman vs. Godzilla is just one of
any potential Godzilla films that
ve been discussed throughout
e years. We're going to briefly talk
out three others that almost rose
om the depths of the filmmaking
a.

ODZILLA: KING OF THE MONSTERS
D: In 1983, Steve Miner (Friday
e 13th Part 2 and 3) pitched Toho
American-produced version of
dzilla that would feature A-list
tors and Hollywood special
ects. Fred Dekker (pre-House/
ght of the Creeps) was hired to
ite the screenplay, which took a
ielbergian approach to the King of
e Monsters. Due to a growing price
g and an unrecognizable name
tached (in Miner), the project
led to materialize.

DZILLA VS. GHOST GODZILLA: With
Star's Godzilla (1997) on the verge
release, Toho planned to make
e more Godzilla movie before
utting down the series (at least
til 2005). To honor their history,
ho hatched a concept that would
e their nineties version of Godzilla
ht the spirit of 1954's Godzilla.
e film was scrapped when the
mmakers felt a third film in a row
ere Godzilla fought a different
rsion of himself would be too
uch for audiences.

E MONSTER SQUAD VS. GODZILLA:
e second Fred Dekker Godzilla
m to hit the bonus round, this was
st an initial concept for a potential
nster Squad sequel. There were
further developments on the
azy concept, which would have
ken some real nards to pull off.

then knock him unconscious with explosives. Once Godzilla is out, they plan to send him into space.

The Bat-family then puts their plan into action, resulting in Klaus somehow falling to his death. In the ensuing chaos, the trio does battle with Godzilla in their Bat-vehicles, and during the fight, Godzilla grabs Batgirl. Batman, unfazed by the dangling Barbara, again uses the mating call, causing Godzilla to literally throw Batgirl across Japan. Batman is then, somehow, able to lay a string of bombs on the neck of the beast and detonate them, knocking Godzilla to the ground. Japanese scientists craft a rocket around the sleeping monster and launch him into space.

It's a wild and crazy concept, but that's all it was: a concept.

CUT!
Sekizawa's treatment never made it into script form. With no word from anyone on DC's side of things as to whether they had been approached about the project, Batman vs. Godzilla remains one of the most intriguing, and bizarre, films never to happen.

PATRICK LUSSIER'S
HALLOWEEN 3-D

THE PLAYERS

Director
Patrick Lussier

Screenwriters
Todd Farmer and
Patrick Lussier

Starring
Scout Taylor-
Compton, Tyler
Mane

FADE IN

In John Carpenter's *Halloween*, six-year-old Michael Myers kills his sister, Judith, on Halloween night. Fifteen years later, he escapes Smith's Grove Sanitarium and returns home to Haddonfield, Illinois. He steals a mask from the local hardware store and begins stalking high school student Laurie Strode (Jamie Lee Curtis). His psychiatrist, Dr. Samuel Loomis, arrives in town shortly after, setting up a final showdown of good versus evil. Laurie survives the encounter, thus setting up a bumpy, winding road for the franchise in the process.

One of those bumps would have brought Michael Myers into the third dimension.

FLASHBACK

Laurie Strode and Michael both returned for *Halloween II* in 1981. John Carpenter and Debra Hill both returned as well—much to their dismay. Carpenter begrudgingly wrote the screenplay with the help of beer, confusion, and doubt. It was here where the decision to make Laurie Strode Michael's sister happened. This was a plot twist the *Halloween* franchise was left to deal with for the next thirty years, and it proved to be just as explosive as the hospital at the end of *Halloween II*.

The original concept for *Halloween* was for it to launch an anthology series, along the lines of *The Twilight Zone* or *Night Gallery*. After two installments of Laurie versus "the Shape", the franchise took a left turn into Santa Barbara with *Halloween III: Season of the Witch*.

Upon release, the reception to *Season of the Witch* was not kind. Fans wanted Michael Myers, and what they got was a story about witches and head-melting Halloween masks. They also got a catchy jingle from the masks' manufacturer, Silver Shamrock Novelties, whose commercials play throughout the film.

Producer Moustapha Akkad gave fans what they wanted six years later when Michael Myers returned to the big screen in *Halloween 4: The Return*

of *Michael Myers*. And the next year for *Halloween 5: The Revenge of Michael Myers*. And six years later in *Halloween: The Curse of Michael Myers*.

That's a whole lot of *Michael Myers* subtitles. Just as the franchise was getting back on the Michael train, fans were once again starting to question the series. *The Curse* introduced the Cult of Thorn, and, well, that would take an entirely different book to explain.[1] At this point, the franchise was getting a little too convoluted and complicated. What had started with babysitter murders now found itself intertwined with witchcraft and with druid-family-killing cults. It was time to take the franchise back to the basics: Laurie versus Michael.

Halloween H20: 20 Years Later opened on August 5, 1998. The film featured the return of Jamie Lee Curtis, as well as Michael's return to a theatrical wide release. *H20* was a massive box office success and resurrected the franchise . . . until, ironically, it was killed again by 2002's *Halloween: Resurrection*.

Halloween was rebooted five years later by Rob Zombie. Featuring his trademark hillbilly-horror style, Zombie's *Halloween* gave us a look at a young Michael Myers . . . and then it gave us a giant-sized version of Michael played by Tyler Mane. Scout Taylor-Compton took up the mantle of Laurie Strode and brought new life to the character we last saw giving Michael a goodbye kiss as she dangled from the wall of Smith's Grove. The film slashed its way into the Labor Day box office record books with an opening of $30.5 million. It remained the biggest box office opening for the franchise until—well, we're getting ahead of ourselves.

In the least shocking news ever, Malek Akkad , now overseeing the Halloween franchise and his father Moustapha's legacy, announced a sequel to Zombie's *Halloween* in 2008. What was shocking, however, is that Zombie declined the offer to return. Exhausted by the process of remaking *Halloween*, he wanted to focus on other projects. With a sequel already announced, Akkad scrambled to find a replacement director—or, in this case, directors. French filmmakers Julien Maury and Alexandre Bustillo (*Inside*) were in talks to direct the sequel in November 2008. After talks broke down, Zombie ultimately did sign on to return to Haddonfield a month later.

1 You have my information, Abrams.

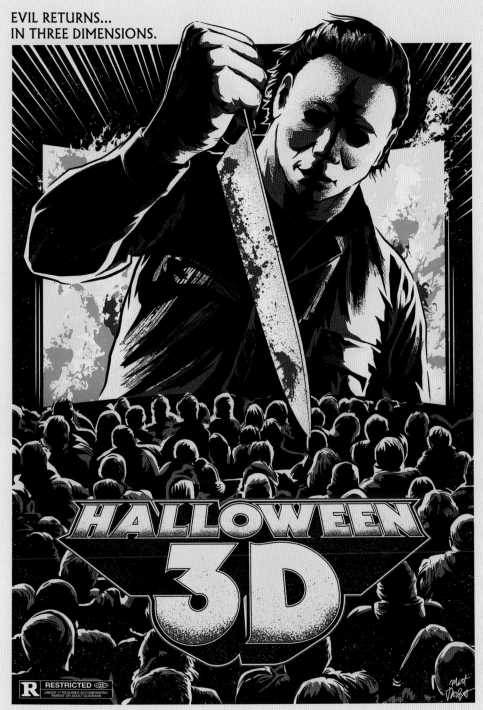

EVIL RETURNS...
IN THREE DIMENSIONS.

HALLOWEEN
3D

R RESTRICTED
UNDER 17 REQUIRES ACCOMPANYING
PARENT OR ADULT GUARDIAN

BASED ON CHARACTERS CREATED BY JOHN CARPENTER

He did so free from the established rules of the franchise, as he only agreed to return if he was granted the freedom to take the franchise wherever he wanted. The results are a psychological drama mixed with horror fantasy, as his sequel deals with how the characters were impacted by the events of the previous *Halloween*. It did not, however, connect with critics or audiences, earning a disappointing box office total of $39.4 million. That's just $8 million more than the opening weekend of his *Halloween* remake. From there, Zombie left Haddonfield for good.

Meanwhile, Patrick Lussier was about to enter town. Lussier got his start in editing, working on a variety of projects including *Wes Craven's New Nightmare*, *Red Eye*, and all four *Scream* films. He transitioned into directing in the late nineties with his directorial debut, *The Prophecy 3: The Ascent*. He followed that up with *Dracula 2000*, *Dracula II: Ascension*, *Dracula III: Legacy*, and *White Noise 2: The Light*. After helming reshoots on Jessica Alba's *The Eye*, Lussier signed on to direct the remake of *My Bloody Valentine*.

Lussier collaborated on a screenplay called *Scarecrow* with his friend Todd Farmer (that script went on to be made without Lussier's involvement as *The Messengers* in 2007). After reading multiple drafts of the *Bloody Valentine* script, Farmer was brought on to give it new life.

Production started on *My Bloody Valentine 3-D* in Pennsylvania on May 11, 2008. It was released in theaters on January 16, 2009. *MBV3D* was the first R-rated film to have a wide release in 3-D–enabled theaters and the first R-rated film to be projected with RealD technology. It opened number three at the box office with $24 million, falling behind *Gran Torino* and *Paul Blart: Mall Cop*. After making a killing at the box office, Lussier and Farmer set their sights on developing an *MBV* sequel, unaware a different killer franchise had set its black eyes on them.

ACTION!

With a script in hand and a clear franchise trajectory, Lussier and Farmer went to Lionsgate with their proposed *MBV* sequel. The house that *Saw* built informed the duo they never intended for *My Bloody Valentine* to be a franchise, and development on the sequel ended.

Lussier and Farmer shifted their focus instead to *Drive Angry*, starring Nicolas Cage. With deals in place, *Drive Angry* was in full "go" mode when the opportunity to make *Halloween 3-D* came up in September 2009. The

film was slated to be the second sequel to Zombie's original remake. Official prep on *Drive Angry* was scheduled to begin in January 2010. The duo had less than four months to write, prep, and shoot the film before *Drive* prep began. Facing an unbelievable challenge, Lussier, Farmer, Akkad, and Bob Weinstein nevertheless officially packed their bags for Haddonfield.

CUT!

Lussier and Farmer turned in a forty-page treatment on September 14, 2009—two days after the initial conference call. Prep officially began on *Halloween 3-D* immediately thereafter. The first draft of their screenplay was delivered on September 26.

Halloween 3-D was to pick up immediately where Zombie's *Halloween 2* left off, but then would bridge the gap between Zombie's *Halloween* and Carpenter's *Halloween*. Much like other installments in the franchise, the *Halloween 3-D* script had a number of nods and callbacks. There were nods to Bob's ghost, and the Silver Shamrock commercial appeared on TV in the mental hospital where Laurie and our new final girl, Amy, are committed. There's also a Halloween concert in Plissken Park sponsored by Silver Shamrock, featuring a gigantic pumpkin. The film would also show the return of the iconic mask: Michael wears it *over* the Zombie mask that was permanently burned onto his face (a nice symbol for a franchise that, up to that point, had continued to cover up what Carpenter and Hill created).

Unfortunately, this one never shaped up into a finished film. A few days after delivering their screenplay, Lussier and Farmer were informed the film was not moving forward. There's no telling where *Halloween 3-D* would have landed, in regard to the rest of the franchise, but they had developed a promising entry in only a few weeks' time.

Another attempt to bring *Halloween* back was announced in 2014 when Dimension announced *Saw* writers Marcus Dunstan and Patrick Melton as the official screenwriters for *Halloween Returns*. Intended to serve as a recalibration of sorts for the franchise, *Halloween Returns* would take place between the original *Halloween 2* and *Halloween*.[2] Dimension, however, lost the rights to the franchise and the project died in 2015.

2 You know, when Silver Shamrock was busy selling murderous masks to kids everywhere.

In true Michael Myers fashion, he lived again on the big screen. In October 2018, Blumhouse unleashed Michael Myers across the country in the legacy sequel *Halloween*. Directed by David Gordon Green (*Pineapple Express*, *Prince Avalanche*), the sequel saw the return of Jamie Lee Curtis, Nick Castle, and the master of horror himself, John Carpenter. It also shattered franchise records with an opening weekend box office of $77.5 million. In July 2019, two more sequels were announced: 2020's *Halloween Kills* and 2021's *Halloween Ends*.

Green has stated that *Halloween Ends* will be the true end to the Michael and Laurie saga.

ARTIST BIOS

NEILL BLOMKAMP'S *ALIEN 5*
Tom Coupland (aka BoyThirty) is a graphic designer, illustrator, and keen poster collector based in Newcastle, England. Tom holds a bachelor's degree in graphic arts and design from Leeds Metropolitan University (now Leeds Beckett University).

Working in digital paint, Tom primarily creates complex landscape scenes and detailed portraiture pieces with a focus on composition, color, and texture.

Instagram: @boythirty

TIM BURTON'S *BATMAN UNCHAINED*
Kreg Franco is a NYC-based illustrator and tattooer. He has a BFA in illustration from the Fashion Institute of Technology and is a graduate of the High School of Art and Design.

He's currently exhibiting artwork across the country, commercially illustrating, and tattooing at East Side Ink.

Instagram: @kregfranco

PETER JACKSON'S *A NIGHTMARE ON ELM STREET: THE DREAM LOVER*
By day, Joe Sanchez is the creative director of a lighting company; by night he is a freelance illustrator and sculptor of fantastic creatures, mythical characters, and abominable beings. His art has appeared on numerous heavy metal album covers.

Instagram: @joe_blastard

JOHN HUGHES'S *OIL AND VINEGAR*
Dave O'Flanagan is an Irish illustrator based in London.

Find more of Dave's work at daveoflanagan.com

SOFIA COPPOLA'S *THE LITTLE MERMAID*
Freya Betts is a twenty-three-year-old London-based illustrator. She's had the privilege of designing and creating art for Universal, Paramount, Fox, Warner Bros., and Disney. A full-time freelancer, she is represented by the illustration agency Jelly.

Find more of Freya's work at freyabetts.co.uk

DAVID FINCHER'S *NESS*
Neil Davies has been published in many well-known publications, including the *Wall Street Journal*, and has a regular cover illustration spot with *The Week* magazine in the UK.

In recent years, he's joined the alternative movie poster community and was thrilled at the end of 2018 to produce a Marvel-licensed poster for the tenth anniversary of *Iron Man*.

Find more of Neil's work at neildaviesillustration.co.uk

STEVEN SODERBERGH'S *CLEOPATRA 3-D*
Bella Grace is a UK-based graphic designer and digital illustrator who studied digital film and screen arts at the University for the Creative Arts in England. Her work focuses on conceptual foundations illustrated through composition, color, and texture. Her aim is to create a piece that portrays both the conceptual and aesthetic qualities of a story.

Find more of Bella's work at bellagrace.co.uk

JOHN CARPENTER'S *SHADOW COMPANY*
Ben Turner is an illustrator and designer residing in Bristol, UK.

Working mainly in digital, using a combination of detailed, expressive linework and a limited yet impactful color palette, he creates pieces, particularly portraiture, that focus on finding something different to say about a given subject.

Find more of Ben's work at posterspy.com/profile/bturnerinfo

JEAN-MARC VALLÉE'S *GET IT WHILE YOU CAN*
Alexandra España is an illustrator from Terrassa, Spain, a city near Barcelona. Her work has appeared in magazines and newspapers, including *El País Retina* (Spain), *Forbes* (Spain), *Líbero* (Spain), *De Volkskrant* (Netherlands), the *Guardian Weekly* (UK), and *Variety* (US), among other publications.

Find more of Alexandra's work at alexandraespana.com

NICOLAS WINDING REFN'S *THE BRINGING*
Jaren Hemphill is a twenty-year-old illustrator and graphic designer. He has won several movie poster contests for films such as *It Chapter Two* and *Terminator: Dark Fate*. He was also directly commissioned by Paramount for 2019's *Pet Sematary*.

Find more of Jaren's work at jarenhemphilldesigns.com

PETER BRIGG'S *HELLBOY: SILVERLANCE*
Guillem Bosch is an artist born and raised in Barcelona. He currently works as an independent professional for different studios and clients in the editorial, music, and advertising world. He has done commissions for numerous bands and music festivals and has illustrated for agencies such as DDB, Mccan, Shackleton, Snoop, and TBWA.

Find more of Guillem's work at guillembosch.es

TIM BURTON'S MONSTERPOCALYPSE 3-D

Based out of Connecticut, Kevin Tiernan is a graduate of Central Connecticut State University and has worked at agencies as art director and in other creative lead roles. He has designed official posters for TV series, including *Rick and Morty*, *BoJack Horseman*, *Stranger Things*, and *WWE*.

Find more of Kevin's work at tiernandesign.com

STEVEN SPIELBERG'S OLDBOY

Albert Collado is a freelance illustrator based in Long Island, New York. Traditionally trained, Albert has illustrated a children's book, articles, book covers, and has been hired for various private commissions.

Find more of Albert's work at albertcolladoart.com

THE TONY CLIFTON STORY

Simon Caruso resides in France and studied illustration at the Emile Cohl School in Lyon. He has created alternative posters with Poster Posse, ARTtitude collective, Hero Complex Gallery, and Gallery1988, and board games with Jeux FK, Facily Jeux, Gigamic, and Catch Up Games.

Find more of Simon's work at simoncaruso.com

GEORGE MILLER'S JUSTICE LEAGUE: MORTAL

Julien Rico Jr. is a graduate of a graphic design and web design program out of France, specializing in alternative posters for long/medium/short films for studios and individuals.

Find more of Julien's work at behance.net/ricojr

ROB ZOMBIE'S THE BLOB

Anthony Galatis is a freelance concept artist and illustrator based in Athens, Greece, creating visual development, concept art, and illustration for the game and movie industry.

Find more of Anthony's work at anthonygalatis.carbonmade. com

SHANE CARRUTH'S A TOPIARY

Brandon Michael Elrod is a graphic designer and writer from Kalamazoo, Michigan. He is a part of the design team at Bell's Brewery. Besides design, Brandon spends his time writing poetry, short stories, and is currently working on his second full-length novel.

Find more of Brandon's work at ElrodDesign.com

NICK CAVE'S GLADIATOR 2

Danny Schlitz is a mostly digital artist from the Pacific Northwest. He makes posters and artwork for anyone and everyone including Microsoft, Samsung, Amazon, Netflix, and more. Danny and his family love to hike, read comics, listen to vinyl, watch movies, and eat whatever he can forage . . . in the fridge.

Find more of Danny's work at dannyschlitz.com

WILLIAM FRIEDKIN'S THE DIARY OF JACK THE RIPPER

Rafał Rola is a digital painter out of Poland with a characteristic style based on the reproduction of traditional painting methods in digital space. His paintings give the impression that they were created with the help of oil paints or watercolors.

Find more of Rafał's work at rafalrola.pl

THE WACHOWSKIS' PLASTIC MAN

Zoltan Kovacs, known as Genzo, is a graphic designer from the small town of Salonta, Transylvania. He graduated from the Partium Christian University with a fine arts/graphic design degree in 2013 and earned his master's degree in 2015. He was one of the first one hundred users on PosterSpy.

Find more of Genzo's work at posterspy.com/profile/genzo

THE DAY THE CLOWN CRIED

Los Angeles-based Scott Saslow is a magna cum laude graduate of Florida Atlantic University. He has collaborated with Arrow Academy on nine projects and has created key art for many up-and-coming indie filmmakers and two Oscar-nominees. His work has been exhibited at Creature Features in Burbank, SXSW in Austin, and at the Old Street Gallery in London, and he was featured on io9 and in PosterSpy's *Alternative Movie Poster Collection*.

Find more of Scott's work at scottsaslow.com

ALFRED HITCHCOCK'S KALEIDOSCOPE

Chris Garofalo

Philadelphia, Pennsylvania

Equal parts anxiety/creativity/whiskey with a love for trash, cult, and horror cinema. Taking the madness in my brain and spewing it all over paper. Conventionally unconventional. Having the best time enjoying the process as much as the final result.

Instagram: @QFSChris

A CLOCKWORK ORANGE STARRING THE ROLLING STONES

Laura Streit, born in 1991, is a self-taught artist. She mainly practices

drawing and photography. Her studio work is largely inspired by pop culture: drawings about TV shows, movies, portraits of characters, and music.

Instagram: @laurastreit_art

CATHERINE HARDWICKE'S HAMLET

Eileen Steinbach (SG Posters) is a graphic designer from Hannover, Germany. Upon completion of her degree in 2011, she began working with design agencies in her hometown, gaining experience and new perspectives into the possibilities of design—from logos and editorials to brochures and creative campaigns. In her free time, she loves experimenting and exploring new things, like screenprinting and abstract painting, never wanting to limit herself to just one style or medium. Her portfolio ranges from artwork for short films to indie movies to big studio productions, with her latest clients including Disney, Sony Pictures, and Marvel.

Find more of Eileen's work at sg-posters.com

SPIKE JONZE'S HAROLD AND THE PURPLE CRAYON

Mat Roff is an illustrator from Staffordshire, England, now based in Oxford. Mat began freelancing in 2012, building an online following with his work for PlayStation Access, SEGA Europe, Twitch, and PosterSpy, to name but a few.

At present, Mat works from his studio in Oxford and hosts a monthly art event called the Oxford Doodle Club, where illustrators, designers, and hobbyists meet up to doodle and sketch at some of the area's most well-known venues.

Find more of Mat's work at matroff.co.uk

THE COEN BROTHERS' TO THE WHITE SEA

Noah Bailey is an illustrator and cartoonist from Bettendorf, Iowa, residing in Austin, Texas. His work has regularly been featured in many periodical magazines, including Alfred Hitchcock Mystery Magazine. His first graphic novel, Tremor Dose, was released by Amazon's Comixology Originals in October 2019. He is currently working on several sequential illustrated projects, as well as projects for film and literature.

Instagram: @boyishdeathtribe

RIDLEY SCOTT'S I AM LEGEND

Nicolas Bascuñán is a Chilean illustrator whose work appears on numerous posters and covers, T-shirt designs, and in various publications. One of his latest projects was for Netflix's Hip-Hop Evolution documentary series.

Instagram: @nbascunan

ALEJANDRO JODOROWSKY'S KING SHOT

Ksenia Lanina is a concept and cinematic artist as well as an illustrator and architect (Dessau International Architecture) based in Germany. She mainly works in the cinema industry producing alternative posters or storyboards for short films or movies.

Find more of Ksenia's work at behance.net/redlights

NEIL MARSHALL'S BURST 3-D

Currently living in Russia, Alexander Cherepanov has had an interest in the arts since childhood. Now working as a freelance illustrator, he has created poster art for short films of students of the "Industry" film school, the official movie poster to

Kirill Sokolov's splatterpunk action comedy Why Don't You Just Die!, and concept art for posters to several Russian commercial films with Central Partnership.

Instagram: @cherepanov_inkart

JOE CARNAHAN'S DAREDEVIL TRILOGY

Brit Sigh was born in Kansas City, Missouri, but grew up in Texas and the Midwest. Brit attended Union College, where he received a degree in psychology. Years after graduating, he followed his passions and pursued a career as an illustrator/graphic designer. He has done illustrations for Disney, Marvel, Bleacher Report, Freeform, and a long list of other great clients.

Instagram: @MidnightRun54

DAVID LYNCH'S ONE SALIVA BUBBLE

Edgar Ascensão is a French artist living in Portugal and working worldwide. His biggest passions are cinema and movie posters, and he loves to create art for both.

Find more of Edgar's work at behance.net/edgarascensao

VINCENZO NATALI'S NEUROMANCER

Aleksey Rico started drawing as a graffiti artist and decided to study graphic design at Udmurt State University. Based in Izhevsk, Russia, he's worked as a graphic designer for fourteen years. His art has appeared in The Thing Artbook and on posterspy.com.

Find more of Aleksey's work at behance.net/AlekseyRico

STANLEY KUBRICK'S *THE LORD OF THE RINGS* STARRING THE BEATLES

Liza Shumskaya, aka kino_maniac, is a full-time freelance illustrator and poster artist based in Kyiv, Ukraine. She has worked on projects for the Scorpions, the Strokes, Paramount, Sony Pictures, Netflix, Warner Bros., PosterSpy, ARTtitude, Monsa publications, and many more.

Instagram: @kino_maniac

QUENTIN TARANTINO'S *THE PSYCHIC*

After more than ten years in the world of advertising, web, and apps design, Miki Edge took a leap of faith to devote himself almost exclusively to the design of movie posters and short films. He believes a movie doesn't start with credits, it starts with the poster.

Instagram: @mikiedge

ROBERT RODRIGUEZ'S *BARBARELLA*

Yvan Quinet is a French freelance illustrator living in Geneva. After working as an engineer in the watch industry for more than ten years, he made the decision to change careers by devoting himself entirely to one of his passions: drawing.

Find more of Yvan's work at yvanquinet.com

TIM BURTON'S *CATWOMAN*

Born in 1985, Patrick Connan is a freelance art director and illustrator based in Paris. He spent more than two years of intensive training in the advertising industry under the wing of a respected and award-winning former creative director for Saatchi & Saatchi and McCann Eriksson. Then, in 2008, Patrick joined Le Cercle Noir, one of the oldest and most prestigious movie poster agencies in Paris. Alongside this, in 2013 he created Barbarian Factory, in order to take his first steps in the wonderful world of illustration.

Find more of Patrick's work at patrickconnan.com

JASON VS. CHEECH AND CHONG

Si Heard is an award-winning freelance illustrator, designer, and artist (operating under Sinage Design) and based in Brighton (on the UK's south coast). Artistically specializing in 100 percent vector-based digital illustration, he creates super-detailed and unique graphic-led/graffiti-inspired pieces, injecting an edgy and distinctive style across his artwork.

Find more of Si's work at sinagedesign.com

HENRI-GEORGES CLOUZOT'S *INFERNO*

Of Stick and Bone is a creative partnership of Steven Key and Dave Huntley, who both live and work in Sheffield, UK. Having worked together in a commercial design studio and seeing the potential to create work that is more than the sum of its parts, they decided to apply that partnership to personal work. If in the pub, they're probably discussing Batman.

Find more from Of Stick and Bone at ofstickandbone.co.uk

HARMONY KORINE'S *FIGHT HARM*

Drusilla Adeline (aka Sister Hyde Design) originates from a place in the Americas known as Indiana. She journeyed west across the Americas, as far as the roads would take her, ending in the City of Angels. In this wild terrain, she designed original posters and artwork for theatrical one sheets, Blu-rays, records, and more. Her clients included Paramount, Kino Lorber, 88 Films Ltd., and Altered Innocence, among others.

Find more from Sister Hyde Design at SisterHyde.com

TEENAGE MUTANT NINJA TURTLES: THE NEXT MUTATION

As an artist, Josh Campbell has appeared in several publications with many credits as an illustrator and designer. His signature style highlights strong lines and bold colors that invoke a blend of classic, traditional art with modern graphic style. Influenced by his BA of Fine Arts and collegiate football career, his company, Payback Penguin, is built upon the duality of art presented through professional tones integrated with humor. Josh resides with his family in Omaha, Nebraska.

Find more of Josh's work at paybackpenguin.com

MARTIN SCORSESE'S *GERSHWIN*

Dakota Randall is a freelance illustrator based out of Portland, Oregon. Dakota has spent the better part of a decade honing his craft and working on a multitude of projects ranging from illustration, digital imagery, movie poster design, and graphic design projects both commercial and creative.

Find more of Dakota's work at dakotarandall.com

JOHN CARPENTER'S *ESCAPE FROM EARTH*

QzKills (Quinnzel Kills) is a freelance illustrator based in California with a particular passion for cinema and pop culture. Fueled

by ramen and synthwave, her work regularly features a vibrant neon glow-in-the-dark aesthetic. This is probably the result of a childhood spent playing entirely too much laser tag.

Find more of QzKills's work at qzkills.com

LARRY CLARK'S *MONA LISA*

Sam Coyle is an illustrator and designer working in London who finds the task of trying to translate the themes, ideas, and aesthetics of films over to a different medium to be really rewarding. He loves to have a few different styles in his back pocket, and it varies depending on the film.

Find more of Sam's work at samcoyledesign.com

KEVIN SMITH'S *FLETCH WON*

Derek Eads is a self-taught artist/ illustrator from Indiana. He works in multiple mediums that include prints, paintings, wooden crafts, and others. His artwork has been featured in pop culture art galleries in California and New York. Derek contributed to the film art publications *Poster Spy's Alternative Movie Poster Collection* and *Alternative Movie Posters II*, and illustrated the cover for *The Tao of Bill Murray*. He works closely with several bands (Freddy & Francine, Michaela Anne, the Spring Standards, and many more), designing logos, gig posters, apparel, and album covers.

Instagram: @derek_eads

GUILLERMO DEL TORO'S *AT THE MOUNTAINS OF MADNESS*

For Laura Racero, movie posters were just a hobby. She created them after finishing the working day in the advertising agency for which she was a visual designer. But then, one day, a filmmaker asked her to design the key art for his sci-fi short film *REM*. And she realized she had always wanted to become a film poster designer.

Find more of Laura's work at lauraracero.com

JOE DANTE'S *THE MAN WITH KALEIDOSCOPE EYES*

I'm Nicky Barkla—but you can call me Nic. I'm a self-taught painter and illustrator wandering around the land of Oz (Australia), currently living among the faraway forests of Victoria. Imagination is my favorite ice cream flavor—if I'm not painting movie posters, album covers, or just scribbling pink aliens on table napkins for strangers, I'm usually quietly reading about physics or daydreaming clumsily about everything and nothing at the same time.

Find more of Nicky's work at nickybarkla.com

VAMPIRELLA

Rachael Sinclair is an illustrator and designer from Kentucky. She loves creating in different styles and for all sorts of subjects, including her native state, nature, food and drink, and pop culture. When she's not working, she enjoys cooking and baking, reading mysteries, and studying the paranormal.

Find more of Rachael's work at rachaelsinclair.myportfolio.com

DAVID CRONENBERG'S *TOTAL RECALL*

Nick Taylor is an illustrator and graphic artist based in Nottinghamshire. He combines his love of drawing, collage, mark making, and printing with digital techniques. His clients include *The Guardian*, *Variety*, Red Bull Radio, *Times Higher Education*, AQUILA, Ubiquity Records, Universal Music, and *Little White Lies*. When time permits, he also runs a small cassette label called Miracle Pond, releasing strange and esoteric sounds into the world.

Find more of Nick's work at nicktaylorillustration.co.uk

BATMAN VS. GODZILLA

Mark Levy trained traditionally in oils on canvas and spent a few years freelancing as an illustrator before entering the Amusement Industry. He designs and provides artwork for penny pushers and various other amusements machines. He has also continued to freelance, creating key art and poster design for film and gaming.

Instagram: @marklevyart

PATRICK LUSSIER'S *HALLOWEEN 3-D*

Matt Talbot is an illustrator and graphic designer from New Hampshire. He's worked on movie poster projects with Marvel Studios and Warner Bros. and is a frequent exhibitor at Gallery 1988. When not working, you can probably find Matt watching horror movies and thinking about his next poster.

Find more of Matt's work at mattrobot.com

ACKNOWLEDGMENTS

The following people are the reason *Underexposed* exists. And the reason it was an absolute joy of an experience.

Jack Woodhams/PosterSpy, for making this entire book happen. And for his unwavering support.

To Eric Klopfer, for the opportunity, encouragement, honesty, and guidance. I'm forever in your debt.

To Connor Leonard, for being incredibly supportive and getting this book to the finish line.

To Fred Dekker, for a fantastic foreword. I've spent thirty plus years quoting you; it's insane to me that our words now share space in this book.

To fifty of the most talented artists across the globe. You gave these films life and I truly hope your work impacts the filmmakers we're paying tribute to. Thank you for believing in this project.

Thank you to Tom, Frankie, Jake, Glenn, Matt, Eilise, Nick, Lea, Mitch, and Jeremy.

To my family and to my Mom, for showing me how important creativity is.

To Daisy/Gatsby, for helping me wake up at 4 a.m. every day to write.

To Phoenix, for being the coolest daughter around. I'm glad I slipped that stork a hundred-dollar bill when it tried to drop a boring kid in my lap. It's been a blast to grow up with you.

To Cam, for saving my life. And my dreams. For always being you and never minding the fact that I'm, well, me. Thank you for always believing in me.

To the movies. For stealing my heart at the age of four and never letting go.

JOSHUA HULL

Firstly, I would like to thank Joshua for his wonderful writing and exploration of the films within this book. It's quite amazing seeing what was originally a pitch for a blog series become a real tangible production. Joshua's excellent understanding of pop culture and the filmmaking industry shines through page-to-page. Throughout the whole process from concept to publishing this book, Joshua has put in his all, and I'm delighted to have had this opportunity to work with him.

I'd like to thank my mother, who throughout my whole life has supported and championed my passion for the arts, and who has always offered guidance when nobody else has. Without her, I wouldn't be where I am today, and for that I'm forever thankful.

The people of Abrams! This book wouldn't even exist if it weren't for Eric Klopfer and Connor Leonard who trusted our idea and PosterSpy to deliver the book that is now in front of you. I must also thank the design and production team: art director Deb Wood, design manager Eli Mock, and production manager Larry Pekarek for their support along the way. The book looks ace.

Finally, I thank all of the kind, talented, and wonderful people in the PosterSpy community who've enabled me to turn what was once a passion project in my teens into my day job. The opportunities and experiences I've had would be nonexistent without you. I am indebted to you all.

JACK WOODHAMS